Albert Paley

Dedicated to Frances

Whose love and compassion has been my strength.

Carter Ratcliff

Albert Paley
in the 21ˢᵗ Century

May 1 – June 27, 2010

MEMORIAL ART GALLERY
UNIVERSITY of ROCHESTER

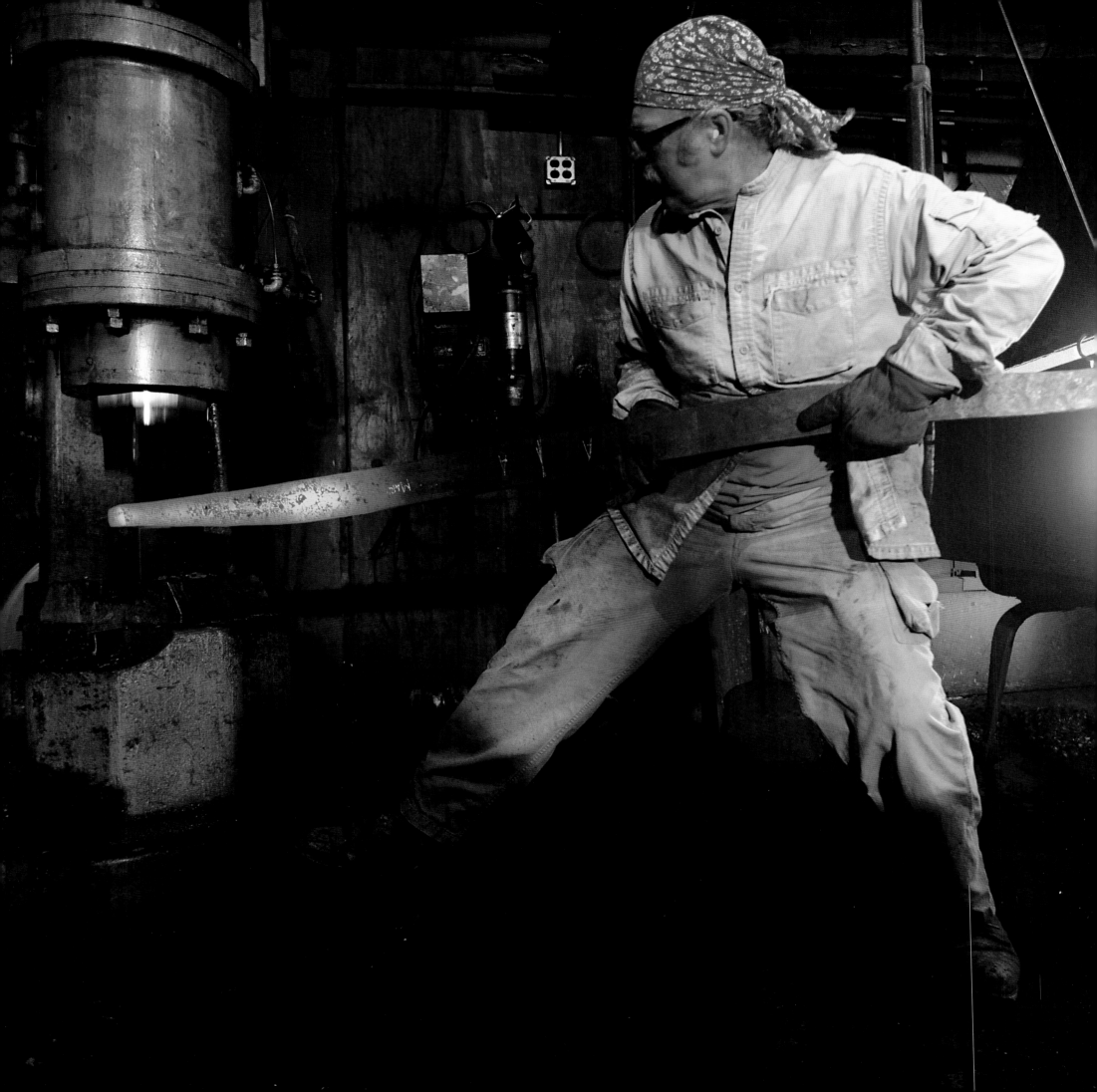

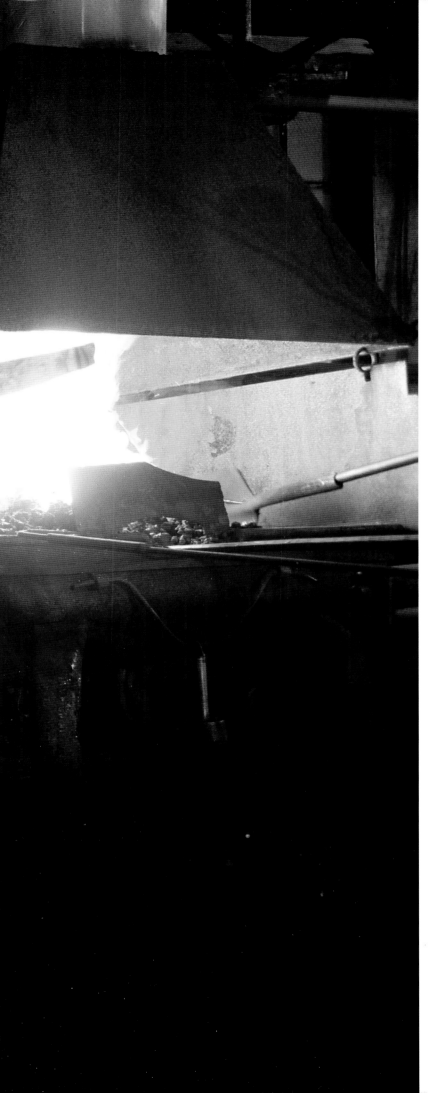

Contents

1. Paley, Forging
East Main Street Studio
Rochester, New York

2. Design Studio
North Washington Street Studio,
Rochester, New York

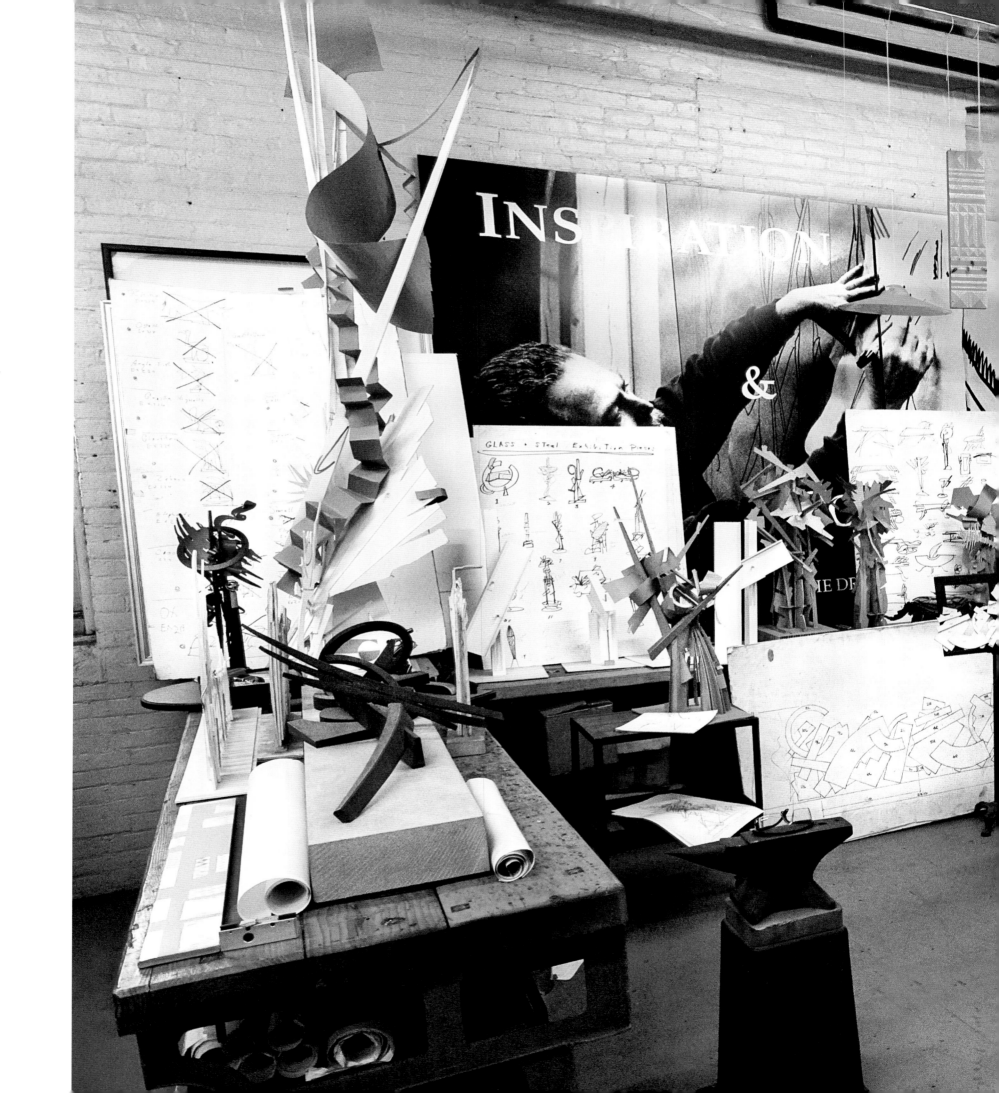

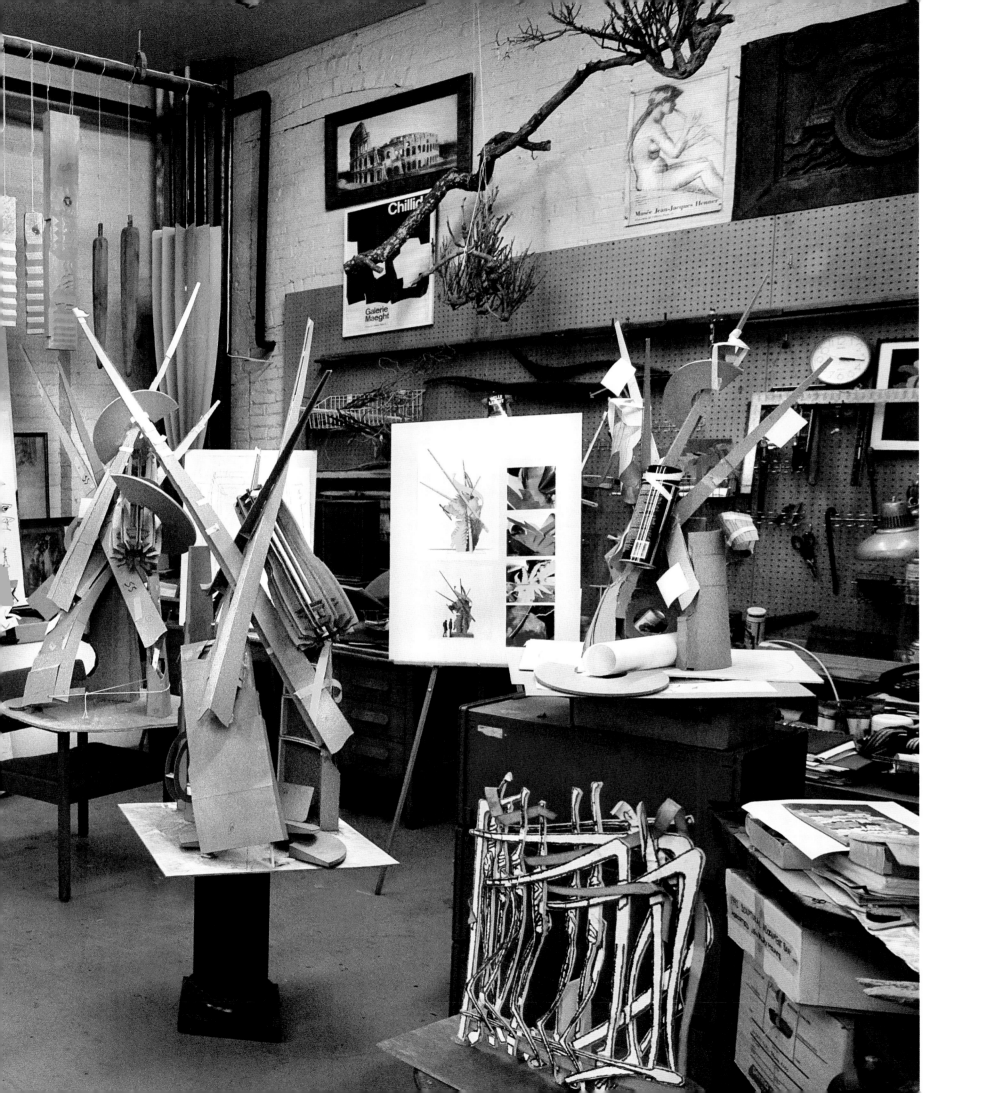

Covers
Spiral, 2008
Detail

Front flyleaf.
Forged Elements
Detail

Back Flyleaf.
Forged Elements
Detail

Editorial coordination
Paola Gribaudo

Printed and bound by Litho Art New, Turin, Italy.
First edition
ISBN-13: 978-0-615-35392-0
ISBN-10: 0615353924
Library of Congress Control Number: 2010901989

**MEMORIAL
ART GALLERY**
UNIVERSITY *of* ROCHESTER

This exhibition is organized by Memorial Art Gallery and made possible by Presenting Sponsors Bank of America and
the Mr. and Mrs. Raymond J. Horowitz Foundation for the Arts, Inc. Additional underwriting is provided by the Gallery
Council of the Memorial Art Gallery, the Gouvernet Arts Fund of Rochester Area Community Foundation, Nancy G.
Curme and Nancy Turner. Support is also provided by Deanne Molinari, Mr. and Mrs. Robert V. Gianniny, the
Elizabeth F. Cheney Foundation and Mann's Jewelers.

Acknowledgements

I would like to acknowledge my appreciation to all those individuals that have supported and championed the cause of my Studio activities. Without such support this exhibition and publication would not have been realized. Special thanks to Nancy and Alan Cameros.

From Grant Holcomb, the Gallery Director, who initiated the concept of the exhibition to Joe Carney in Development, to Marie Via, the exhibition's Curator, as well as all the gallery staff who have worked over several years - I am grateful for their efforts.

I would like to thank the dedicated individuals in my Studio for their contributions;

Elizabeth Cameron. Whose efforts made this publication a reality.
Gina Foster
Scott Frarey
Tyler Guay
Jeff Jubenville
Jennifer Laemlein
Ellen McCooe
David Owens
Jason Reszetucha
Jennifer Schab
Brian Shares
Amanda Sharpe
Blake Terzini

I would also like to recognize those institutions and individuals that have supported my Studio endeavors.

Howard and Roberta Ahmanson
Craig Baker
Brooke Barrie
John Batiste
Claude Bennett
Martin Blank
Alan and Nancy Cameros
Clay Center for the Arts
Myra Daniels
Dr. William Destler
David and Sally Dieterich
Alice Duncan
Mark Engelbrecht
David Feinstein
Mark and Emilyn Feldberg
General Welding
Grounds for Sculpture
Todd Graham
Paul Greenhalgh
Paola Gribaudo
Dr. Jeremy Haefner
Tom Hawk

Albert Paley

Greg Hawthorne
Robert Holton and Marie Kraft
Malcolm Holzman
Pitt and Barbara Hyde
Iowa State University
Iowa West Foundation
Jackson Welding
Klein Steel
Joe Klein
George and Erica Kobor
Kodak
Stewart and Donna Kohl
Ellen Landis
Stanley Lechtzin
Robert Lombard
Tony Machi
Maple Grove Enterprises
Nancy Mann
Robert Mann
Mayerson J.C.C.
John and Ruth McGee
Stanley McKenzie
Miller Sandblasting
Bruce Miller

Ann Mulligan
Naples Philharmonic Center for the Arts
New Jersey Council for the Arts
Dodge Peters
Gerald Peters
Milt Peterson
Lynette Pohlman
Carter Ratcliff
Melody Sawyer Richardson
Rochester Institute of Technology
Mark and Robin Rubenstein
Don and Chris Sanders
Sebastian
Chris and Barbara Seidman
Mike and Renee Silverstein
Albert Simone
Carl Solway
Rich Sorich
Bob and Connie Springborn
Steel Work, Inc.
John Summers
Gina Taro
University of Rochester
Thelma Zalk

Fifteen years ago, the Memorial Art Gallery organized the first major exhibition of the drawings of Albert Paley and now we are pleased to host the first exhibition that solely focuses on Albert's work in the 21 century. Albert Paley has already established himself as one of the "masters" in the long history of noted Rochester artists. His work has been collected, exhibited and installed across the country from the San Francisco Civic Center Courthouse to the New York State Senate Chambers in Albany, New York. Certainly, he is one of the few Rochester artists whose work can also be appreciated on a driving tour of the city: we might start at his *Main Street Bridge* downtown before going to see *Genesee Passage* at the Bausch and Lomb Headquarters at Clinton Square and, around the corner, Paley's abstract sculpture in front of the Strong National Museum of Play; we would proceed to the RIT campus and note the monumental *Sentinel* before driving to Vanguard Parkway to see *Threshold* at Klein Steel Corporation.

We could then return to the Memorial Art Gallery to appreciate Paley's rich legacy in sculpture, jewelry, drawing and print-making and end with a toast to one of Rochester's singular artists in front of the Gallery's site-specific forged steel screen *Convergence* in the Vanden Brul Pavilion. Indeed, Albert's presence in this city over the past four decades has enchanted and enriched us all.

We remain grateful for this long friendship and now look forward to equally dynamic years with "Albert Paley in the 21st Century."

This exhibition was generously supported by friends and organizations of who have long admired Albert Paley as well as the Memorial Art Gallery. We are deeply grateful for the major corporate sponsorship of the Bank of America; Joe Rulison was instrumental in providing this key support.

The Elizabeth F. Cheney Foundation of Chicago and its President, Larry Belles, have supported major Gallery exhibitions over the years and, for that, we remain deeply grateful.

The Gallery Council, Suzanne Gouvernet and Nancy Turner are long time Gallery friends who have remained both steadfast and generous in their support of the Gallery's exhibition programs.

We would like to recognize the assistance provided by Nancy and Alan Cameros in making this exhibition and the associated publication into realities. I also want to note Marie Via's superb oversight of the organization of this exhibition. Both friend and colleague, she truly remains one of the Gallery treasures.

Grant Holcomb
The Mary W. and Donald R. Clark Director
Memorial Art Gallery

"The main function of ornament is to articulate emotion."
 Albert Paley

I saw my first Albert Paley when I visited the Hunter Museum of Art in Chattanooga in 1980. I was unfamiliar with his work at that time—but I can distinctly remember being mesmerized by the sinuous steel tendrils that formed a fence around the museum's sculpture court, reminiscent of the kudzu vines that can so easily envelop the southern landscape. Two years later, when I moved to Rochester, I experienced an immediate thrill of recognition when I saw a newly-acquired sculpture at Memorial Art Gallery. Standing over nine feet tall, it was a brobdingnabian *Candlestick* that rose from a gracefully twisting base to culminate in steel tongues of flame. I wanted to see more! Even after I learned that Paley's studio was here in Rochester, I had no inkling that one day I would have the pleasure of organizing the first exhibition devoted to his 21st-century work.

Many people do not know that Paley began his career in the mid-1960s as a goldsmith, the maker of jewelry that might be described as futuristically Art Nouveau. A decade later, he was working in forged and fabricated steel, coming to national prominence with an exquisite set of portal gates for the Renwick Gallery, part of the Smithsonian Institution in Washington, D.C. Even as the scale of his work grew, so did his reputation as an artist. Today, his public and private commissions occupy pride of place across the country, from Orlando to Houston to Beverly Hills. He has earned the description of "iconoclastic traditionalist" for his ability to successfully integrate naturalism and abstraction in a personal and highly recognizable aesthetic.

Albert Paley is a Romantic, and by this I mean that nature and our relationship with it dominates his aesthetic. He is endlessly fascinated by plant life, sometimes interpreting its structures quite literally, and then again abstracting it to a suggestion of itself. At the intellectual core of his work is the belief that natural forms have the power to humanize the minimalist architecture of factories, apartment complexes, and arts centers that too often have become impersonal, even inhospitable. He understands that people who try to work, live, shop, and relax behind brutal facades can find some sort of balance by walking through or passing by artworks that celebrate our connection with nature.

We here in Rochester are fortunate to live with major examples of Paley's outdoor sculpture from all periods of his career. At one end of the spectrum is the 1982 *Sculpture for the Strong Museum*, a massive circular form anchored to the ground by a horizontal element referencing the roofline of the building it complements. Since 1989 we have been enjoying the *Main Street Bridge Railing*, which employs forms that suggest canal boats gliding through the gently rippling water of the Genesee River that flows beneath it. *Genesee Passage* of 1996, commissioned for the international headquarters of Bausch & Lomb, features a sectioned column topped with heraldic banners and split by an undulating form that, again, suggests the river that bisects downtown Rochester. And now we have *Threshold*, completed for Klein Steel in 2006, a geometric construction that pays homage to both the history of the company and of Paley's own work by recycling "drops" that contain skeleton shapes from past projects.

As Memorial Gallery marches toward its centennial in 2013, it is fitting that we take this opportunity to honor Albert Paley with the most significant one-man exhibition of his sculpture to date. *Albert Paley in the 21 Century* recognizes his deep roots in our community, celebrates his contribution to contemporary sculpture nationwide, and anticipates his continued faith in the humanizing power of art.

Marie Via
Director of Exhibitions
Memorial Art Gallery

Monument as Provocateur: The Art of Albert Paley

by *Carter Ratcliff*

Over two millennia ago, the Greek rhetorician Callistratus described a figure of Dionysus that Praxiteles had cast in bronze. So lifelike was this image of the god, according to Callistratus, that the sculptor's metal had the softness of flesh. Illusions of this sort were long a goal of sculptors. In the 17th century, Gian Lorenzo Bernini carved a statue of an angel piercing the heart of St. Teresa with a spear. To give his work maximum verisimilitude, Bernini gave the saint's drapery the texture of cloth, not marble. Albert Paley is our contemporary. He has no wish to convince us that his materials are not what they are. When he works in steel, he makes it clear that steel is heavy. It is hard. It is inanimate. Yet he endows it with vitality. He does not, however, try to persuade us that steel is somehow animate. Instead, he persuades the metal to contradict itself—to *be* one thing (a sculptor's medium) and to *mean* another (a living presence).

Nearly ten feet tall, *Alberto*, 2008, has no pedestal (Image 76). Standing on the same ground we do, it towers above us.

Yet this sculpture is not overbearing. For a contrast, think of colossal Egyptian figures. Emblems of a rigid and sometimes cruel authority, they themselves are rigid. With their blank expressions and stiff frontal postures, they encourage us to stand at a distance and consider ourselves insignificant by comparison. *Alberto* invites us to approach, to circle it. We get involved in its complexities—in following the undulations of its flat, ribbon-like forms, for instance, though we might wonder if they really are ribbon-like. Maybe they are more like pennants. Or are these readings too literal? This is, after all, an abstract sculpture. Why not see these flowing forms as evocations of gestures or the sum of them as a sign of the torsion felt by a body shifting its posture?

Alberto brings to mind the ancient and still pertinent idea of *contrapposto*—the opposition hip to shoulder that inflects a sculptural figure with a graceful S-curve. Making a complete circuit of *Alberto*, we see hints of this curve. And we intuit rather than see the grandly spiraling energy that flows through this monumental object, joining its parts into an organic unity. At this point, it might be asked what became of the idea that *Alberto* is an abstract sculpture. I've been talking about it as if it were as figurative as Praxiteles's Dionysius. It is not and yet the idea of "pure sculpture" doesn't survive very long in *Alberto's* vicinity. This work of art is in some way representative. But what in what way, exactly?

Like *Alberto, Portal*, 2005, is built of complex shapes with sharp-focus edges. This clarity of outline appears first in stark, black-on-white drawings [fig. 1]. These lead to cardboard models and onward to three-dimensional maquettes in metal. Four feet tall, the stainless steel *Portal* maquette in this exhibition was preceded another one just over half that size. At every stage, Paley makes adjustments of shape and scale, some immediately noticeable, others too subtle to be detected without minute comparisons.

Unlike *Alberto, Portal* stands on a large metal plate. At its heart is a roughly rectangular element pierced by a narrow opening—a portal [fig. 2]. As the other elements of this sculpture crowd around the one that gives the work its name, an outsized but subtle hint of the human form emerges. Paley has suffused a portal with the presence of the one who goes through it. So *Portal* is and is not a monumental figure, just as *Alberto* is and is not a self-portrait of the artist, given that "Alberto" is "Albert," but not exactly.

Paley's sculptures are multifaceted, rich with allusion, and impossible to see in a single glance.

Thus his art invites, with brilliant concision, what life invites in a sprawling, haphazard way: not just one interpretation but an echoing, amplifying sequence of speculative responses. In each of his sculptures, Paley calibrates com-

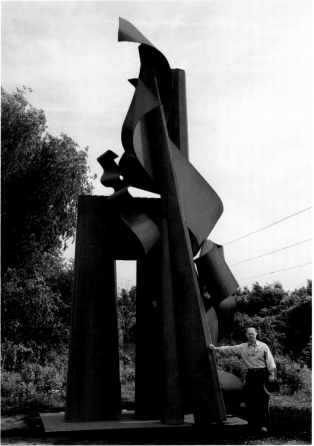

plexity with extraordinary finesse. He wants to challenge the imagination as vigorously as he can without overwhelming it. By contrast, a Minimalist cube is an aggressively simple object with a single ambition: to be seen as absolutely identical with itself. To place Minimalist poverty in opposition to Paley's richness is to indicate, all too sketchily, where he stands in the aesthetic terrain of our times. For a fuller view, we must look back to the beginning of his career.

Paley is a graduate of the Tyler School of Art, in his native city of Philadelphia. Entering in 1963, he received his Bachelor of Fine Arts degree three years later. As an undergraduate, he studied a variety of subjects—drawing, jewelry-making, sculpture. At the graduate level, he concentrated on goldsmithing. Working as an instructor, as well, he earned his Master of Fine Arts degree in 1969. By then, Paley was an accomplished goldsmith with an already lengthy record of exhibitions and awards. Working not only in gold but also with silver and a variety of jewel stones, he achieved a high level of craftsmanship in the production of necklaces, bracelets, and brooches. Later, he would transpose his skill—and his flair for the minutiae of fabrication—to objects of monumental stature.

A piece of jewelry is an embellishment of the body. Its wearer must feel adorned, not burdened, and Paley's early work has a simmering, almost airy delicacy. From the start, however, he had a penchant for intricately interwoven forms, and by the early 1970s his inventiveness was demanding more room. His jewelry had to increase in size to provide his exuberantly looping, tendril-like shapes a chance to elaborate themselves. Brooches and pendants, in particular, became larger and weightier. As bodily ornaments acquired body, becoming fully three-dimensional, jewelry turned into wearable sculpture [fig. 3]. Moreover, forms that emerged in his jewelry were taking on the scale of furniture.

In 1969, a cluster of Paley's characteristically curling, swirling lines coalesced as a wrought-iron candleholder. Two feet tall, it stands comfortably on a table. The following year, he made a candleholder to stand on the floor. Three times taller than the earlier one, it has human stature and was followed by tables, plant stands, and lamps scaled to human use. Though these objects all have a sculptural presence, Paley was not yet a sculptor. A jeweler evolving into a designer, he scaled up his forms still further for his first major commission: a pair of gates for the Renwick

Gallery of the National Gallery of American Art, in Washington, D.C.

Completed in 1974, the *Renwick Portal Gates* are made of forged and fabricated steel, brass, bronze and copper [fig. 4]. Here, in these massive objects—they are six feet wide and over seven feet high—Paley's mastery of his materials merged triumphantly with his vocabulary of sinuous forms. This was the most important work that he had done until then, not only for its technical and formal brilliance but also because it declared unequivocally his aesthetic allegiance. In 1974, Paley was a proponent of Art Nouveau, a style that flourished in Europe from the late 19th century until the early years of the 20th century.

Art historians often describe Art Nouveau as an objection to industrial progress. After all, it opposes the efficiency of machine with leisurely suggestions of stems and branches and vines—as in Hector Guimard's entryways to the Paris Metro, which grace the city with stylized intimations of gardens and forest glades. Yet Guimard's forms are the products of sophisticated metal-working.

He and other proponents of Art Nouveau had no quarrel with advanced technology. However, they resisted the assumption that form in the industrial age should be starkly utilitarian. Why not put industry at the service of nature or, at the very least, merge mechanical method with natural form?

Paley's Renwick gates pose the same question, which had become all the more urgent since Guimard's time. In the decades after the Second World War, American cities were increasingly dominated by the stripped-down geometry of International Style architecture. Dispensing with ornament, the new style proposed an ideal of impersonal clarity. This ideal expanded like an imperial power into every region of design, yet it exerted no authority over Paley's imagination. At its infrequent best, the International Style attained a crystalline stasis. From the start of his career, Paley charged inert matter with intimations of motion, an organic energy as elegant as it is insistent. With the Renwick gates, he brought this elegance to the verge of restlessness. For he, too, was restless, a designer drawn to the endlessly contested border between functional design and the autonomous activity of art-making.

At Renwick, right and left gates are like a pair of hands: fold them together and they make an exact match. In the

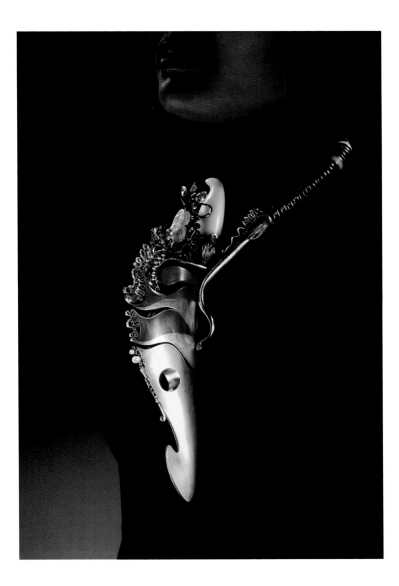

Fig. 1
Portal, 1990
Presentation Drawing
Graphite on Paper
11" x 8.5"

Fig. 2
Portal , 2005
Formed and Fabricated Cor-ten Steel
30' x 11.75' x 8'6"
Construction Site,
Rochester, New York

Fig. 3
Pendant, 1973
Forged, Formed and Fabricated
Silver, Copper, 14K Gold, Antique Cameo,
Pearls and Delrin
17" x 4.5" x 4.5"

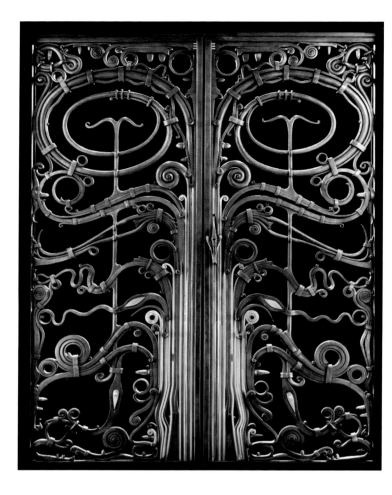

Fig. 4
Renwick Portal Gates, 1974
Forged and Fabricated Mild Steel, Brass, Bronze and Copper
7'6" x 6' x 3"
Renwick Gallery of the Smithsonian American Art Museum,
Washington DC

Fig. 5
Volute, 2003
Preliminary Drawing
Conte Crayon on Paper
28" x 20"
Studio Archive

Fig. 6
Interlace, 2002
Formed and Fabricated Mild Steel
12' x 18'6" x 4'

Fig. 7
Village of Hope Gate Model, 2008
Formed and Fabricated Mild Steel
4'3" x 6' x 1'

mid-1970s, Paley brought the asymmetry of his later jewelry to architectural projects. This asymmetry—traditionally a quality of sculpture but not of design—persisted over the decades, and can be seen throughout the *Memphis Portal Gate Model*, 2008. At the very center of this piece, left precisely mirrors right. Elsewhere, the mirroring is inflected by the differences produced—indeed, fostered—by the forging process.

Despite his affinity for Art Nouveau, Paley has his uses for the unadorned geometry of International Style architecture—see the starkly angular form that supports the massive fronds of *Stainless Steel Sculpture*, 2008 (Image 86). When Cubism met the International Style, in the 1920s, Art Deco was born. There are no clear traces of Art Deco in Paley's sculpture, and yet I wonder if the extreme artifice of that style might be hovering near the central symmetries of *Memphis Portal Gate* or weaving through the flat patterns of *Design Study for the Washington Cathedral Gate*, 2008 (Images 17 and 23). It is certain, though, that the improvisations of drawing leave their mark on all of Paley's work.

His way of forging steel—his style of blacksmithing—is a kind of drawing, and a sculpture often originates in a rough, quick Conte Crayon sketch on paper [fig. 5]. However sharply defined a sculpture's ultimate form, it originates in a flurry of line and texture. Paley's preliminary drawings are haunted by Abstract Expressionism, still a flourishing style when he was a student, despite the ascendance of Pop Art and Minimalism. Art Deco was enjoying a revival in those days, as International Style modernism struggled to defend itself against the challenges posed by postmodernism.

Because the Renwick gates ignore the directives handed down by modernist theories of aesthetic progress, we could see them as remarkably resourceful ventures in a postmodernist mode. Like Paley's jewelry and furniture, these gates are the work of an artist who ranges at will through our culture's repertory of style. For every artist, however, some earlier style is exemplary—a reliable reminder of what art can be. Early in Paley's career, Art Nouveau had this meaning for him. I think it still does, though his work of the past two decades shows no obvious traces of the style. Yet Art Nouveau has stayed alive and present for Paley as a repertory of forms driven by the energy he experiences as primordial—the pulsing, organic force that courses through the most vital art of every era, regardless of style.

Season after season, this energy renews itself in a fresh burst of sculpture. In *Interlace*, 2006, it generates a lush tangle of frond-like shapes, each one distinct and each making an equally powerful claim on our attention [fig. 6]. By 2008, it had modulated, giving a staccato clarity to the vertical bands in *Village of Hope Gate Model*, 2008 [fig. 7]. This looks like a clear pattern of development, yet I don't want to insist on it. Paley works on several sculptures at once, so the chronology of his oeuvre is complex.

The four-foot high *Interlace* included in this show marks a step on the way to a version that is three times as tall. The taller one is the final version, and yet it is dated 2005—a year earlier than the date assigned to its predecessor. As it happens, Paley often assembles and installs a large sculpture a year or two before he gives a maquette its final touches. In cases like these, the date of a maquette does not indicate its place in the artist's process. However, it does tell us something about the tempo of Paley's studio. With so many works simultaneously under way, it not surprising that dates sometimes seem to be out of order.

Ever since the avant-garde emerged in the mid-19th century, artists have felt compelled to advance along clearly marked paths. Entangling time itself with their yearning for progress, they give their chronologies a militant clarity. Paley, however, never assimilated the avant-garde sense of time. He reinvented Art Nouveau when it was thoroughly out of fashion. From his reinvention emerged a panoply of options, everything from linear severity to lushly foliated abundance. Rather than march directly from one option to the next, Paley moves between them at will, often circling back to a previously realized idea and reimagining it.

Interlace is a study in organic architecture, an astonishing burst of form as densely woven as the upper reaches of the rain forest. With *Stainless Steel Sculpture*, Paley recapitulates the basic element of *Interlace*—a broad-leafed frond—and entwines it with a form reminiscent of architecture strictly defined. Organic curves meet inorganic geometry. The line connecting *Interlace* and *Stainless Steel Sculpture* reaches back to 1974 and the Renwick gates, Paley's first engagement with architecture.

A more recent connection leads from *Interlace* and *Stainless Steel Sculpture* to *Double Cross*, 2004, a development model for *Constellation*, 2002 [fig. 8]. Massive over-

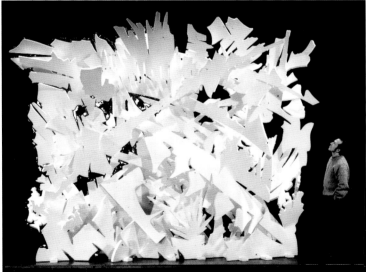

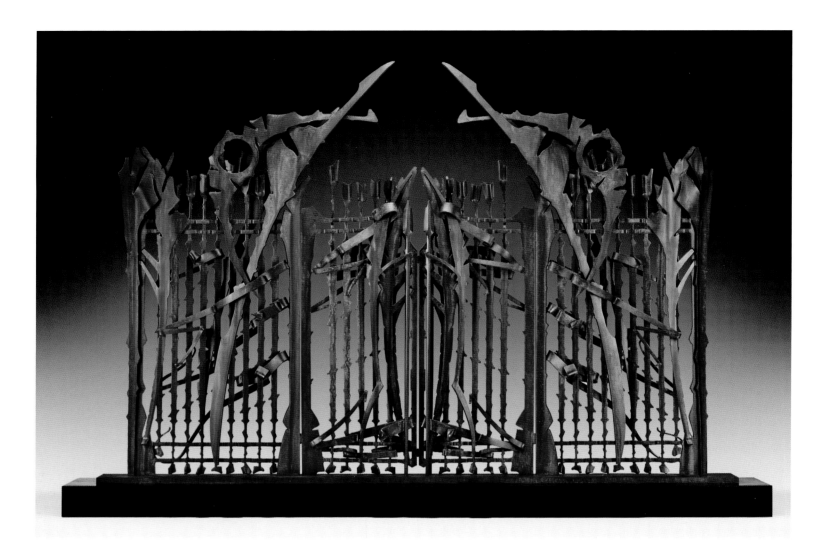

all and yet delicate in detail, *Constellation* is from the same rain forest as *Interlace*. Like *Stainless Steel Sculpture*, it has made its peace with the angular forms of modern buildings, not by incorporating them, but by nestling into the grandiose entryway of a skyscraper in Toronto. It's as if this sculptural trio took shape in the course of a conversation between three voices. Each work became itself by responding to the others.

The trouble with this image of a simultaneous interchange is that the three works appeared one after another, first *Constellation/Double Cross*, then *Interlace*, and finally *Stainless Steel Sculpture*. So the metaphor doesn't quite work. Still, it has the virtue of alerting us to the labyrinthine web of affinity that joins Paley's works into an oeuvre. Any one sculpture evokes all the others, directly or indirectly, suggesting that the entire range of his possibilities is always present to him. There is no protocol of succession, no extrapolation from early to late along a narrow

path. Though Paley is far from indifferent to chronology, he is unimpressed by its imperatives. Seeing how little the one-way flow of time constrains him, we might be tempted to say that his art is timeless.

That would be a mistake. We all live in time. It is our medium, so to speak, and there is no question of escaping it. Yet one can always ask: what is time for me? How do I experience it? Jumping from style to style, medium to medium, many contemporary artists make work in clusters only tenuously connected. For them, time is episodic. By contrast, Paley experiences time as a unity—but not the tight, narrowly defined sequence that forms in the wake of an avant-garde program. For Paley, time's advance is more like that of a warm front on a weather map: spacious, complex, and alive with crosscurrents. From season to season, his present is his past reinvented and his future is the manifold promise of that reinvention. Steadily evolving, his repertory of organic forms finds new ways to embrace his

squared-away emblems of architecture. From Paleyesque interactions of two ecologies—one natural, the other built—a human presence emerges.

Returning for a moment to our starting point, I want to take note of *Portal*'s use of metonymy, the trope that puts a part in place of a whole. Here, a door-like element stands for the entire body of architecture. From certain angles, this form nearly vanishes behind an array of tapering poles and rippling strips of steel. One of the poles is segmented in a manner that suggests a backbone. This is a metonymic image of the human body, perhaps, and it may be that the artist means the steel strips' undulating forms to invoke the body's rhythms. We could, of course, take these forms as gestural. In any case, the built environment is dominated by bodily shapes and energies—a clear situation until we take a closer look at Paley's images of the body.

Alberto has a certain posture, even a personality. Yet these human attributes do not mitigate this sculpture's resemblance to a building, not in its appearance but in its structure. For this is a built object, a whole assembled from disparate parts. Its disparity fascinates, not in itself but as a challenge Paley faced and overcame. We renew this challenge for ourselves when we try to see in detail exactly how the artist went about meeting it—how he wrested unity from the play of straight line against curve, flatness against rounded volume, earthbound form against form that soars. Entangled in the intricacies of a particular sculpture, it is easy to lose sight of the three major themes that Paley's art deploys—the natural environment, the built environment, and the human presence.

Each theme incorporates the other two, and that is why the artist's allusions to the body are not merely bodily. They are also architectural. Furthermore, Paley's architecture is impossible to disentangle from his emblems of nature—remember *Stainless Steel Sculpture,* with its interplay of portal and fronds. When Paley makes a new sculpture, he reweaves his thematic possibilities. He supplies the map of his aesthetic with a new landmark. This metaphor suggests another: getting to know Paley's art is like making a tour of the monuments.

The path from *Alberto* to *Opus*, 2000 takes us from one vision of architecture to another—for *Alberto* is solidly, even heroically engineered, in contrast to *Opus*, which levi-

tates on its own shimmering transparency (Image 32). From *Opus* we could continue onward to *Crescent* and *Clear Arc*, two works from 2001(Image 36). Both employ glass, the material that gives *Opus* its elegant weightlessness. Though *Clear Cut*, 2001, belongs to the same family as *Crescent* and *Clear Arc*, it is a cousin, not a sibling. In *Clear Cut*, the heavy, rough-hewn forms of the other two begin to soften. Hints of stems and leaves appear (Image 35).

Taking these hints, we set out for *Passage*, *Tribute*, and *Splay*, all from 2000 [figs. 9-10]. Tight clusters of vertical, vegetative form, these sculptures imply the figure, an implication that becomes explicit in the coiling, vine-like forms of two works—*Transpose*, 2001, and *Spiral*, 2008—that are as decisively figurative as *Alberto* (Images 12 and 117). Tracing the human presence from *Alberto* to *Spiral*, as that presence shifts from an architectural to a natural mode, we travel from one end of Paley's terrain to the other.

This journey could have followed any number of paths, some of them quick, others slow and meandering. Our encounters with an artist's oeuvre do not all have the same tempo or itinerary. Still, no survey of the Paley art should omit a stopover at *The Ceremonial Archway*, 2007, a luminously rusted steel structure over twenty feet long and nearly six feet high. Despite its dimensions, this is a model for an even larger work—*Animals Always*, an entryway completed in 2006 for the St. Louis Zoo (Image 137). The full-scale version is 130 feet wide, a sculpture at the scale of a habitat. Its double sweep of metallic vegetation is home to life-size figures of over sixty wild species.

These are the most frankly representational sculptures that Paley has ever made.

Yet they are not exercises in a minutely accurate realism. Here as elsewhere, the artist's basic elements are irregular shapes with the power to evoke life-forms and living energies. For this project, however, he leaned toward specificity, so that when each cluster of shapes was assembled it would constitute a statue of an identifiable creature—an elephant, a lion. A giraffe stands beneath the arching fronds of *The Ceremonial Archway* and in the denser regions of its metallic jungle a shark is swimming.

This work is at once figurative and abstract, lush and linear. Marking extremes, it includes everything in between, as does Paley's entire oeuvre at a still grander scale. His art sets us to thinking about all there is—the world's plenitude.

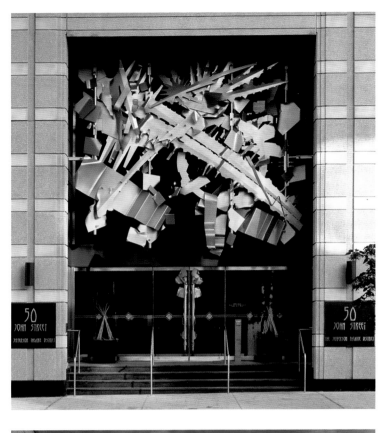

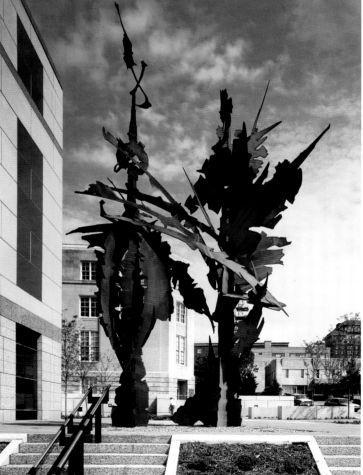

Is this, then, what he represents? No, because the plenitude of existence is beyond representation. Or maybe not. It depends on what we think representation is.

Callistratus, the writer I mentioned at the outset, thought of representation as a kind of mimicry: the best statue is the one we mistake for its subject. Following this idea into the realm of legend, we meet the blacksmith Daedalus, whose effigies of the human body were so accurate that they came alive and would run away if their owners failed to fasten them in place. Lurking in this old story is a primordial idea: an artist's representation captures a vital essence—or, possibly, reveals it. Because this idea is still current, we understand what Michelangelo means when he declares, in Sonnet 151, that a sculptor can conceive of no idea that a block of marble does not "circumscribe." To sculpt is to remove the excess marble so that the idea can shine forth from the stone that remains. Here, representation is mimicry so exalted that it gives a palpable object the power to represent some impalpable and of course transcendent absolute.

Thus we are to see Michelangelo's *David* not as a portrait of a particular man but as the image of manhood itself.

The poet Théophile Gautier revised Michelangelo in a poem called "L'Art," 1857. Using sculpture as a metonym for art of every kind, Gautier advises the artist to "Sculpt, chisel, file, / until your floating dream / seals itself/ in the resistant block." Earlier, the transcendent idea resided in the sculptor's stone, waiting to be revealed. In mid-19th century France, it floats free until the artist induces it to inhabit the irresistibly beautiful form he has created. In both versions of this aesthetic, sculpture captures the transcendent and invisible beauty of an idea—or a "dream"—by mirroring it in earthly matter. Among the artwork's visible beauties is the look of seamless unity that emerges from the process of stone carving or metal casting. The aura of transcendence begins with the mastery of age-old crafts.

When sculptors began to master new crafts, transcendence was left behind, along with the idea of representation as resemblance.

This happened early in the 20th-century, in response to a sudden innovation in painting.

Like sculpture, painting traditionally made a virtue of physical unity. However agitated a painter's brushwork might be, the paint itself was seamless. Pablo Picasso and Georges Braque disrupted this seamlessness in 1912 by past-

ing pieces of newsprint and wallpaper to their Cubist canvases. Interfering with the familiar devices of representation, this new device—called pasted paper or collage—drew attention to the canvas as a physical object. Collage quickly turned sculptural, as Picasso arranged readymade objects and scraps of metal in quasi-abstract configurations. Soon Dadaists and Surrealists were amalgamating a wild variety of objects into works known as assemblages. The complexity—the formal wit—of Paley's sculpture gives it an affinity with assemblage, though, as I mentioned earlier, we can also see certain of his works as drawings in space, welded sculptures of the kind that Picasso began to make soon after he displaced collage from the canvas to three dimensions.

A successful sculpture in these modern modes looks unified, of course, and yet it encourages us to see its discrete parts and to notice every joint and seam. However it is constructed, it flaunts the facts of it construction. Those facts are all we are to consider in the case of a Minimalist object—a cube by Robert Morris, for example, or a gridwork by Sol LeWitt. Insisting that we see their works as nothing more or less than what they are, literally, these artists claimed to have dispensed with representation. Taking that claim a bit further, critics argue that the end of representation is a necessary consequence of the new, constructive modes of sculpture that developed from collage. This is an attractive thesis with several flaws.

No matter how explicitly they display their structures, Minimalist objects cannot obscure their allusions to architecture and much else. These artworks are at least obliquely representational. Moreover, assemblage, drawing in space, and all the other varieties constructed sculpture are forthrightly allusive, suggestive, evocative—and thoroughly comprehensible. Tracing the migration of themes through Paley's oeuvre, we know when he is referring to architecture and when he is returning us to nature. As the beneficiary of drastic changes that took place in the wake of Cubism, Paley conceives of representation as a matter of giving viewers an invitation to make sense of what they see. And our seeing is endless.

No element in any of his sculptures has the look of human anatomy, and yet they strike poses. They do things with their extremities, though it is up to us to say what they are doing. Is *Splay*, 2008, using its thin, cantilevered bars to point at the world around it?

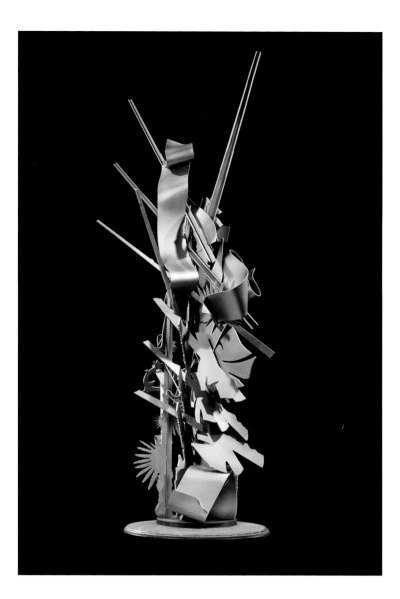

Fig. 8
Constellation, 2002
Formed and Fabricated Stainless Steel
16' x 18' x 2'6"
Wellington Place, Toronto, Ontario, Canada

Fig. 9
Passage, 1995
Formed and Fabricated Cor-ten Steel
37' x 23' x 16'
U.S. Federal Building, Asheville, North Carolina

Fig. 10
Tribute, 2006
Maquette
Formed and Fabricated Stainless Steel and Copper
9' x 3'3" x 2'9"

To lay claim to the surrounding space? To attract our attention and guide it to the subtleties of its construction? The point is not to arrive at the correct interpretation, for there is none. There is, instead, a renewable opportunity to be conscious of the interpretative process—and of ourselves as interpreting creatures (Image 93).

None of Paley's works is more spectacularly interpretable than *Threshold*, a cut-and-welded-steel construction completed in 2007 (Image 149). Painted bright yellow and as tall as an eight-story building, it stands in front of the headquarters of Klein Steel, in Rochester, New York. Not long after Paley settled in Rochester, in 1970, this company became his main supplier. Products available at Klein Steel would suggest sculptural possibilities. In turn, the artist would recommend new products and processes. Over the years, Paley developed a collaborative relationship with Joe Klein, the company CEO and an active supporter of art in the Rochester region. *Threshold* celebrates their highly productive friendship.

This sculpture meets the ground with a cluster of round columns—at any rate, this is the impression we gather from up close, while wandering among these massive, vertical forms. Stepping back, we see the columns not as meeting the ground but as rising from it and lofting into the air an intersecting cluster of immense panels. Tilted, pierced with intricately-shaped openings, these squared-away elements have the dimensions of walls and the airy, floating lightness of massive fronds. The outlines of their openings are variations on the fronds and leaves and branches that proliferate elsewhere in this exhibition and throughout the artist's oeuvre. *Threshold* merges built and natural form at a stunning scale. At first, the human presence seems to be absent, but perhaps it is to be seen—or intuited—in the sculpture's gesturing I-beams.

A look at models and drawings shows just how impressive a feat of engineering this work is [fig. 11]. Yet we do not see it as a solution to a set of definable problems. It is a response to a set of possibilities, none of them knowable in advance. *Threshold* is alive with the intentions that generated it. As certain Ibeams lean and others extend outward, like gigantic arms, every element in this sculpture acquires the air of doing something with grand and sublimely confident deliberation: holding, reaching, buttressing, tilting to reflect the sky.

On a day of shifting sunlight, *Threshold* flickers, as the upper panels cast transient shadows on the ones below. This sculpture engages the entire landscape. Furthermore, it offers a monumental compendium of Paley's entire career. A threshold facilitates a transition, and *Threshold* marks a place where an artist's ambition enters its environment and takes on its scale. I mean its cultural as well as its physical environment, for *Threshold* is a monument in the spirit of American openness and generosity. Confronting us with a presence of great clarity and even greater complexity, it challenges us to speculate.

This is representation not as resemblance but as provocation, for none of *Threshold*'s allusions guide us along a clear path to a firm interpretation. We are on our own, free to see as much as we can in *Threshold*'s manifold forms and formal interconnections. What I have called architectural columns we could just as plausibly call the trunks of huge trees. The I-beams I see as freely gesturing may well be indications of structural necessity—or, rather, that is obviously what they are. Yet they are gestures nonetheless, just as the voids in the panels read as solid, vegetative forms. Void is solid, weight is anti-gravitational. And necessity is freedom, given that every detail the artist shapes in obedience to the steely imperatives of engineering is also a sign of his unencumbered will at work.

In provoking us to say what it represents, Paley's sculpture represents freedom itself—not as an abstraction but as an experience for us to seize and elaborate. *Threshold* is a title that would suit every one of this artist's works, for they all present themselves as entryways, openings to possibility. Like all major works of art, Paley's sculptures point beyond themselves. And they draw us back to them, for it is in their company that we learn what it is to find meaning in our perceptions and to be conscious of doing so. In representing freedom, Paley's sculpture represents everything, or as much of the world's plenitude as we are able to imagine. When we are able to imagine more, his art will be waiting for us, with the monumental generosity of its provocations.

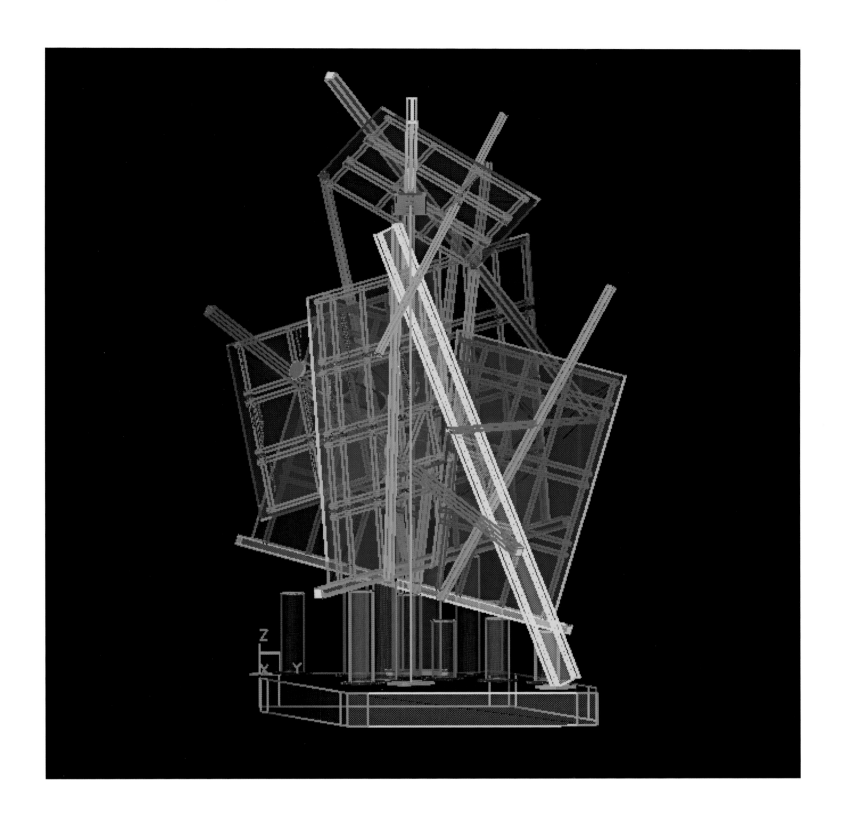

Fig. 11
Threshold, 2006
3D Computer Imagery
Ramar Steel Inc.
Rochester, New York

Paley became involved with the forging of steel in the late 1960's. This process still dominates much of the studio activities. The main design approach to this process is in the exploration of plastic form development as made manifest through the forging process - compression, delineation, twisting, punching, upsetting, imprinting, etc. Fluidity and integration within an organic form context is the prominent characteristic of the resulting work.

4. Forging Studio
1237 East Main Street
Rochester, New York

5. Photo Documentation
Paley, Forging Process
East Main Street Studio
Rochester, New York

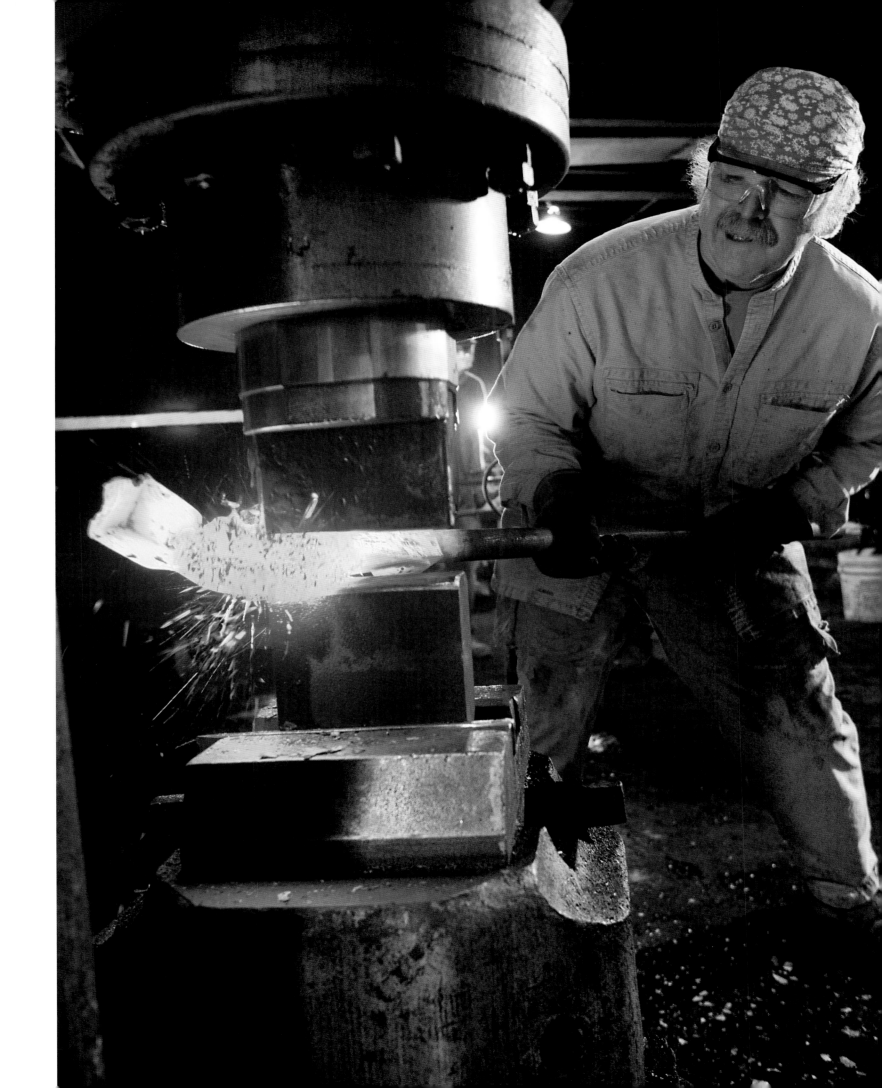

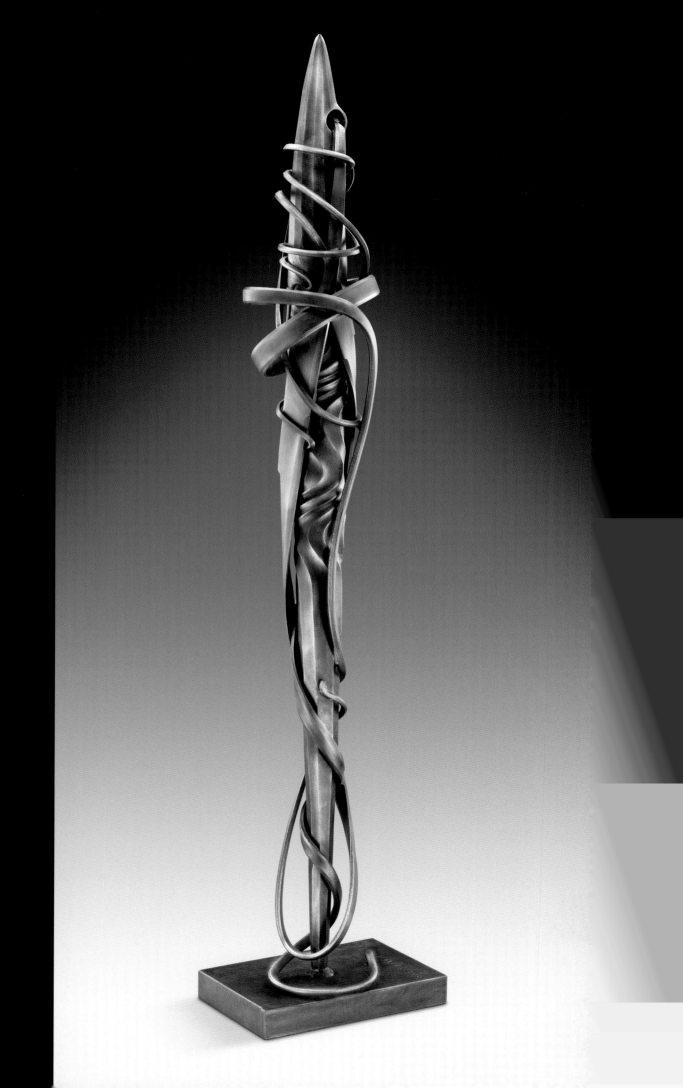

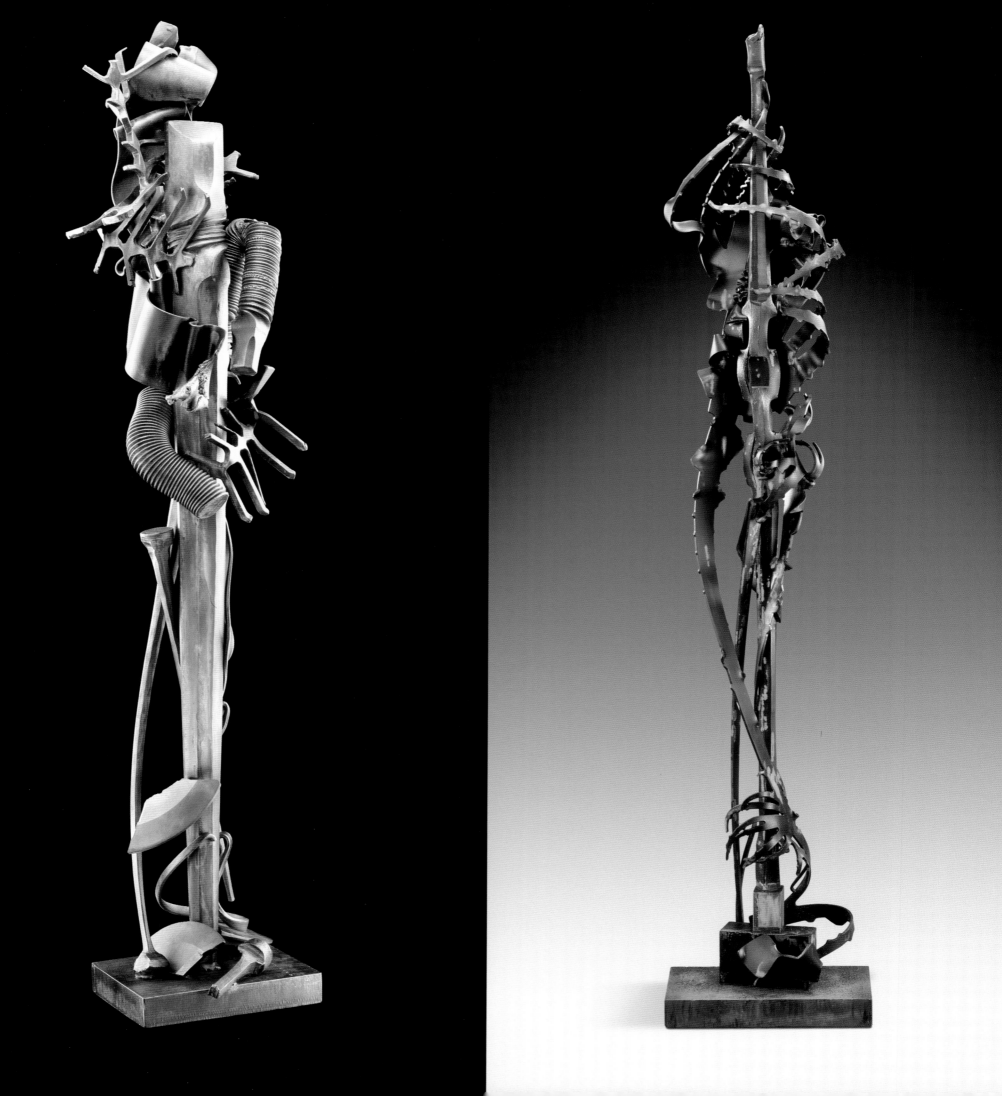

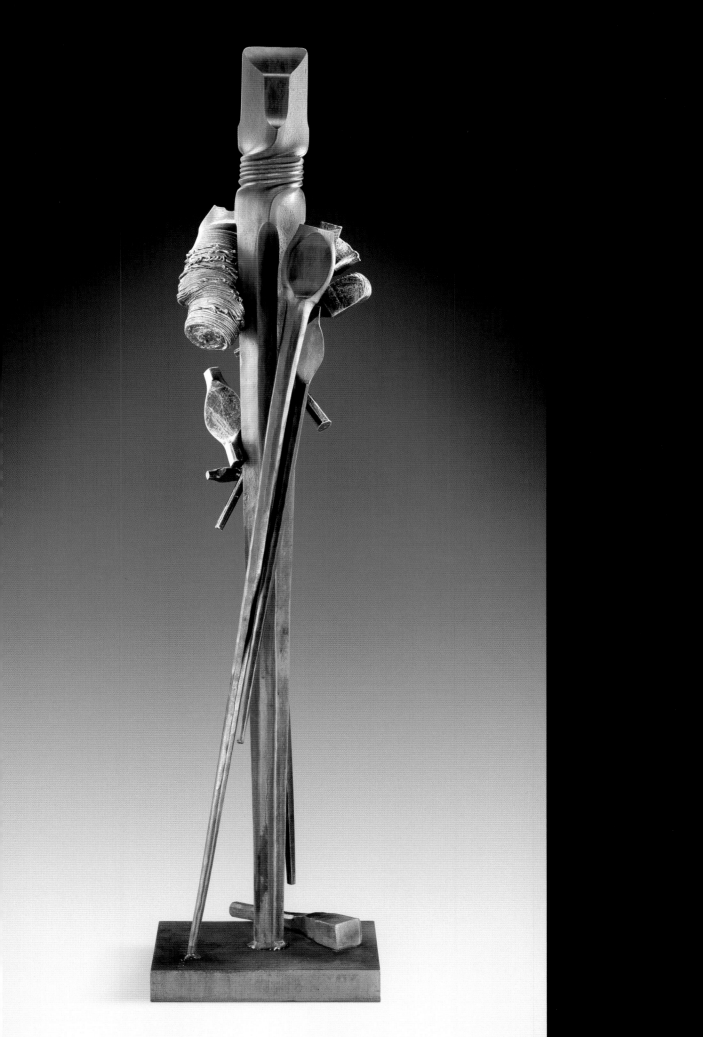
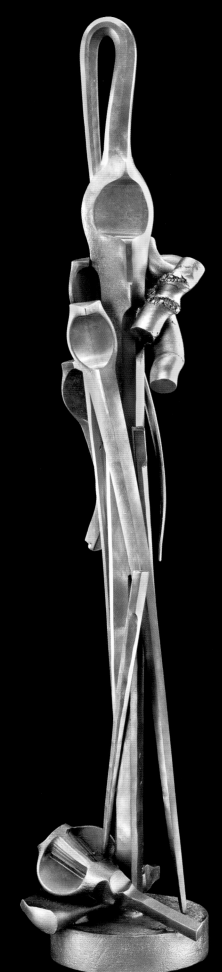

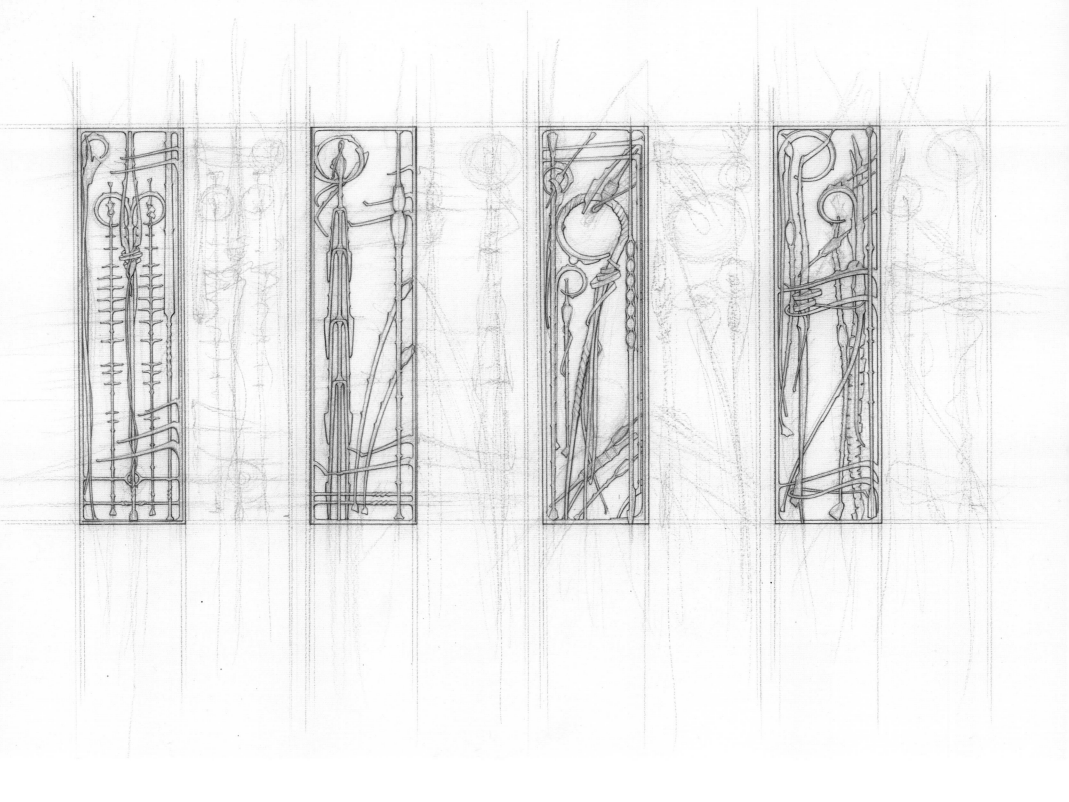

15. *Rubenstein Entrance Doors*, 2007
Four Proposal Drawings
Graphite and Red Pencil on Paper
30" x 24"
Studio Archive

16. *Rubenstein Entrance Doors*, 2008
Forged, Fabricated, Patinaed and
Clear Coat Finished with Glass
8' x 6' x 4'6"
Private Collection, Philadelphia,
Pennsylvania

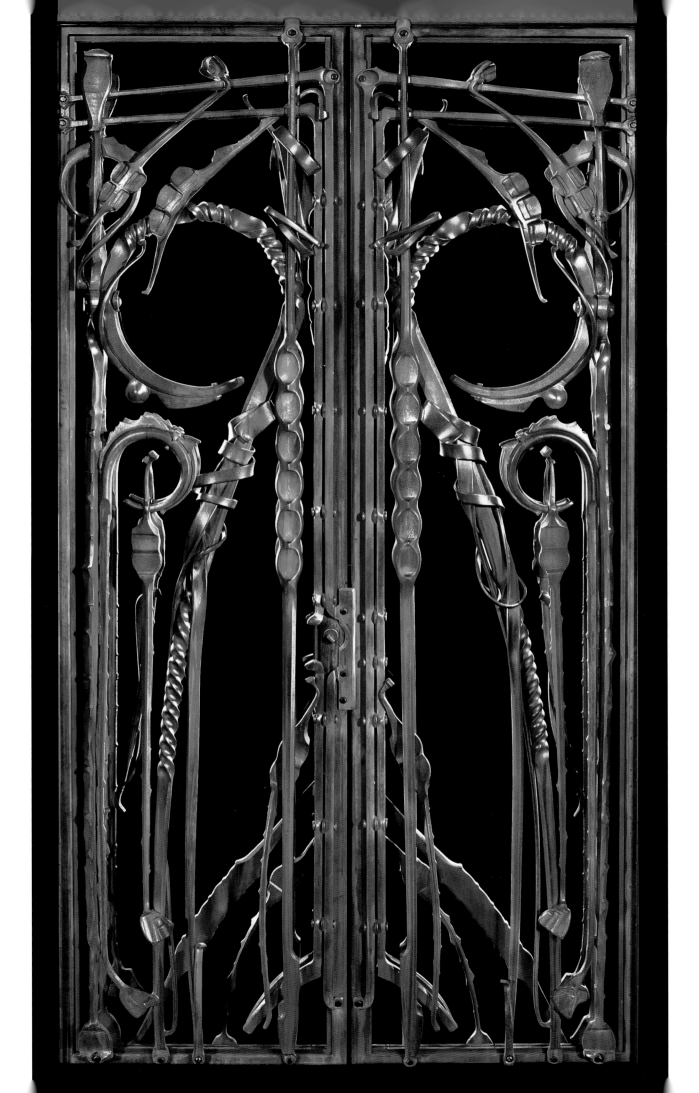

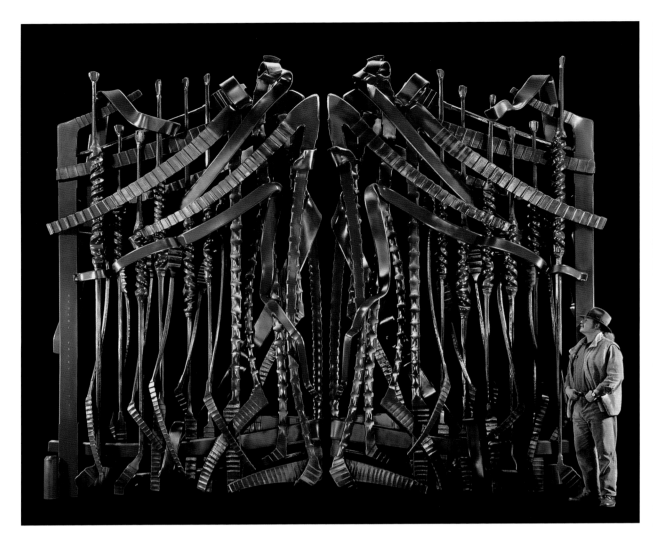

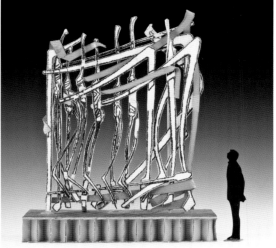

17. *Memphis Gate*, 2009
Developmental Model
Cardboard, Foam Core, Graphite and
Red Pencil
8" x 6"
Studio Archive

18. Albert Paley with *Memphis Gate*, 2005
Forged and Fabricated Mild Steel with
Painted Finish
14'6" x 17'3"
Memphis Brooks Museum of Art,
Memphis, Tennessee

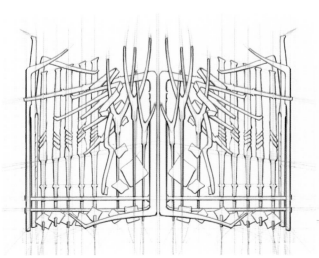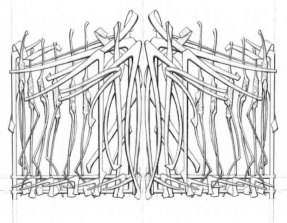

19. *Memphis Gate Proposals*, 2004
Proposal Drawings
Red Pencil on Paper
18" x 24"
Studio Archive

20. *Memphis Gate*, 2005
Paley, Fabrication
North Washington Street Studio
Rochester, New York

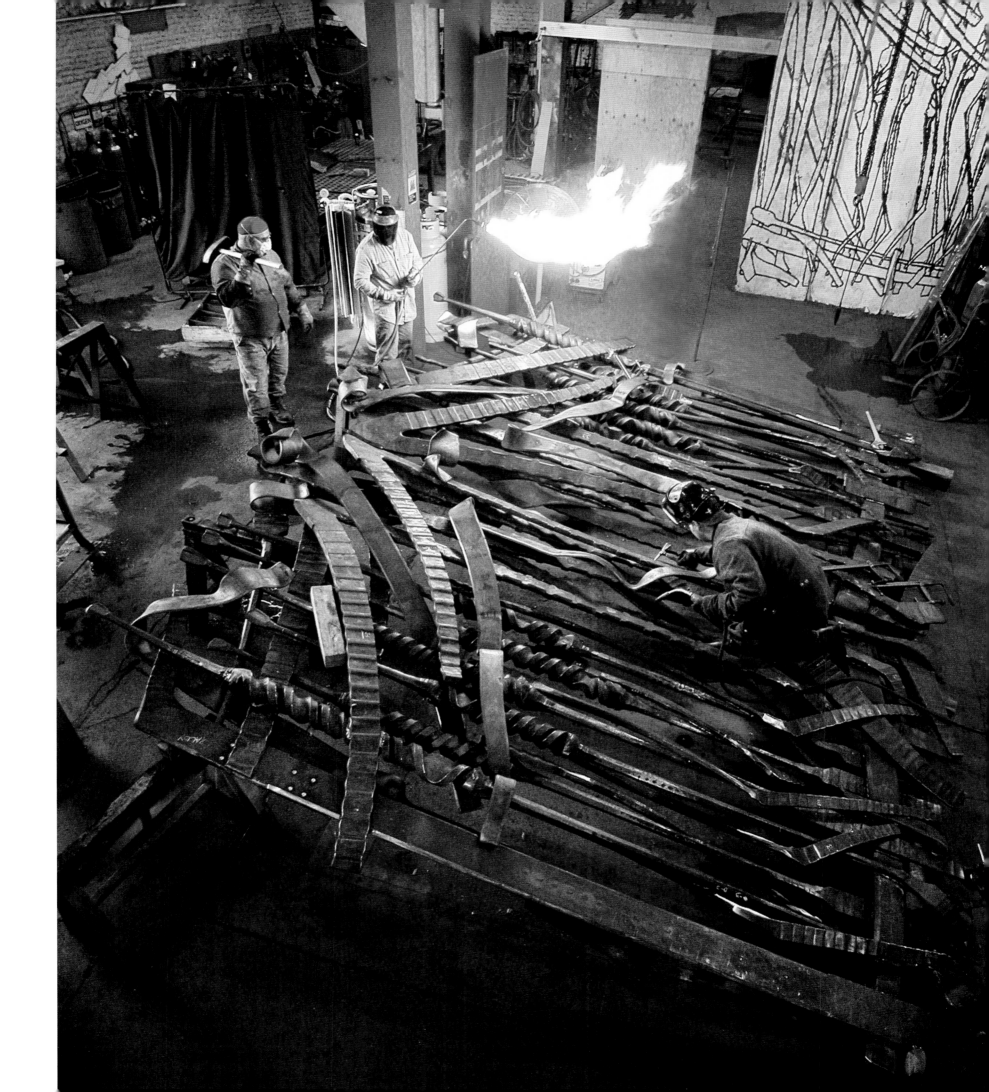

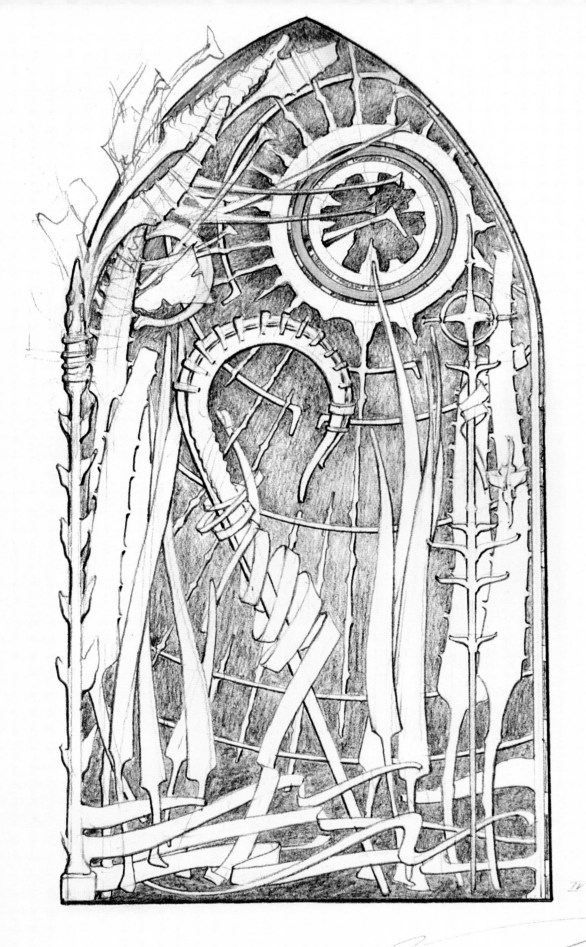

21. National Cathedral Portal Gate for the
Good Shepard Chapel, 2005
Initial Presentation Drawing
Graphite and Colored Pencil on Paper
24.5" x 19"
Studio Archive

22. National Cathedral Portal Gate for the
Good Shepard Chapel, 2005
Presentation Drawing
Red Pencil on Paper
39" x 23"
Studio Archive

23. National Cathedral Portal Gate for the
Good Shepard Chapel, 2007
Studio Documentation
North Washington Street Studio
Rochester, New York

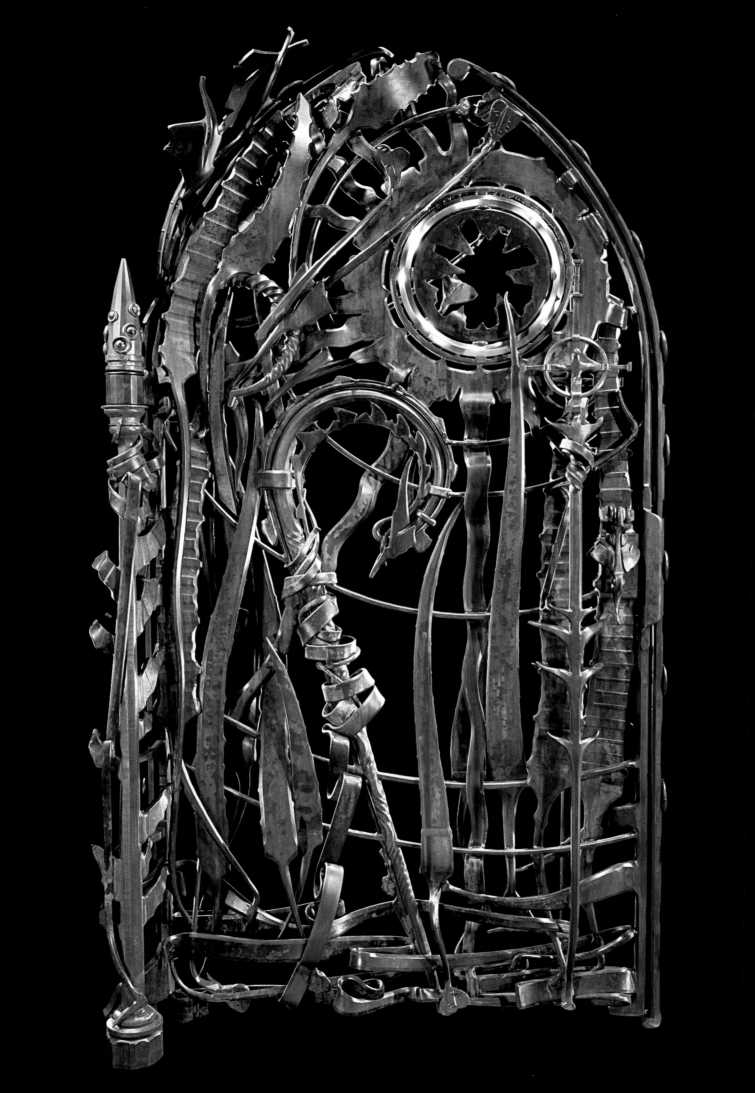

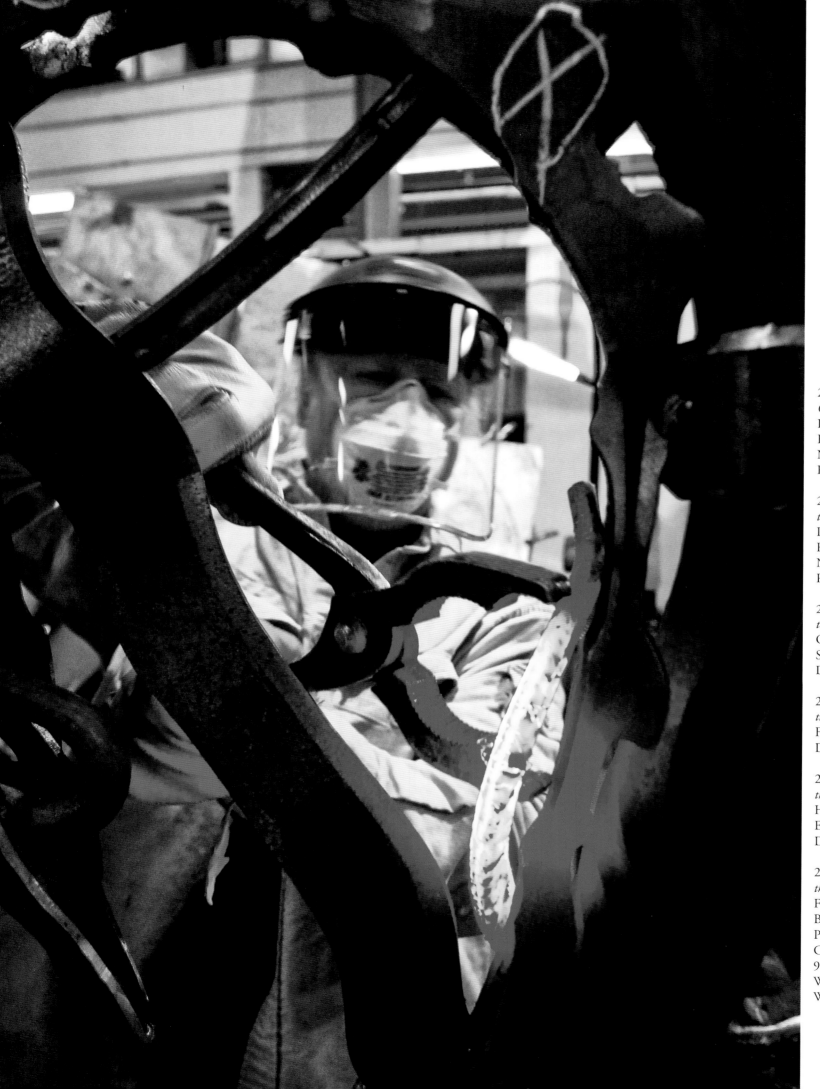

24. *National Cathedral Gate for the Good Shepard Chapel,* 2007
Paley, Fabrication/Heating and Forming of Element
North Washington Street Studio
Rochester, New York

25. *National Cathedral Portal Gate for the Good Shepard Chapel,* 2007
Paley, Fabrication/Heating and Forming
North Washington Street Studio
Rochester, New York

26. *National Cathedral Portal Gate for the Good Shepard Chapel,* 2007
Gold Plated Bronze and Patinaed Mild Steel
Detail

27. *National Cathedral Portal Gate for the Good Shepard Chapel,* 2007
Forged, Twisted and Wrapped
Detail

28. *National Cathedral Portal Gate for the Good Shepard Chapel,* 2007
Heated, Twisted and Formed Hoop Element
Detail

29. *National Cathedral Portal Gate for the Good Shepard Chapel,* 2007
Forged and Fabricated Mild Steel, Bronze and 24K Gold Plate with Patinaed Finish and Protective Clear Coating
9' x 5'3" x 1'6"
Washington National Cathedral, Washington DC

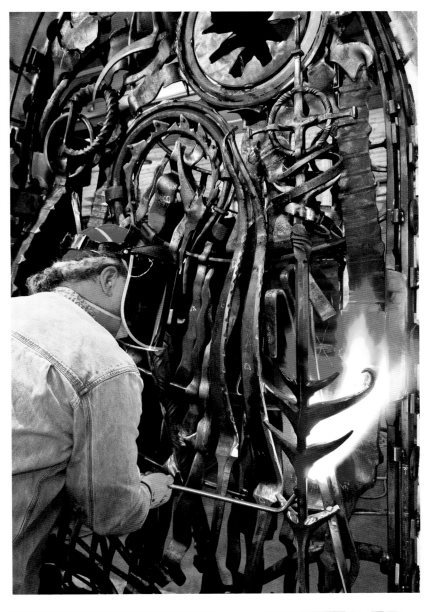
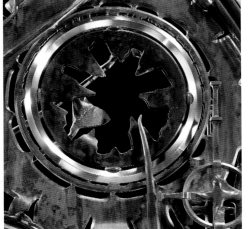
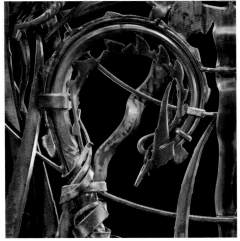
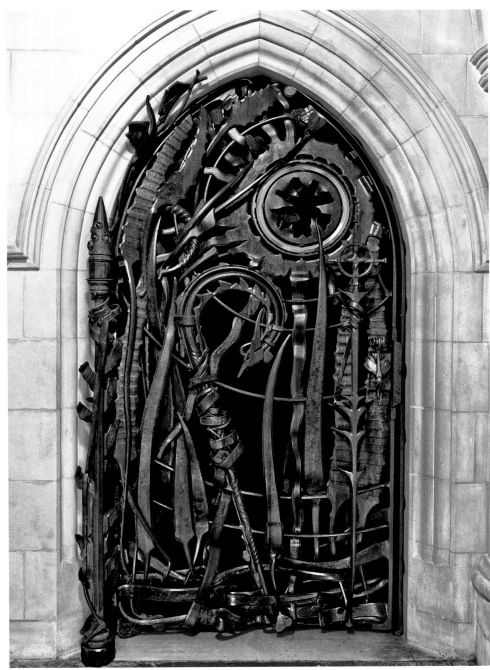

In 1999 Paley was invited to Pilchuck Glass School in Seattle, Washington as an artist-in-residence. This program was initiated to engage professionals from outside the glass field to experience the nature and working processes of glass. Since that time Paley has created glass and steel sculptures as well as architectural elements and decorative art pieces. Although steel and glass as materials appear to be quite disparate, their form development shares a common genesis - heat. With the forming of hot glass and the forging of heated steel, these materials respond similarly - pressure and tension develop forms that speak of a common origin founded in alterability and change. The glass and steel integration has developed a body of work resulting in commissioned projects and exhibition pieces.

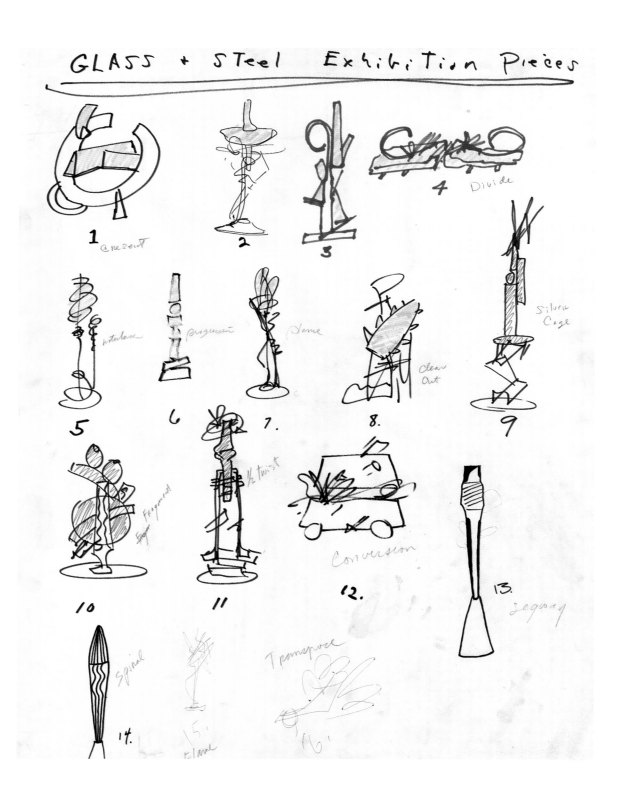

30. *Glass Sketches*, 2000
Exhibition Inventory List
Colored Ink on Paper
36" x 28"
Studio Archive

31. Paley, Glass Forming
Martin Blank Studios
Seattle, Washington

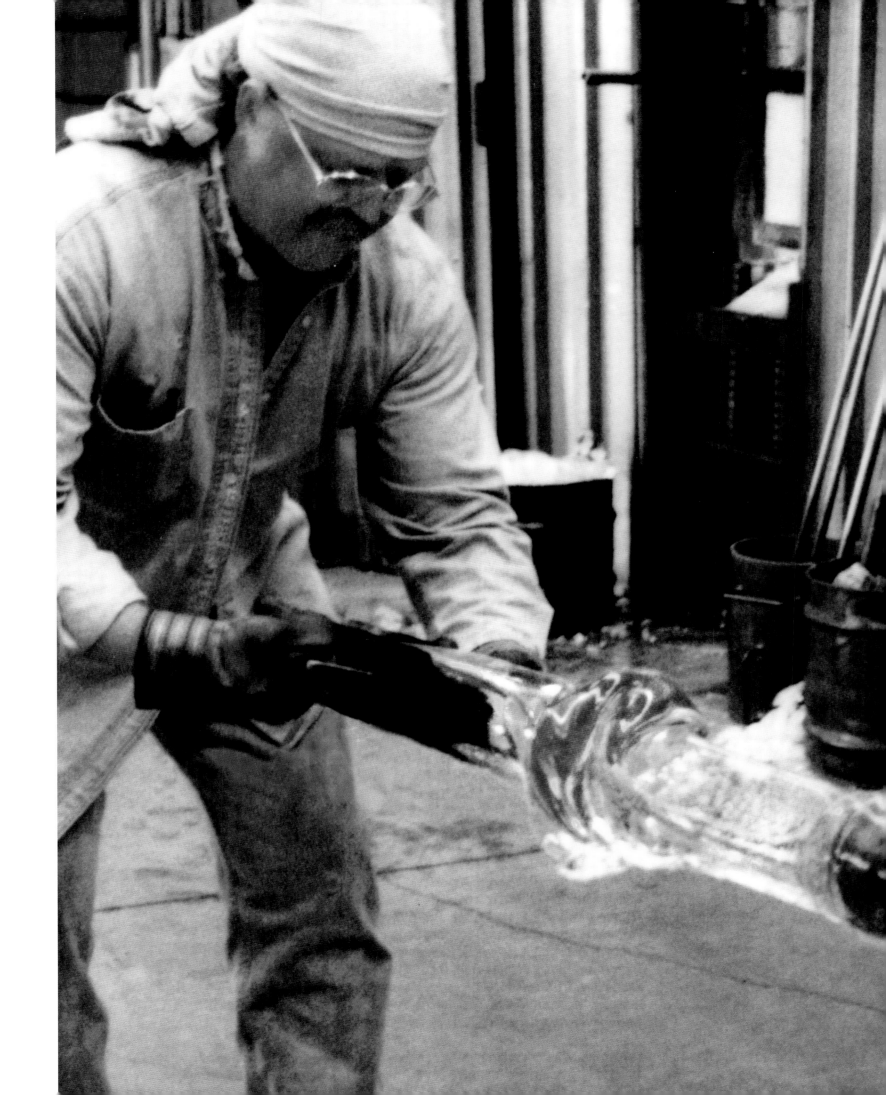

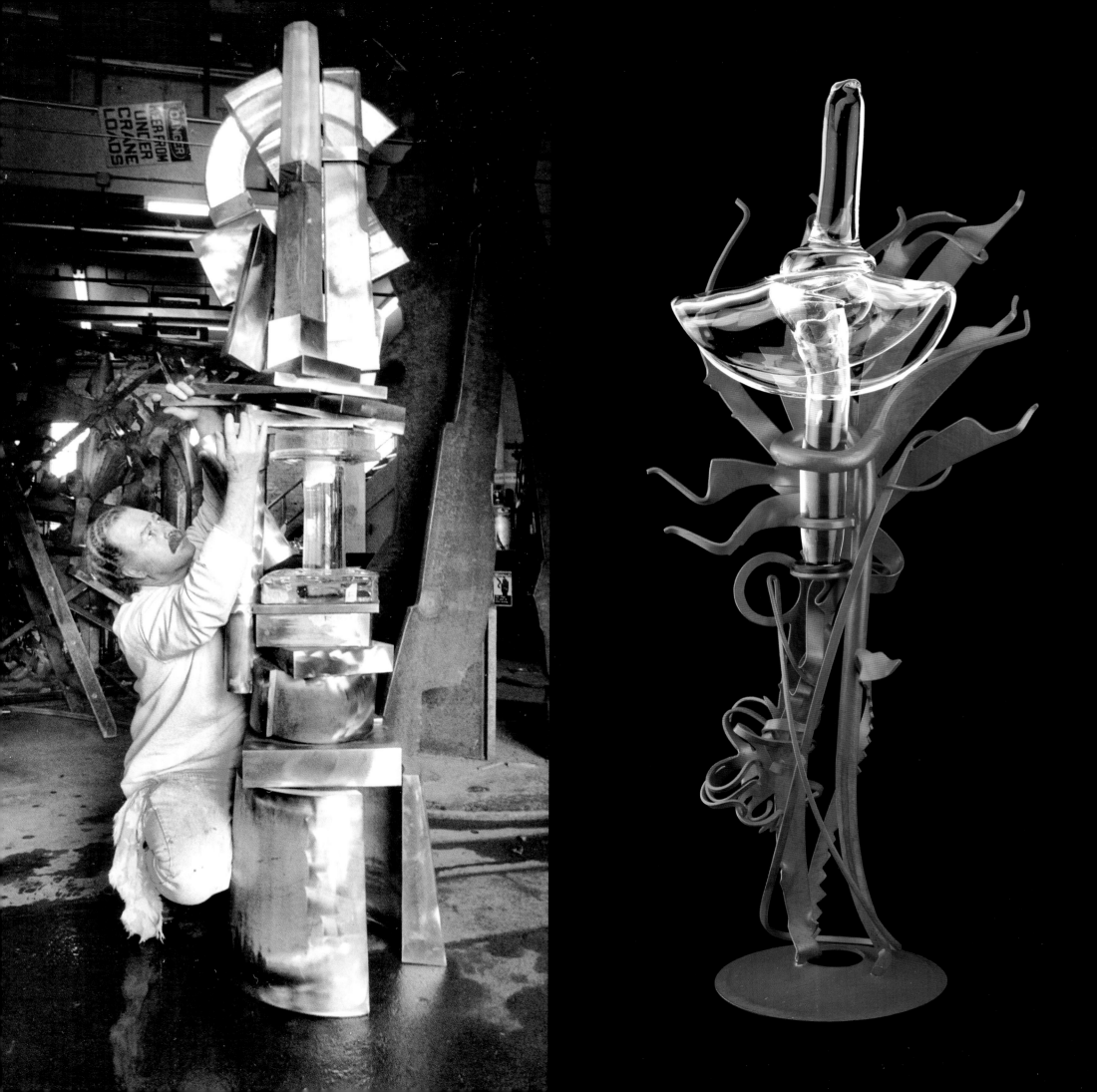

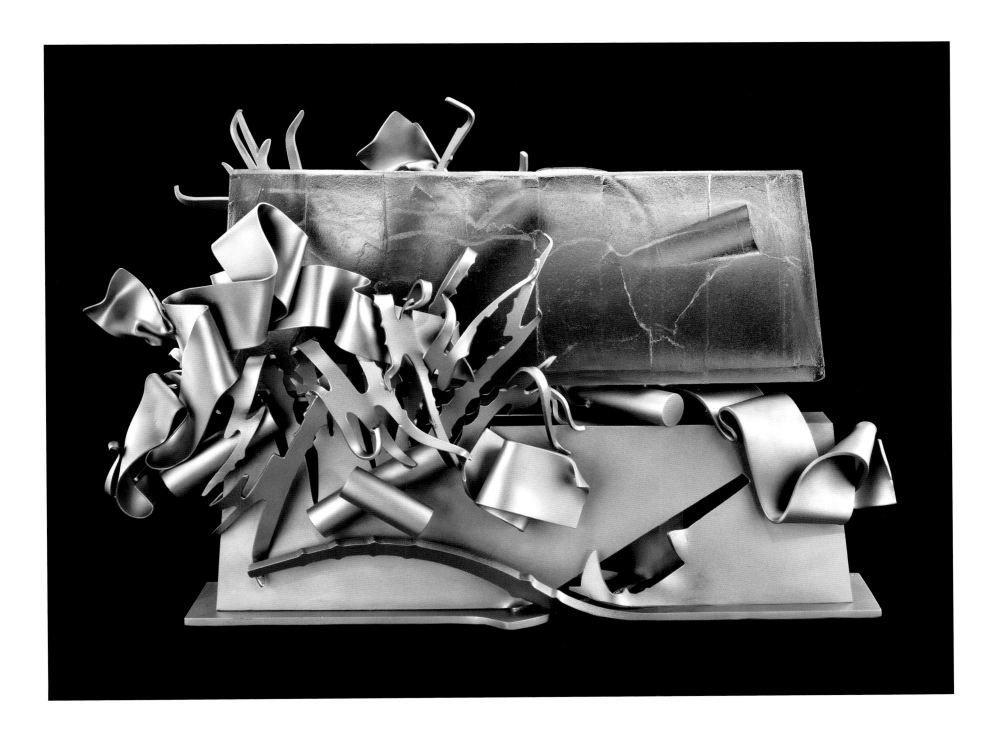

32. *Opus*, 2000
Paley, Fabrication
Bronze, Glass, Rubber and Stainless Steel
7'3" x 24"
North Washington Street Studio
Rochester, New York

33. *Flame*, 2001
Forged and Fabricated Mild Steel and
Glass with Patinaed Finish
4' x 1'6" x 1'
Private Collection

34. *Conversion*, 2001
Formed and Fabricated Stainless
Steel with Cast Glass
2'3" x 3'6" x 1'
Private Collection

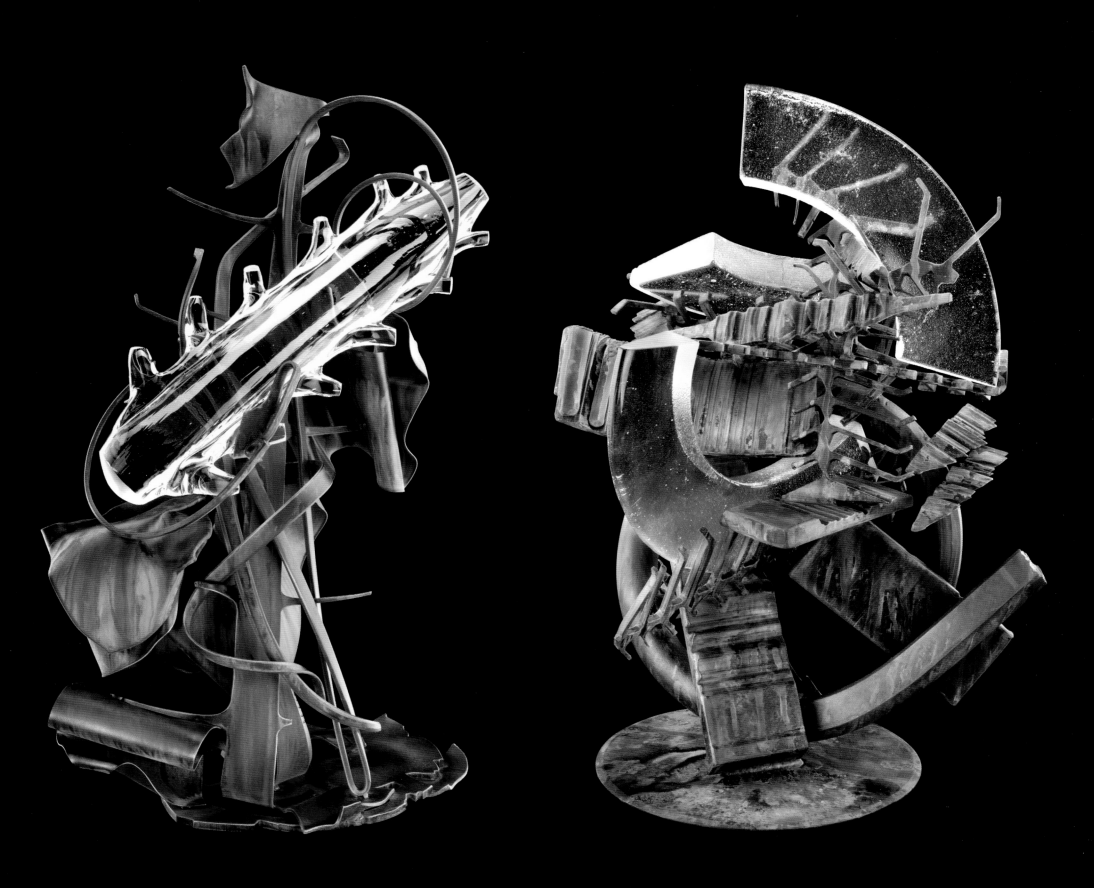

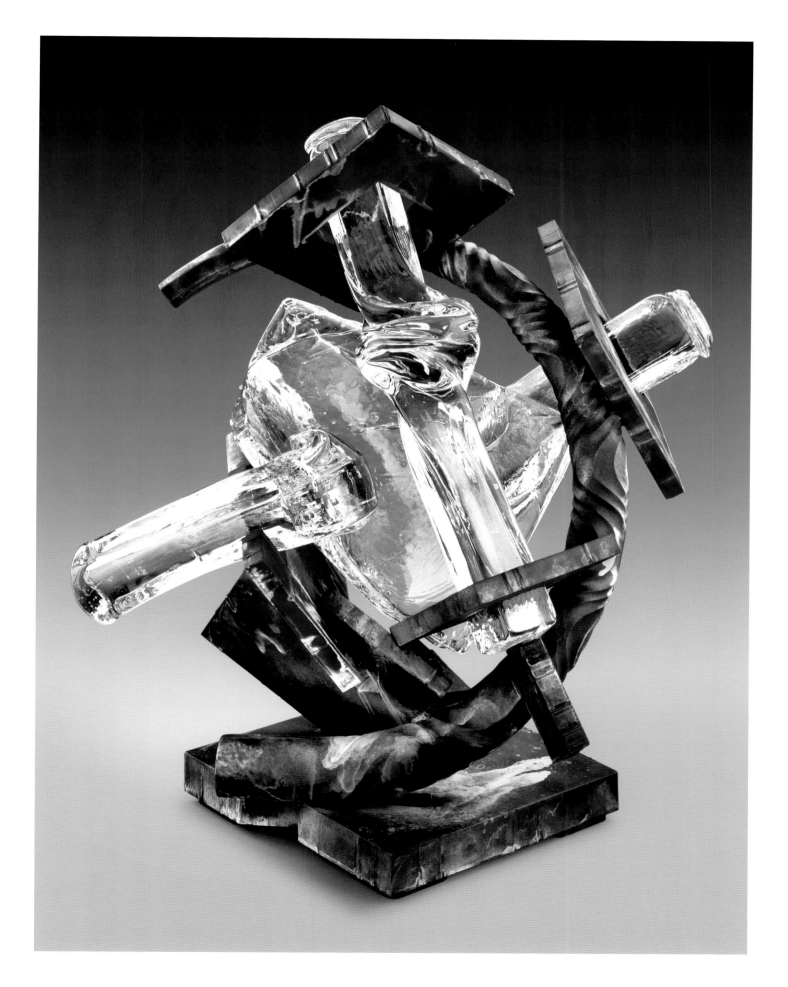

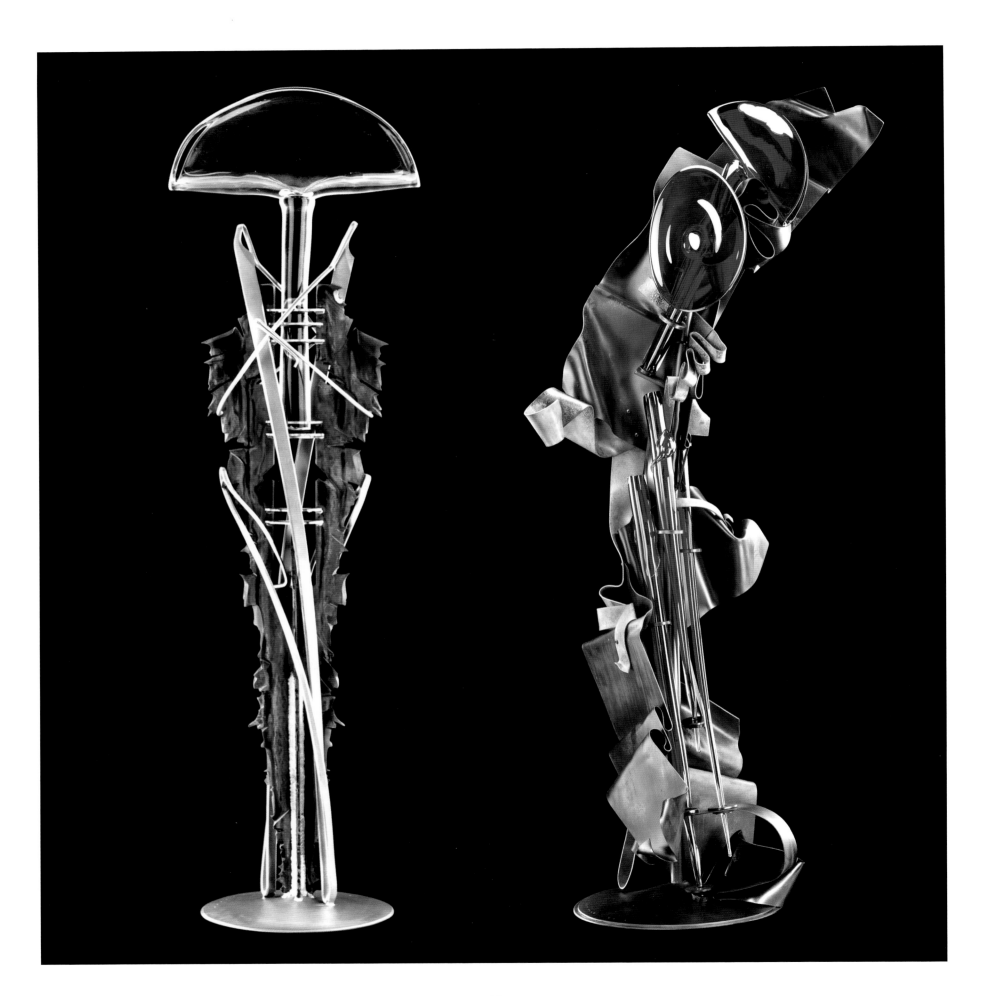

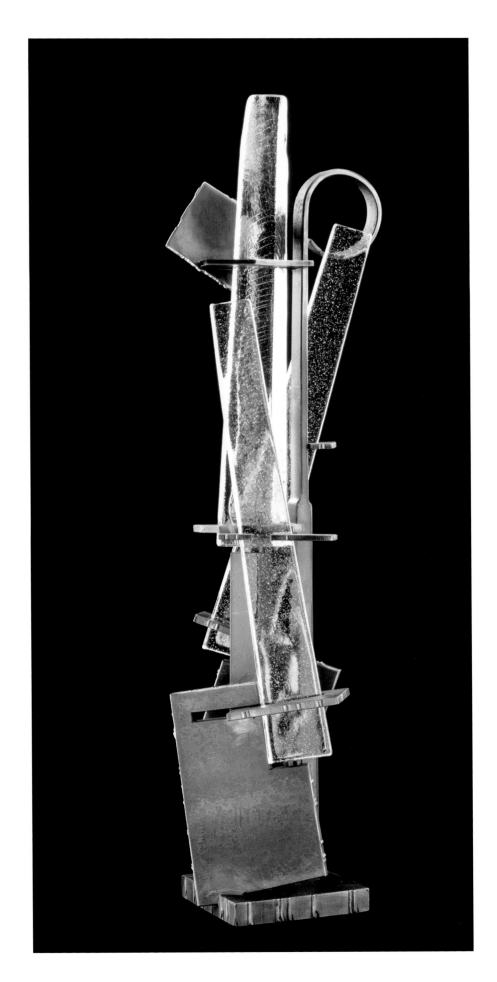

Image on page 42
35. *Clear Cut*, 2001
Formed and Fabricated Mild Steel and
Glass
4' x 2'3" x 1'6"

Image on page 42
36. *Clear Arc*, 2001
Forged and Fabricated Mild Steel with
Cast Glass
2'6" x 1'6" x 1'6"

Image on page 43
37. *Twisted Arc*, 2000
Formed, Fabricated and Patinaed Mild
Steel and Glass
34" x 32" x 26"
Private Collection

38. *Clear Fold*, 2000
Formed and Fabricated Mild and
Stainless Steels with Glass
5' x 1'6" x 1'3"
Private Collection

39. *Cobalt*, 2002
Formed and Fabricated Mild Steel,
Patinaed Bronze and Glass
7' x 40" x 35"
Private Collection

40. *Intersect*, 2001
Formed and Fabricated Mild Steel with
Cast Glass
4'6" x 1'3" x 1'3"

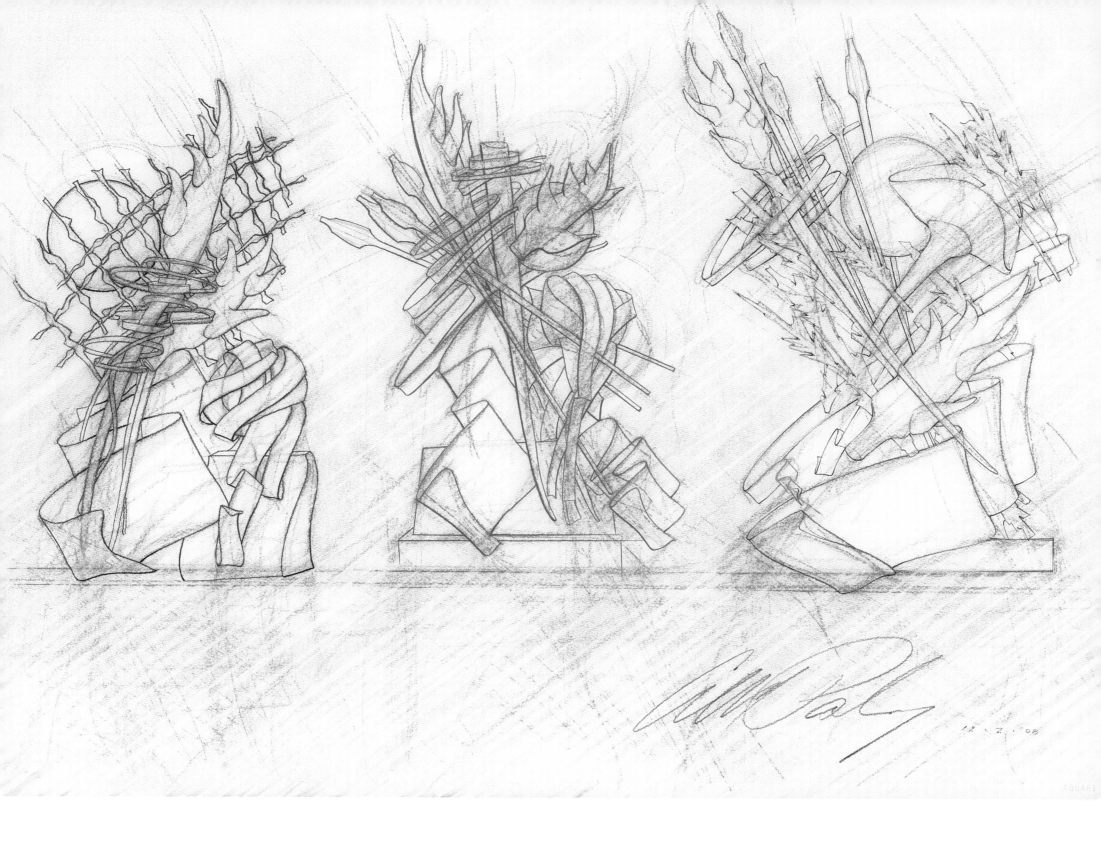

41. *Springborn Sculpture*, 2010
Developmental Drawing
Studio Archive
22.5" x 30"

42. *Springborn Sculpture*, 2010
Formed and Fabricated Mild Steel with
Glass
Private Collection
7' 3" x 4' 6" x 2' 7"

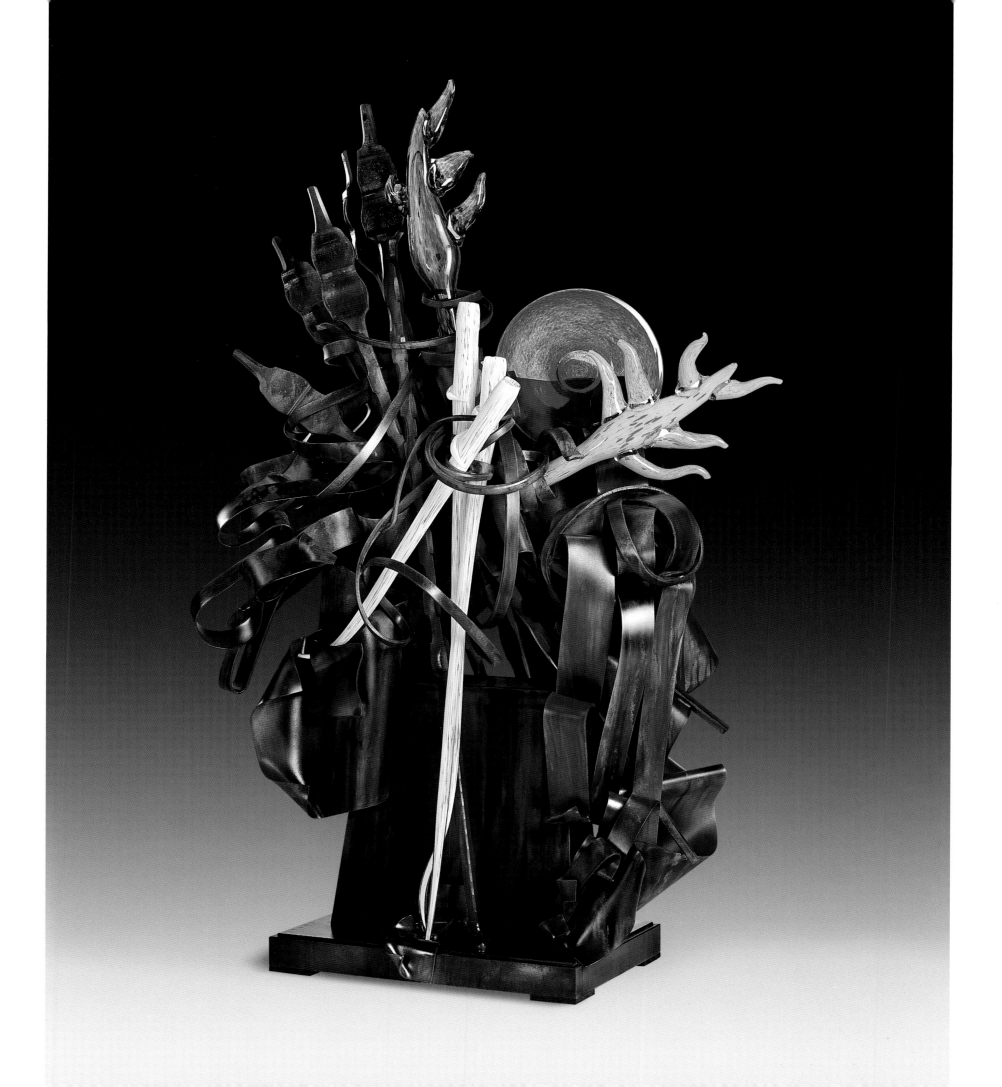

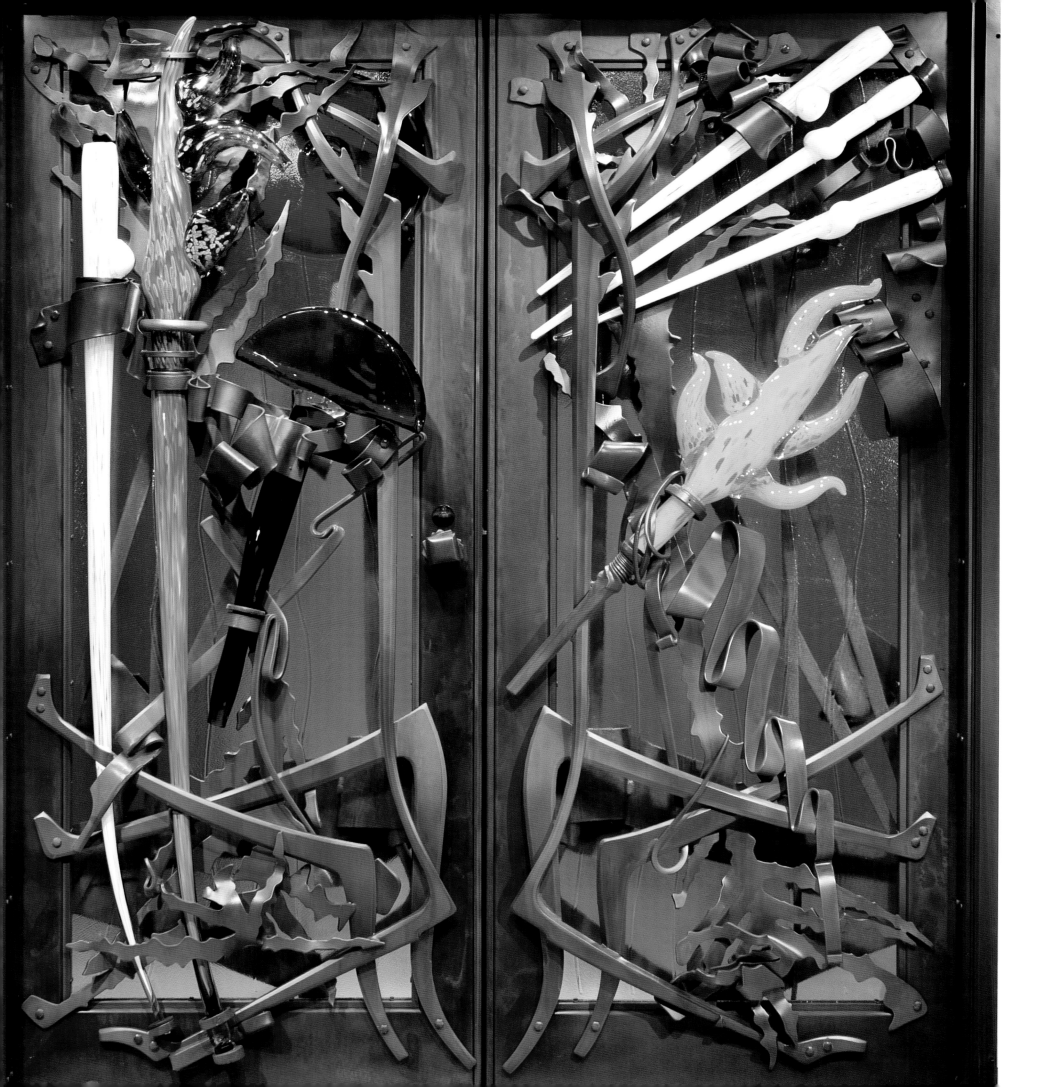

43. *Entrance Doors*, 2004
Formed, Fabricated and Patinaed Mild
Steel with Blown Glass
7' x 6'6" x 6"
Private Collection, Naples, Florida

44. *Entrance Doors*, 2004
Proposal Drawing
Red Pencil and Graphite on Paper
22" x 28"
Studio Archive

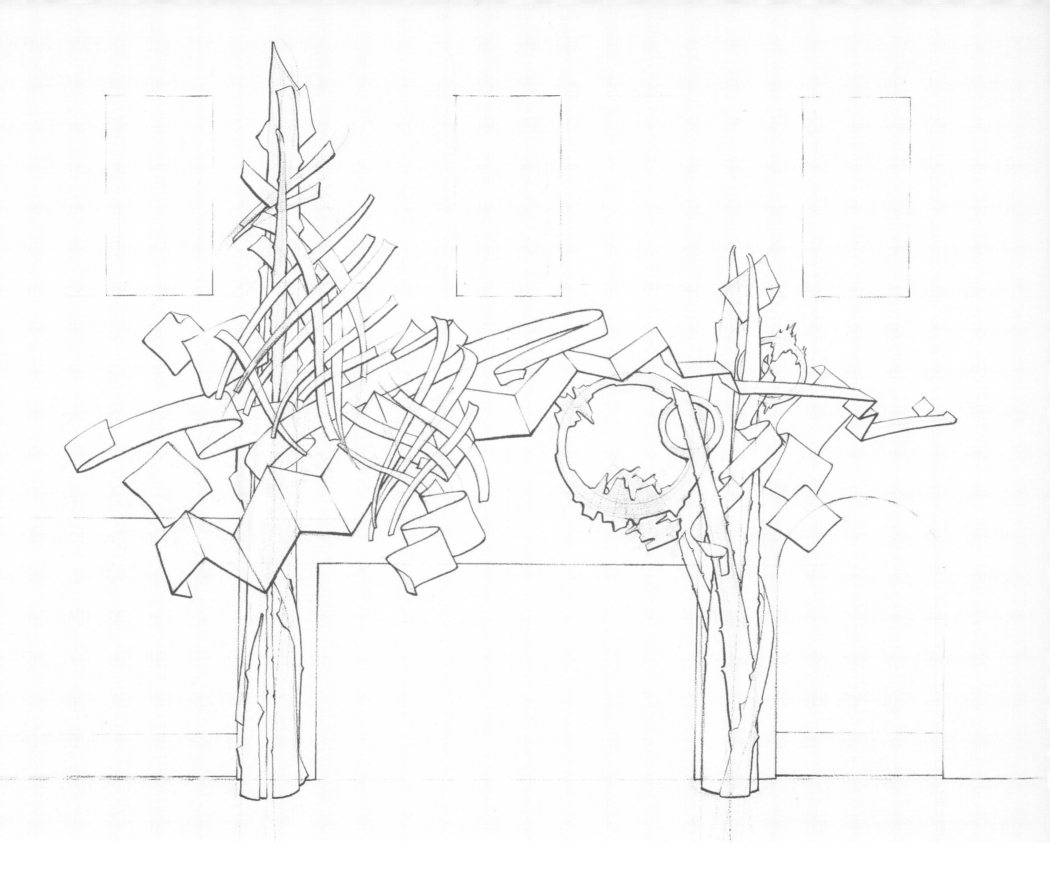

With a commissioned work or a competition based project the concept and form of the sculpture must be realized prior to fabrication. Therefore drawings and or models are produced to convey the concept. Obviously the larger and more involved works must engage structural engineering and a feasibility study based on material usage, labor, installation, etc. Because of these demands the model making stage becomes more advanced and complex, at times resulting in three to four different models, each one investigating a specific concern. Therefore, many of these ideas and concepts exist only within the design context.

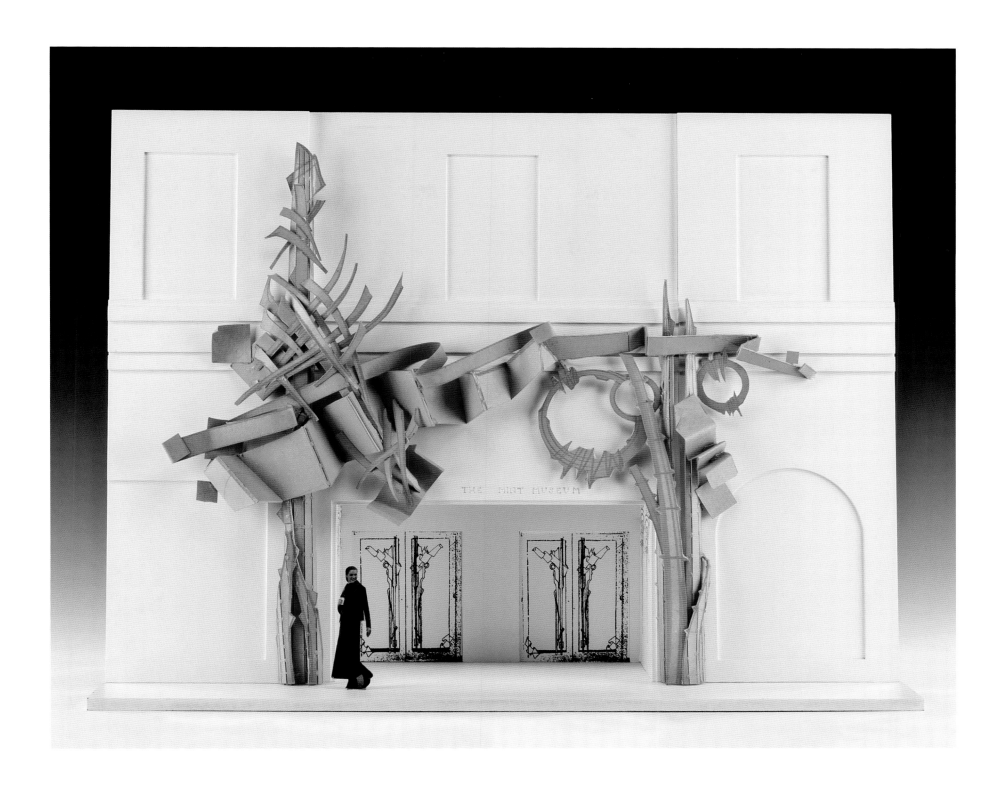

45. *Entrance Sculpture Proposal for Mint*
Museum, Charlotte, North Carolina, 2000
Presentation Drawing
Graphite and Red Pencil on Paper
38" x 36.5"
Studio Archive

46. *Proposal Model for Mint Museum,*
Charlotte, North Carolina, 2000
Cardboard, Wood and Red Pencil
25.5" x 33" x 14"
Studio Archive

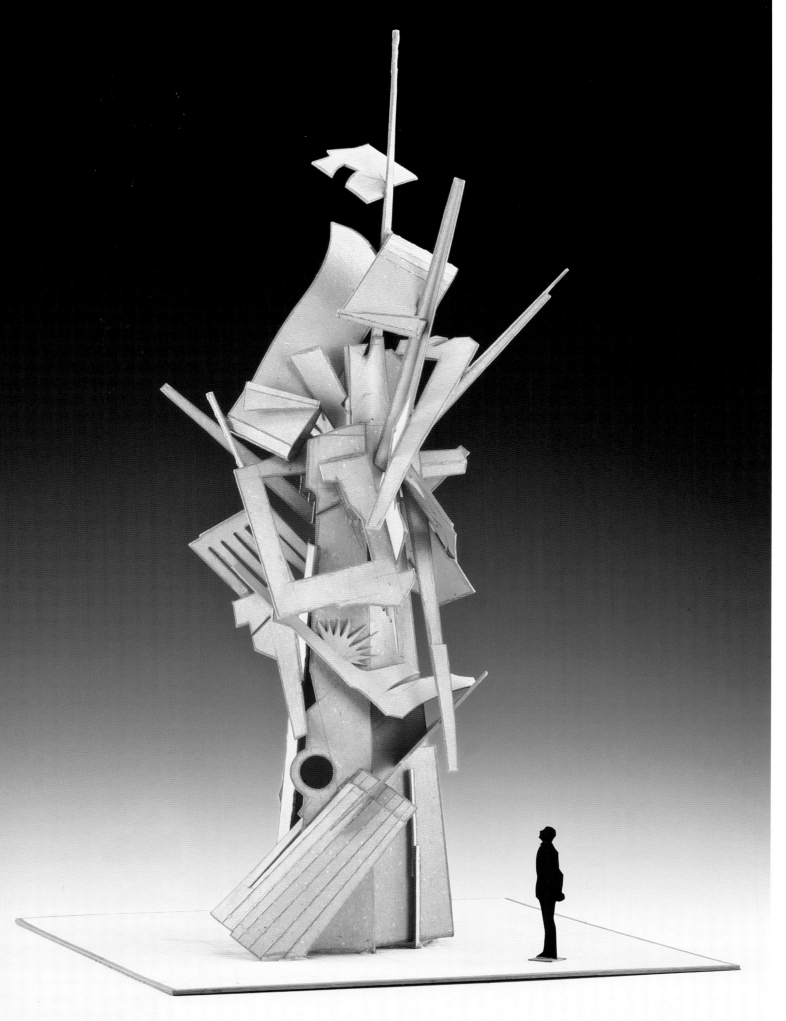

47. *Proposal Model for Capital One,*
McLean, Virginia, 2001
Developmental Model
Cardboard and Red Pencil
36" x 16"
Studio Archive

48-56. *Proposal Model for Capital One,*
McLean, Virginia, 2001
Details

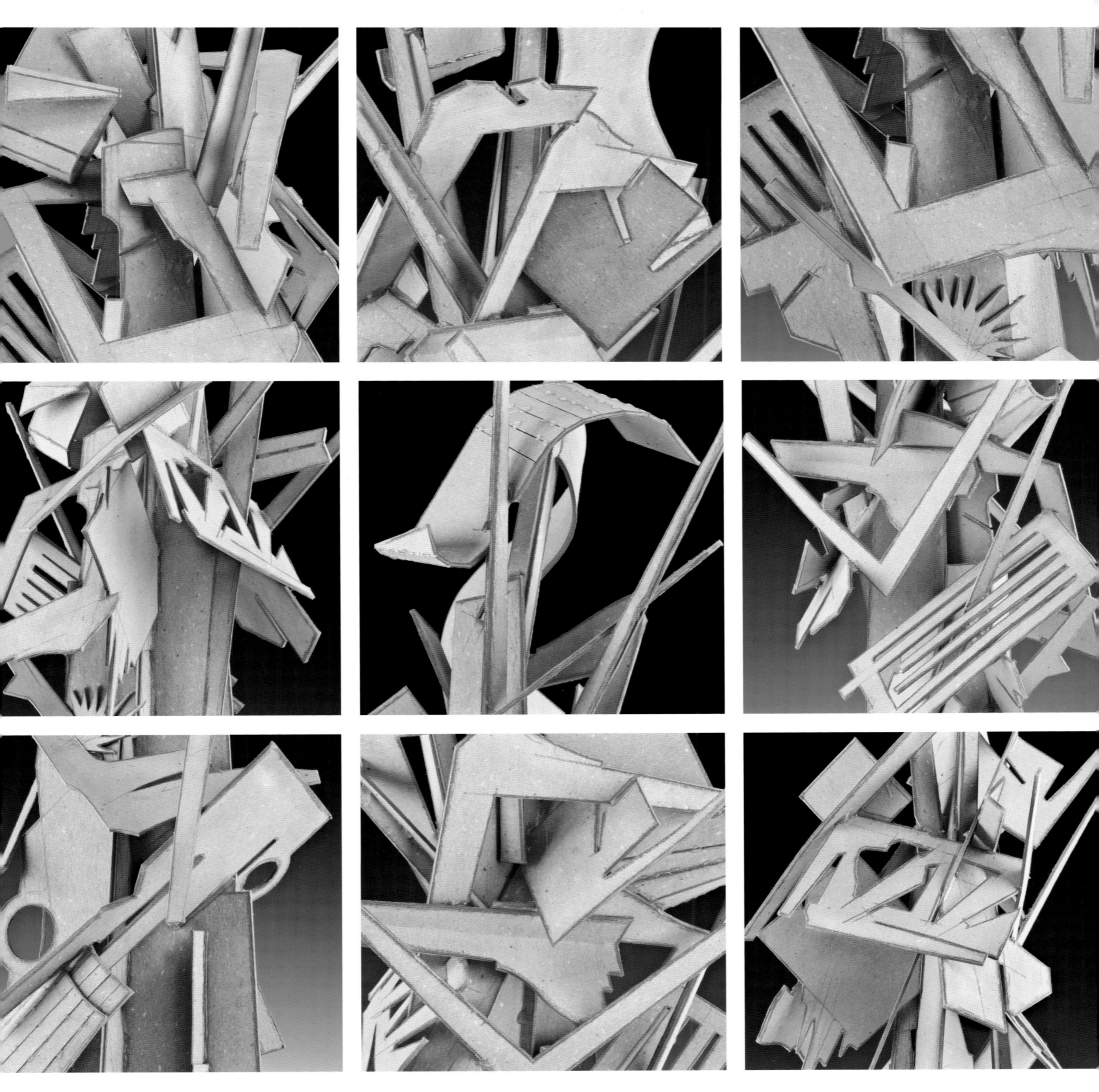

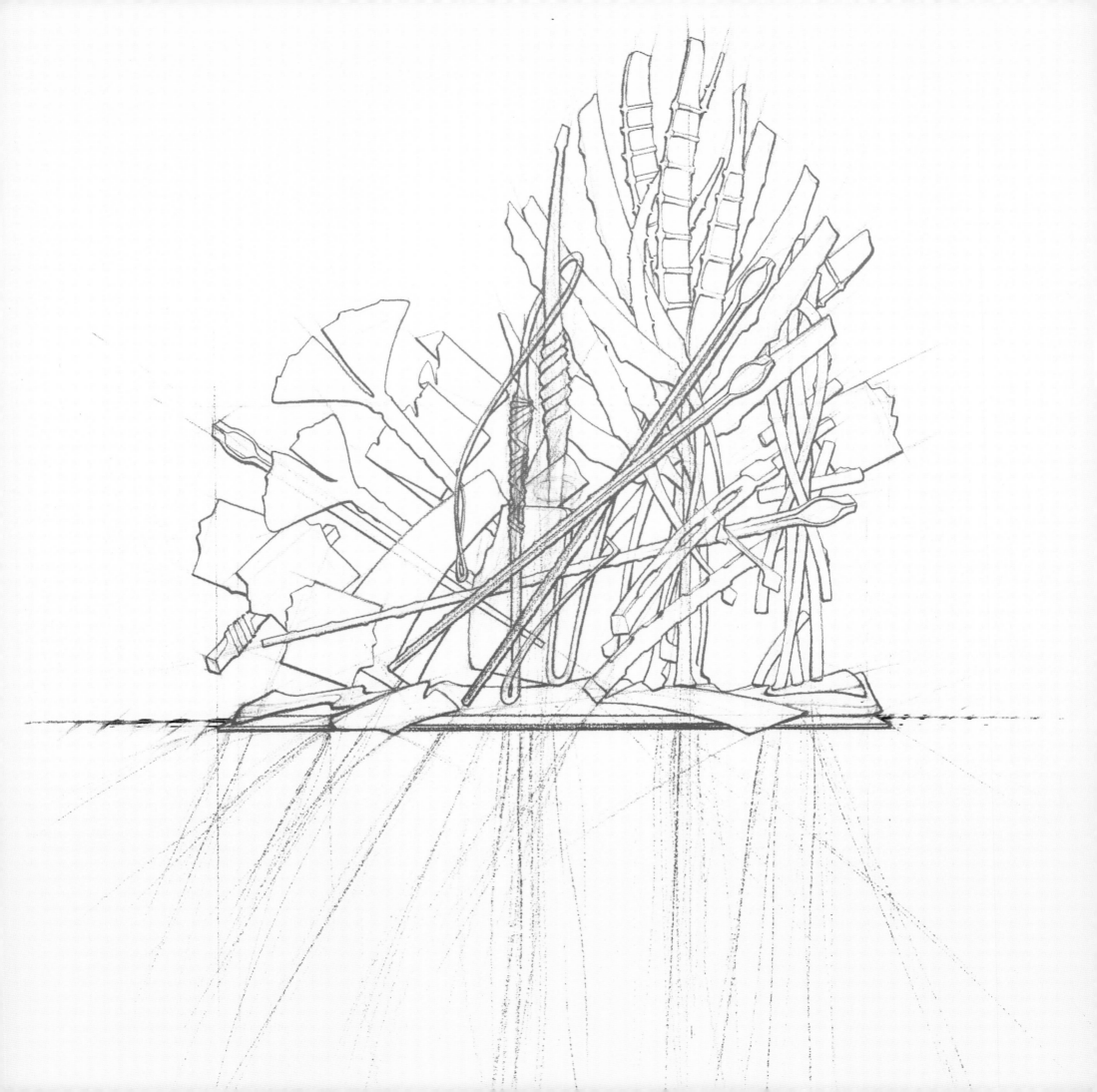

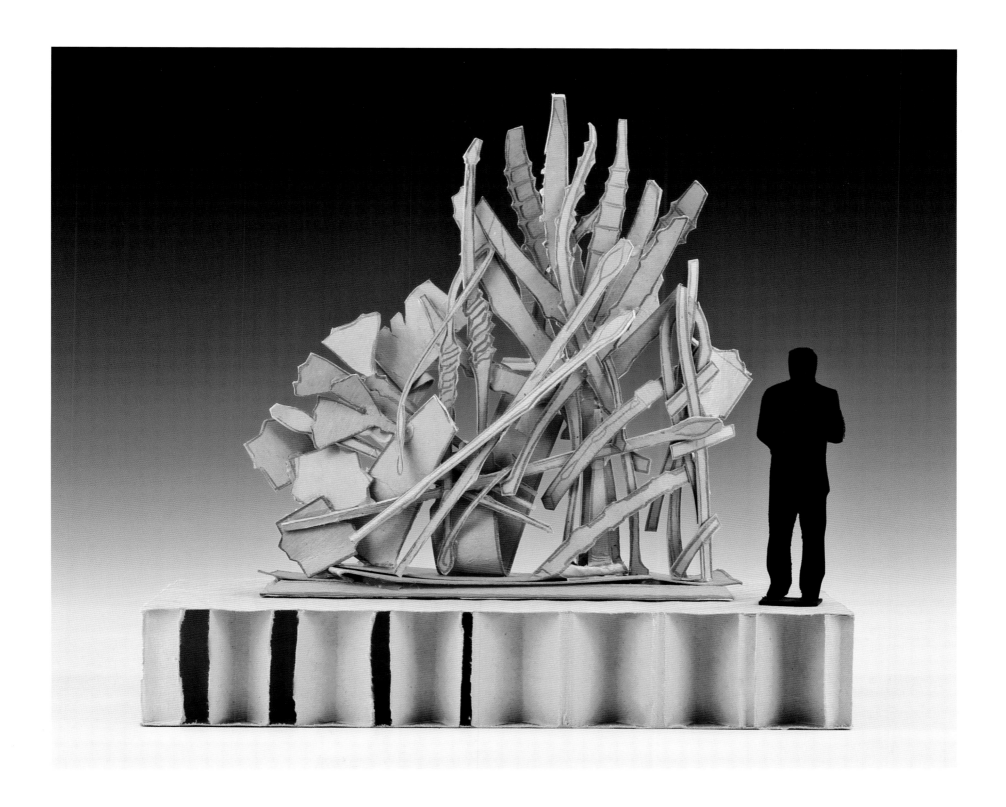

57. *Proposal*, 2004
Drawing
Red Pencil on Paper
20" x 24"
Studio Archive

58. *Sculpture Night Watch*, 2004
Developmental Model
Cardboard and Red Pencil
9" x 8" x 2.25"
Studio Archive

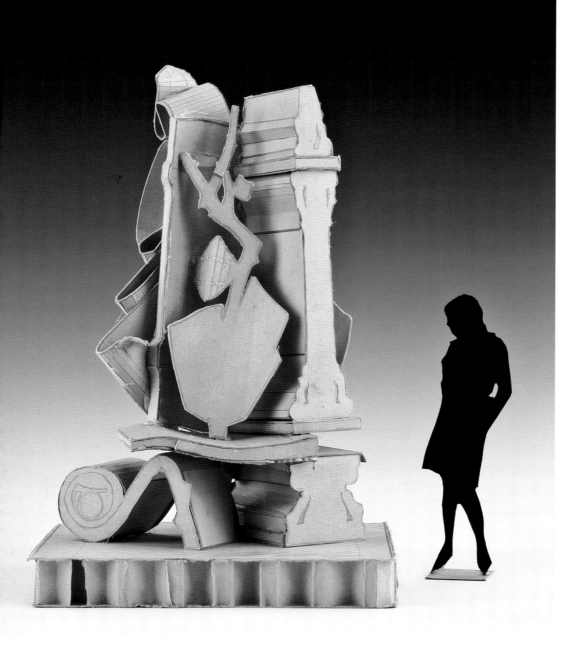

59. *Geometric Chair*, 2005
Developmental Model
Cardboard and Red Pencil
12" x 4" x 3"
Studio Archive

60. *Geometric Chair*, 2005
Developmental Drawing
Graphite and Red Pencil on Paper
22.25" x 14.5"
Studio Archive

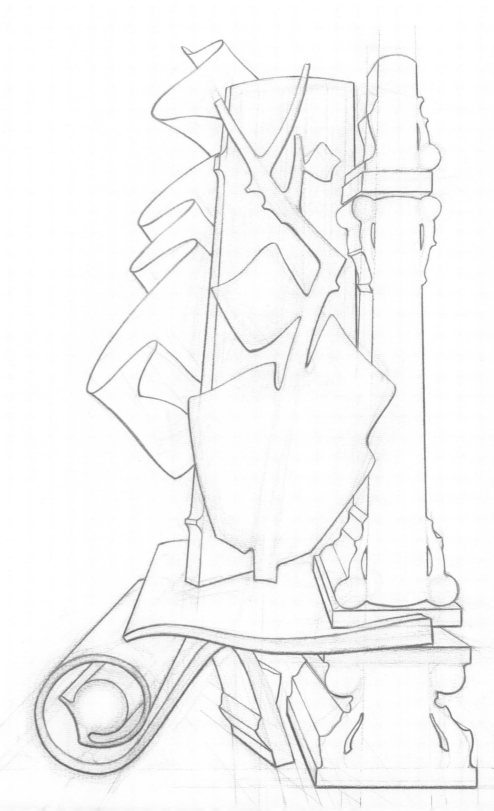

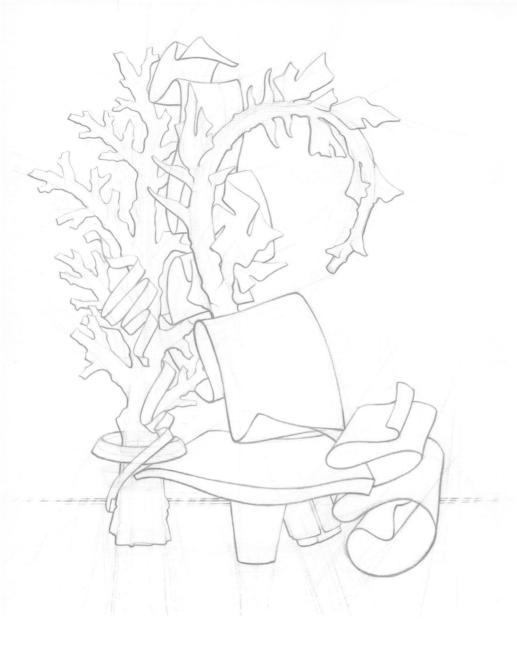

61. *Vegetal Chair*, 2005
Developmental Drawing
Graphite and Red Pencil on Paper
22.25" x 15.5"
Studio Archive

62. *Vegetal Chair*, 2005
Presentation Model
Fabricated Bronze
12" x 4"x 3"
Studio Archive

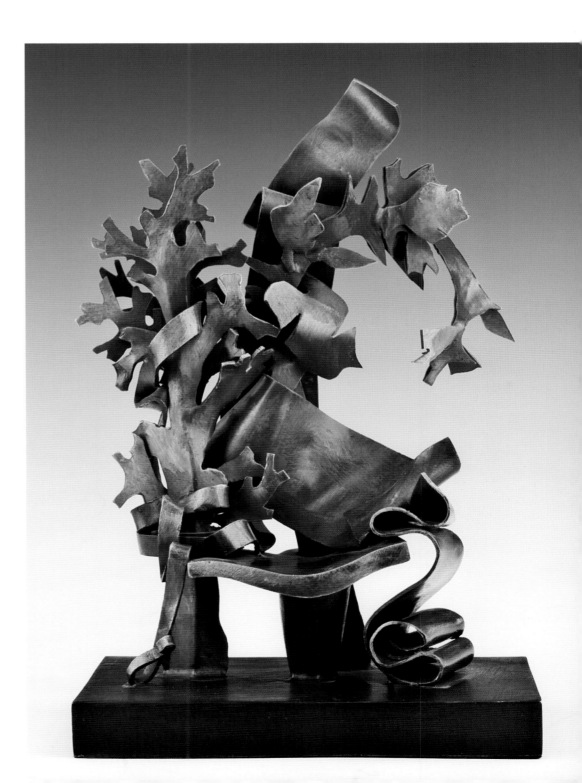

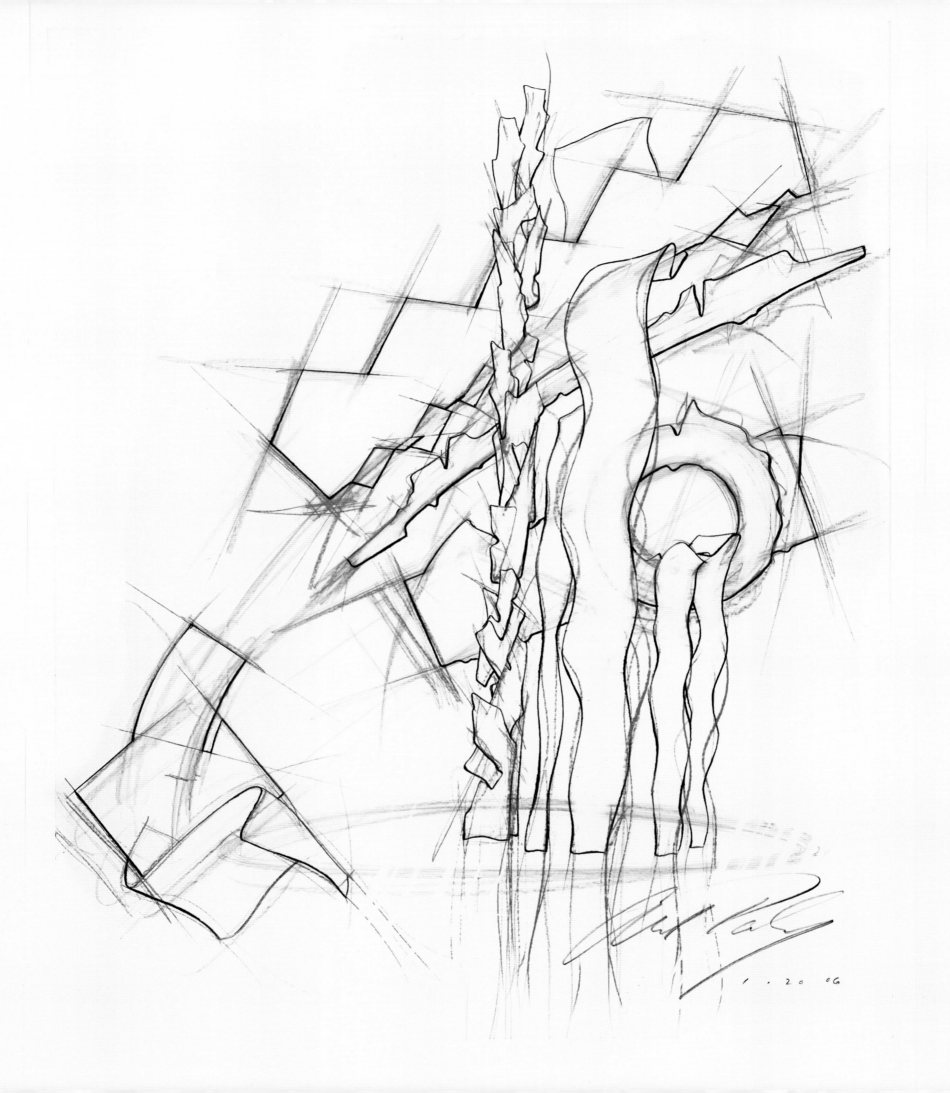

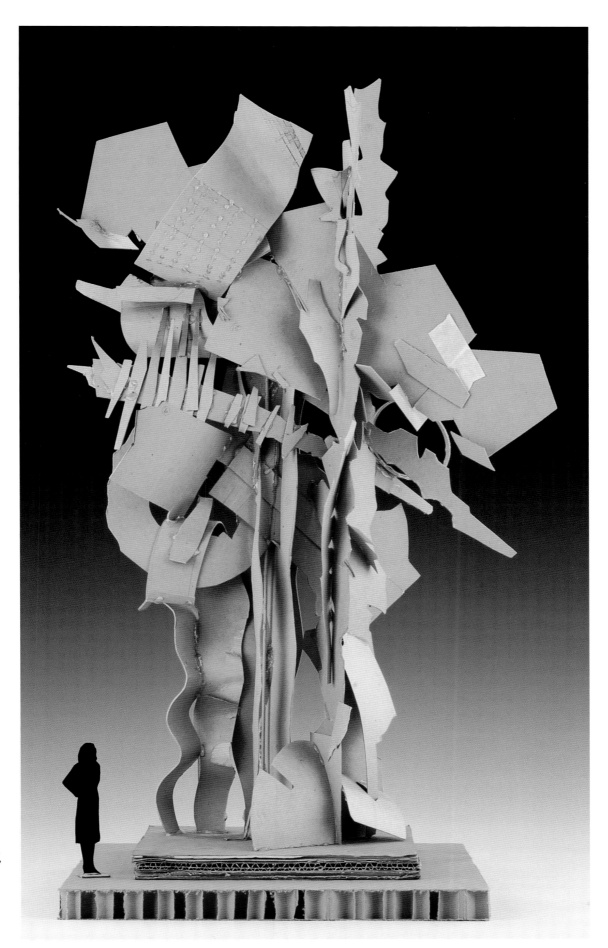

63. *Untitled Sculpture*, 2006
Presentation Drawing
Graphite and Red Pencil on
Vellum
22" x 28"
Studio Archive

64. *Untitled Sculpture Model*,
2001
Proposal Model
Cardboard
20" x 11" x 6"
Studio Archive

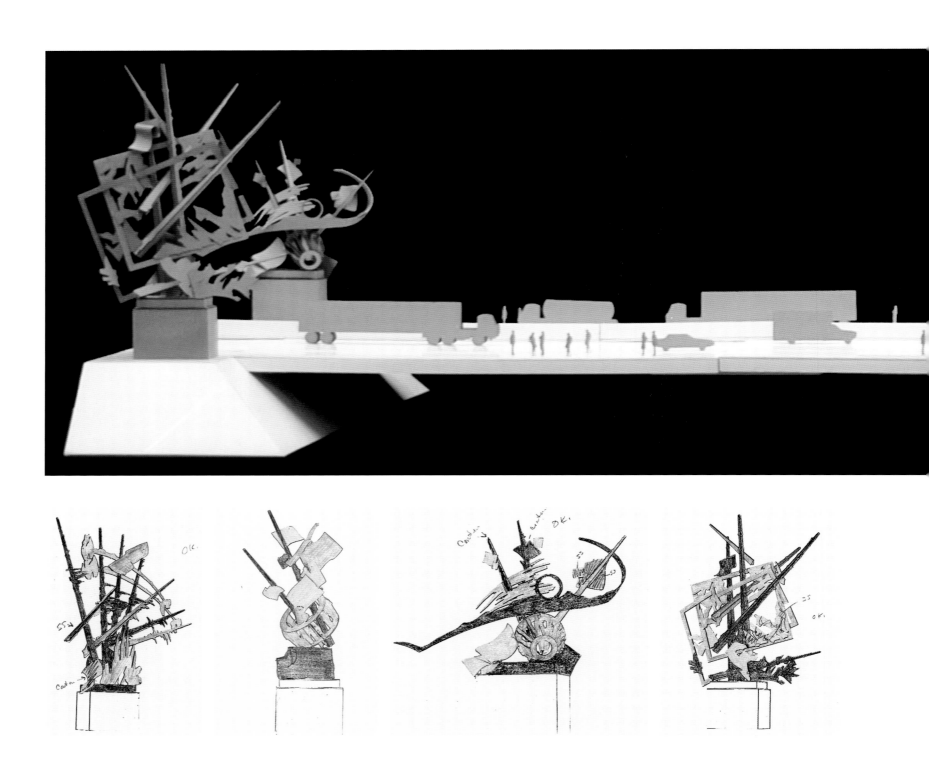

At the time of publication of this book the studio was engaged in the final design phase for four sculptures in Council Bluffs, Iowa. The sculptures, two placed on each side of the bridge, gesture one to the other. The height will range from between 50' to 70' and be fabricated out of cor-ten weathering steel, stainless steel and patinated bronze. The project is entitled Odyssey.

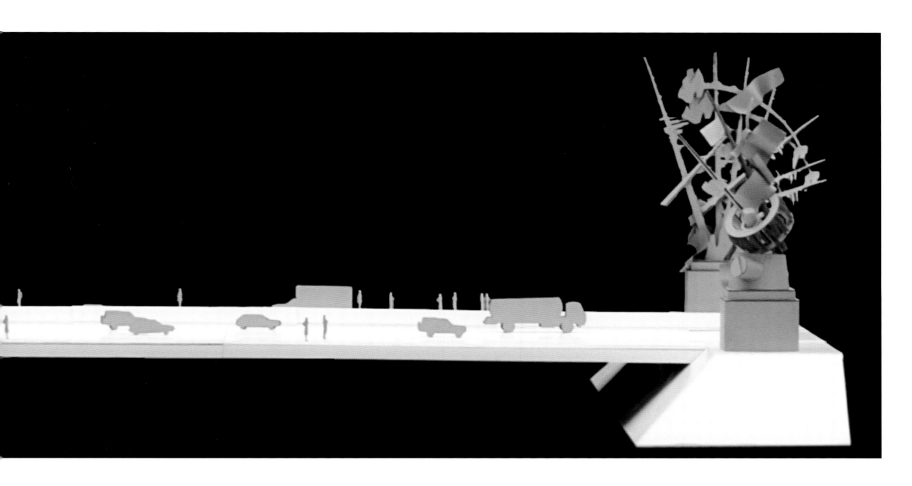

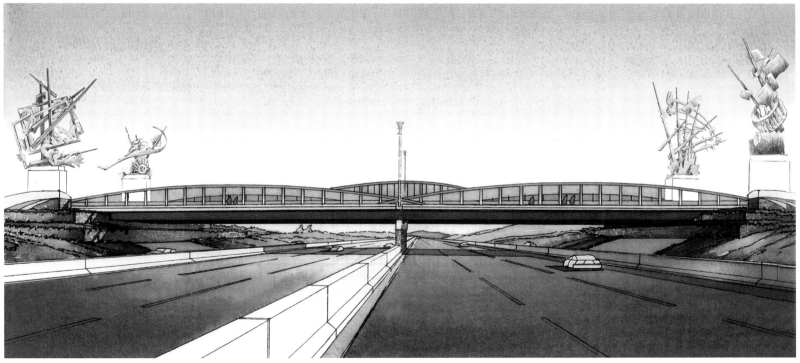

65. *24th Street Bridge, Council Bluffs Model*, 2007
Presentation Model
Cardboard and Foam Core
24" x 12' x 30"
Studio Archive

66-69. *Council Bluffs Color Rendering*, 2008
Indicates Material Usage - Bronze, Cor-ten and
Stainless Steel
Photoshop Montage
Studio Archive

70. *Four Commissioned Sculptures for the*
24th Street Bridge Over I-80, 2008
Iowa West Foundation, Council Bluffs, Iowa
In-situ Rendering
Photoshop Montage
Studio Archive

In addition to the design process, the physicality of fabrication creates its own critical focus in the studio. With commissioned works or with exhibition pieces the process of making engages a different set of disciplines and applications. Visually, scale and proportion must be adjusted in reference to the viewing of the sculpture. Because of foreshortening, adjustments are made during the working process to balance the composition of the work. Many of the initial concepts for the sculpture are developed through the drawing process. Although illusionistic, the drawings are flat and many aspects of the dynamism of three-dimensional form are worked out during the assemblage of the work. Due to the constant adjustment and inter-relationship of the individual elements, structural and material characteristics must be addressed.

71. Paley Studios
North Washington Street
Rochester, NY

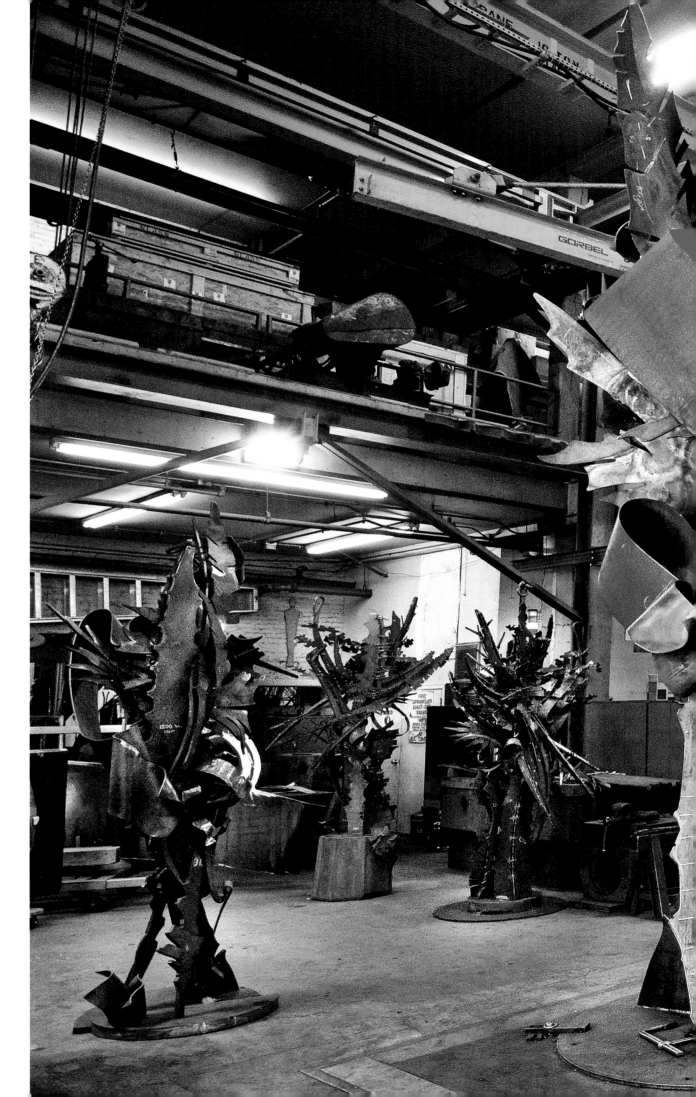

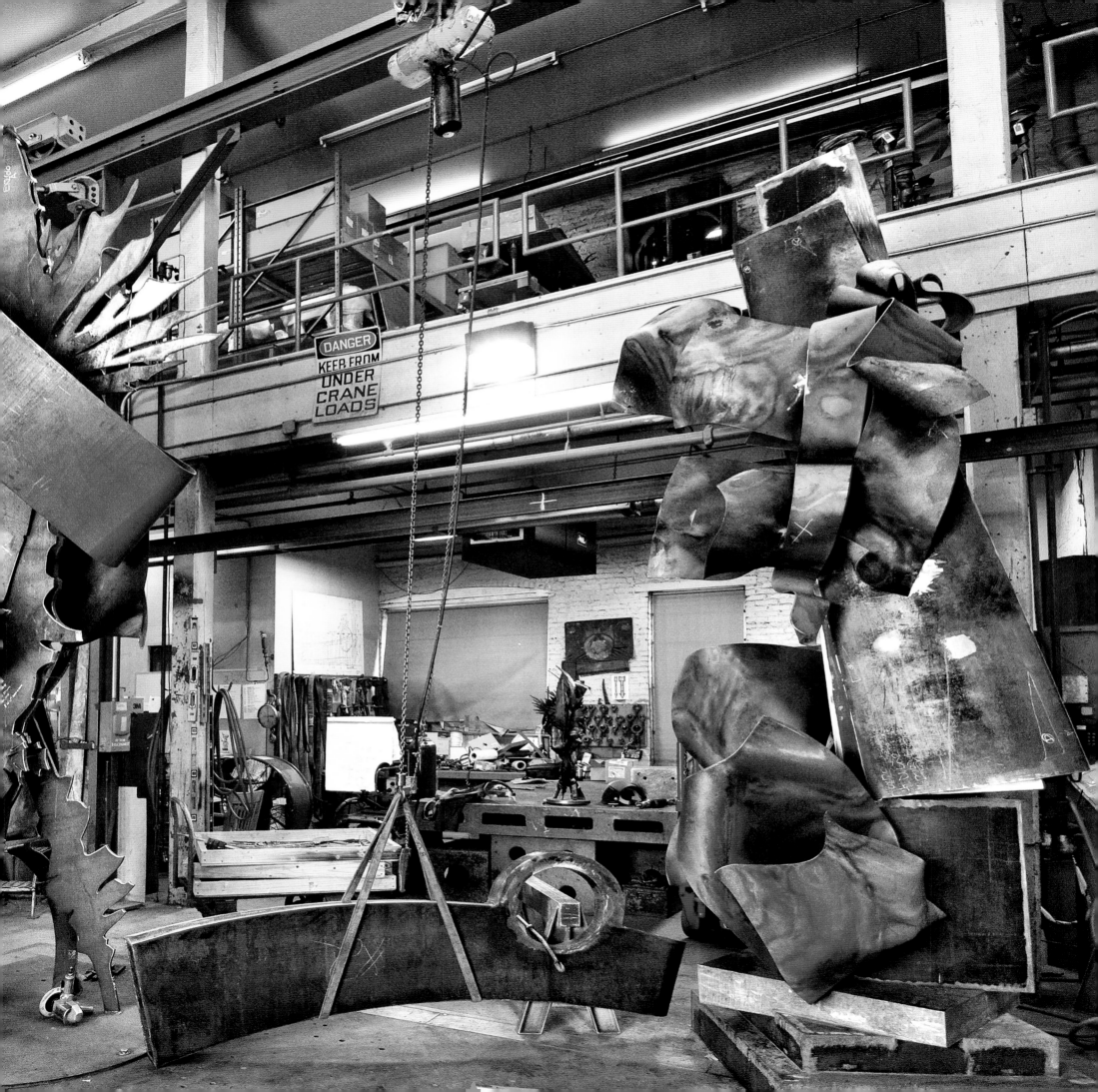

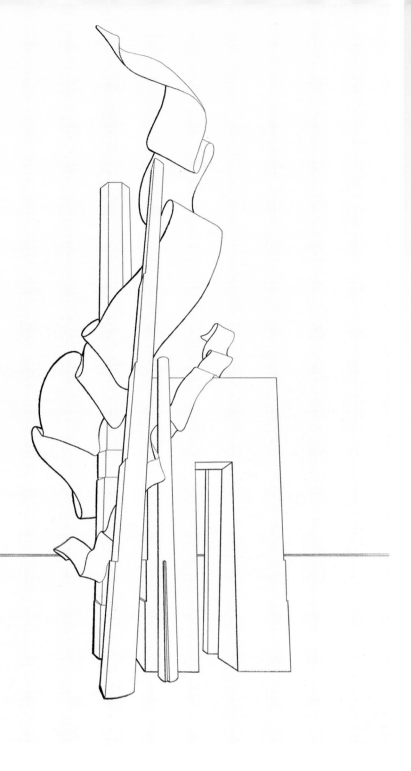

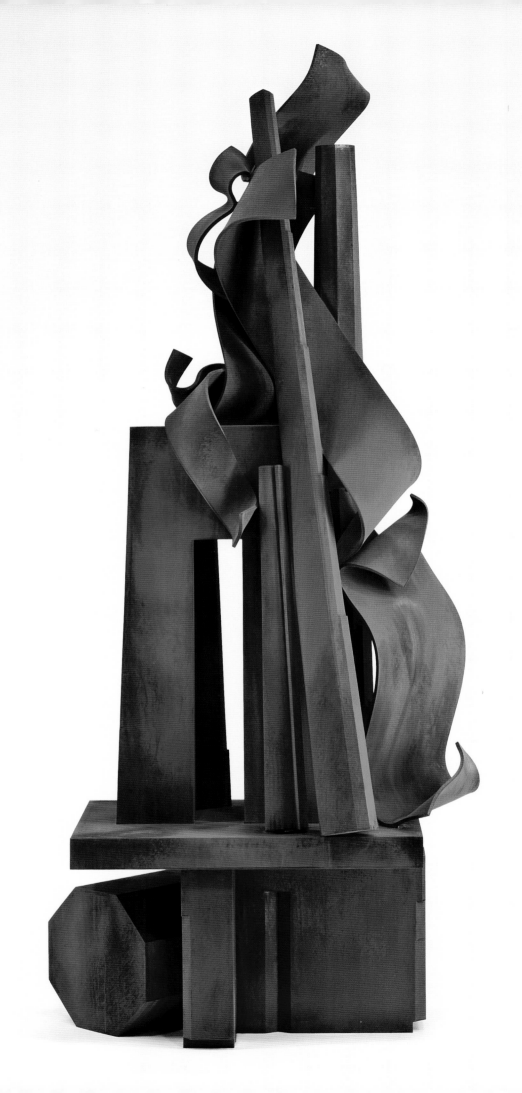

72. *Portal*, 1990
Presentation Drawing
Graphite on Paper
11" x 8.5"

73. *Portal*, 2008
Formed and Fabricated Cor-ten Steel
8' x 3'6" x 2'3"
Collection of the Artist

74. Paley Sculpture Storage
Maple Grove Enterprises
Arcade, New York

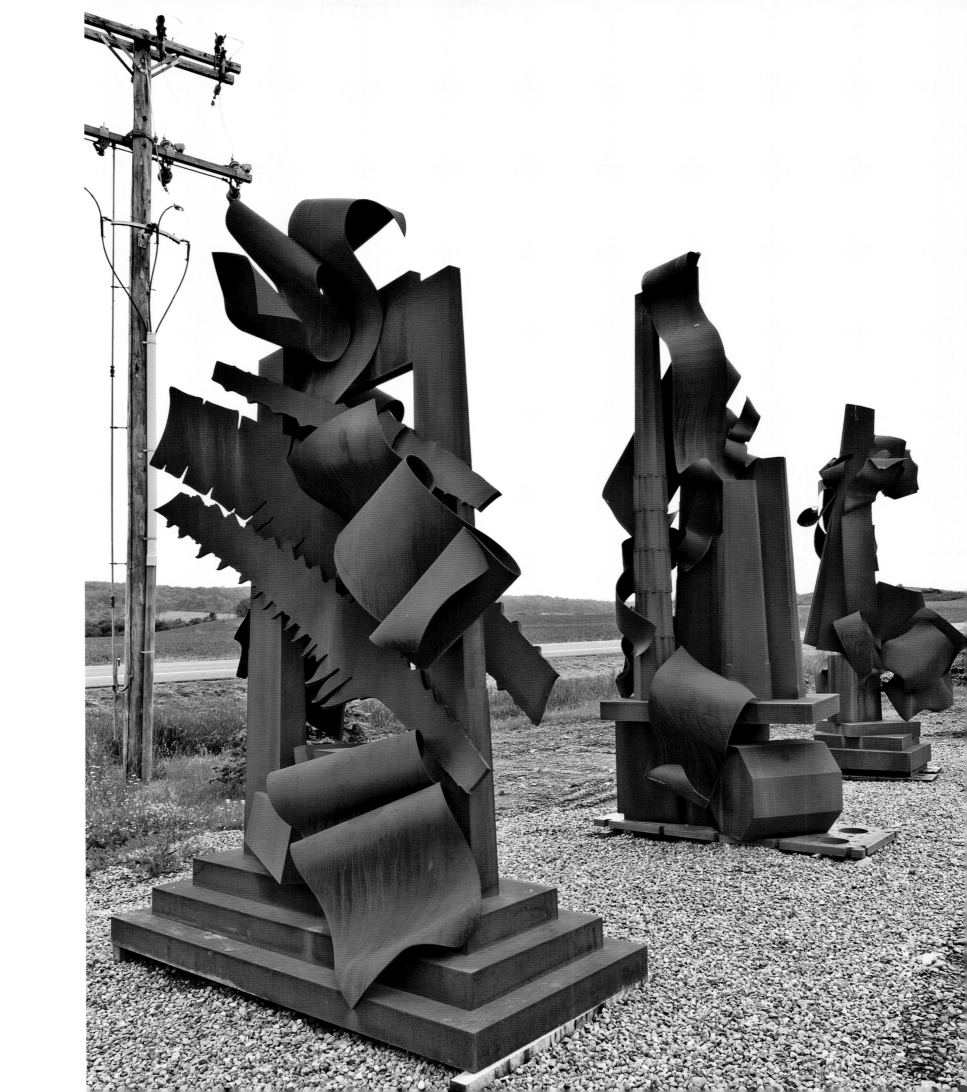

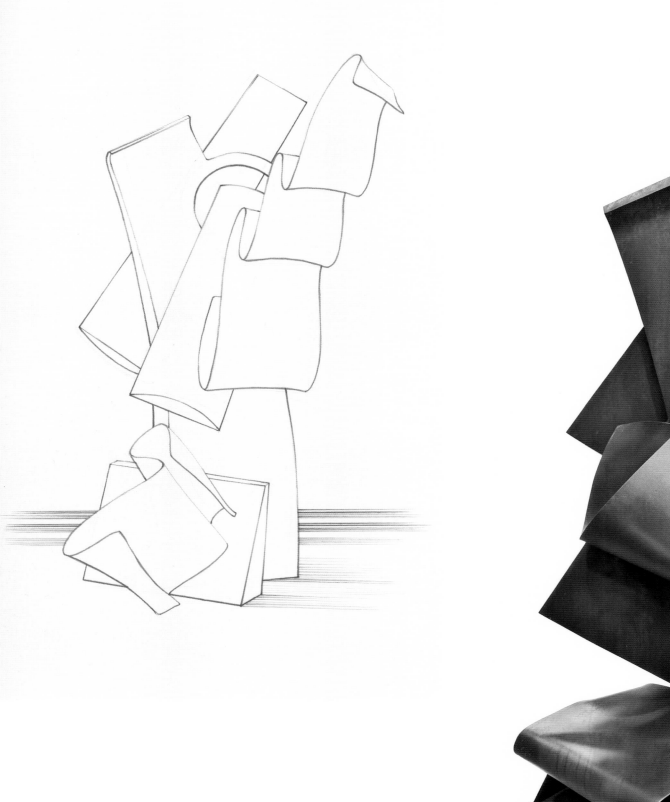

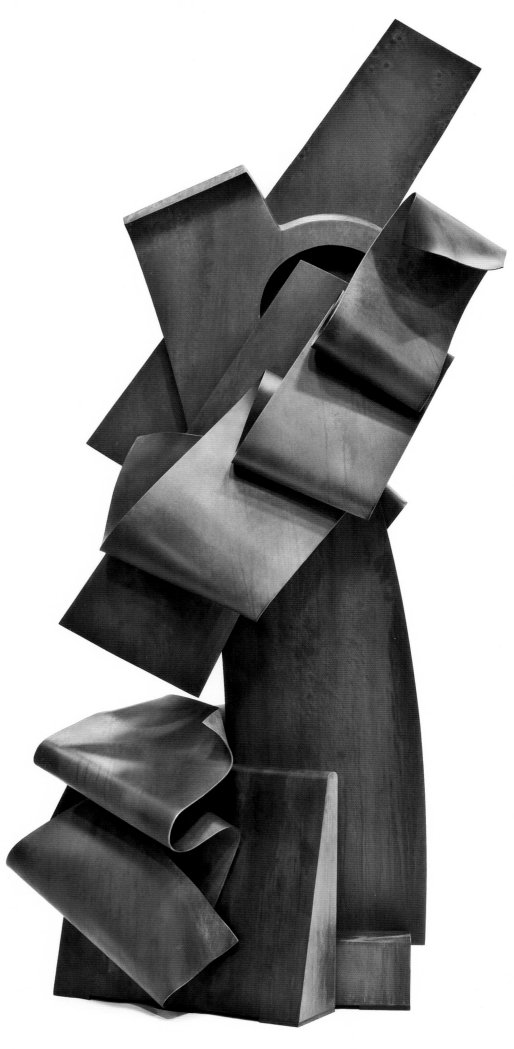

75. *Stance*, 2007
Proposal Drawing
Graphite on Paper
10" x 18.25"
Studio Archive

76. *Stance*, 2008
Formed and Fabricated Mild Steel
9'6" x 2'9" x 4'9"
Private Collection, Osprey, Florida

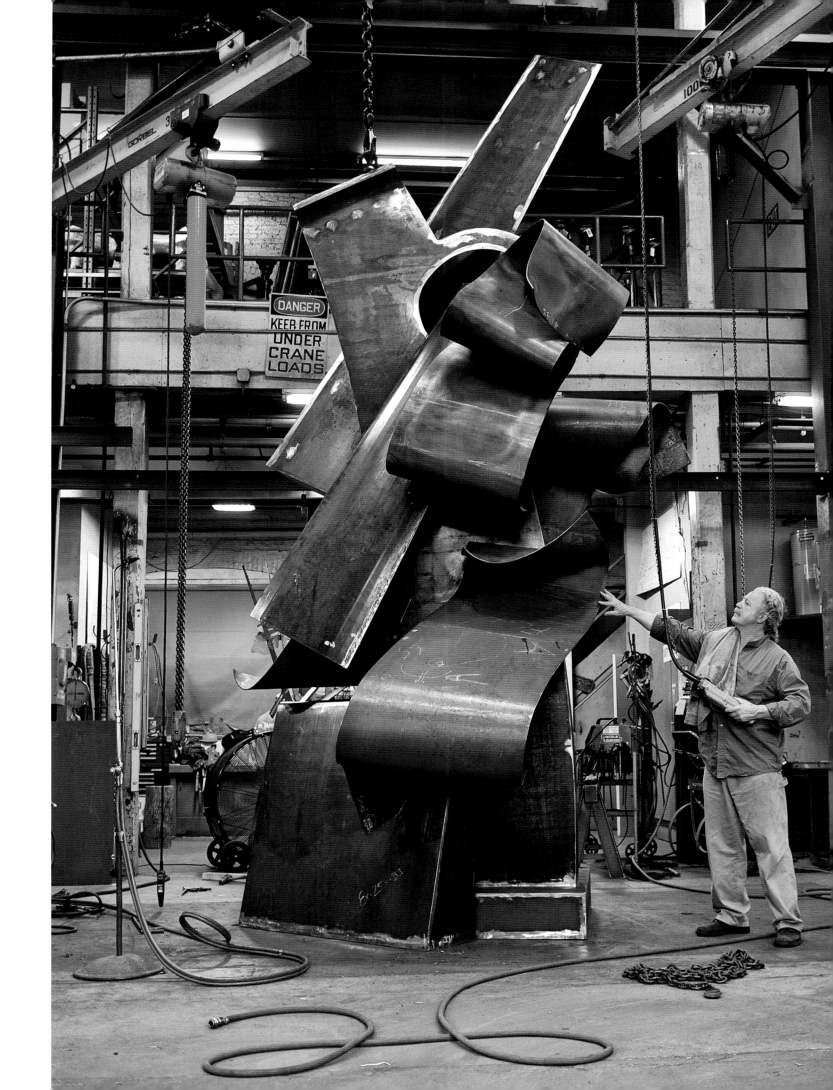

77. *Stance*, 2009
Fabricated Cor-ten Steel
17' x 8' x 7'
North Washington Street Studio
Rochester, New York

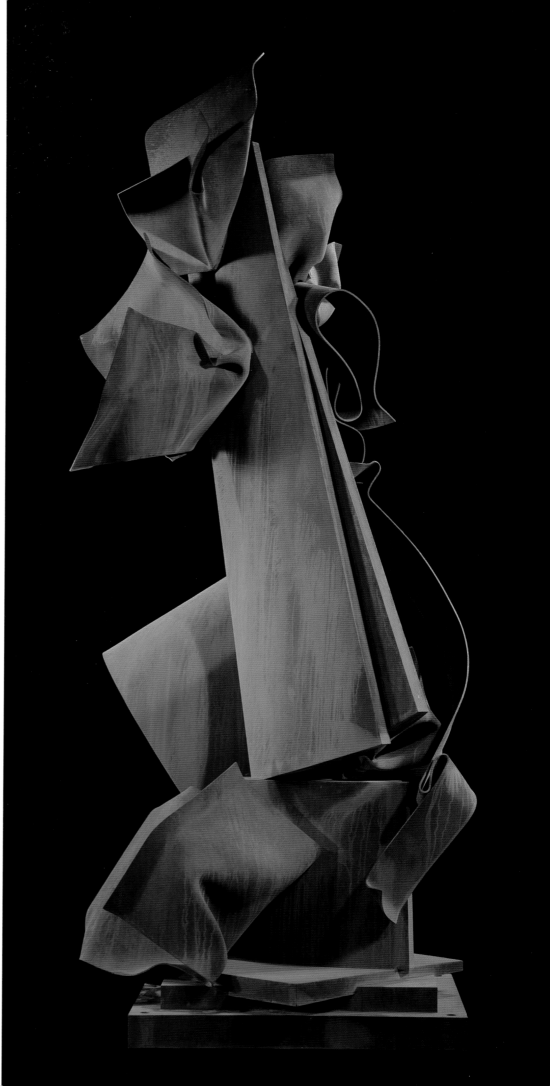

78. *Splice*, 2007
Proposal Drawing
Graphite on Paper
10" x 18.25"
Studio Archive

79. *Splice*, 2008
Formed and Fabricated Cor-ten Steel
12'3" x 4'6" x 4'9"
Private Collection: Currently on Loan
to Academy Art Museum, Easton, Maryland

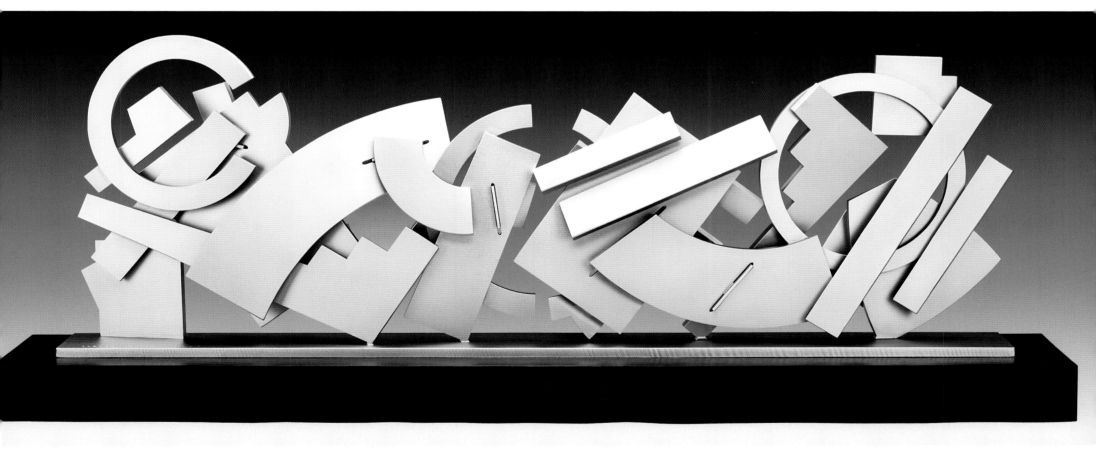

80. *Geometric Sequence*, 2003
Drawing
Red Pencil on Paper
21'3" x 30'6"
Studio Archive

81. *Geometric Sequence Model*, 2007
Formed and Fabricated Stainless Steel
2' x 5'6" x 1'3"
Collection of the Artist

Image on page 70-71
82. *Geometric Sequence*, 2006
Formed and Fabricated Stainless Steel
12' x 40' x 4'
North Washington Street Studio
Rochester, New York

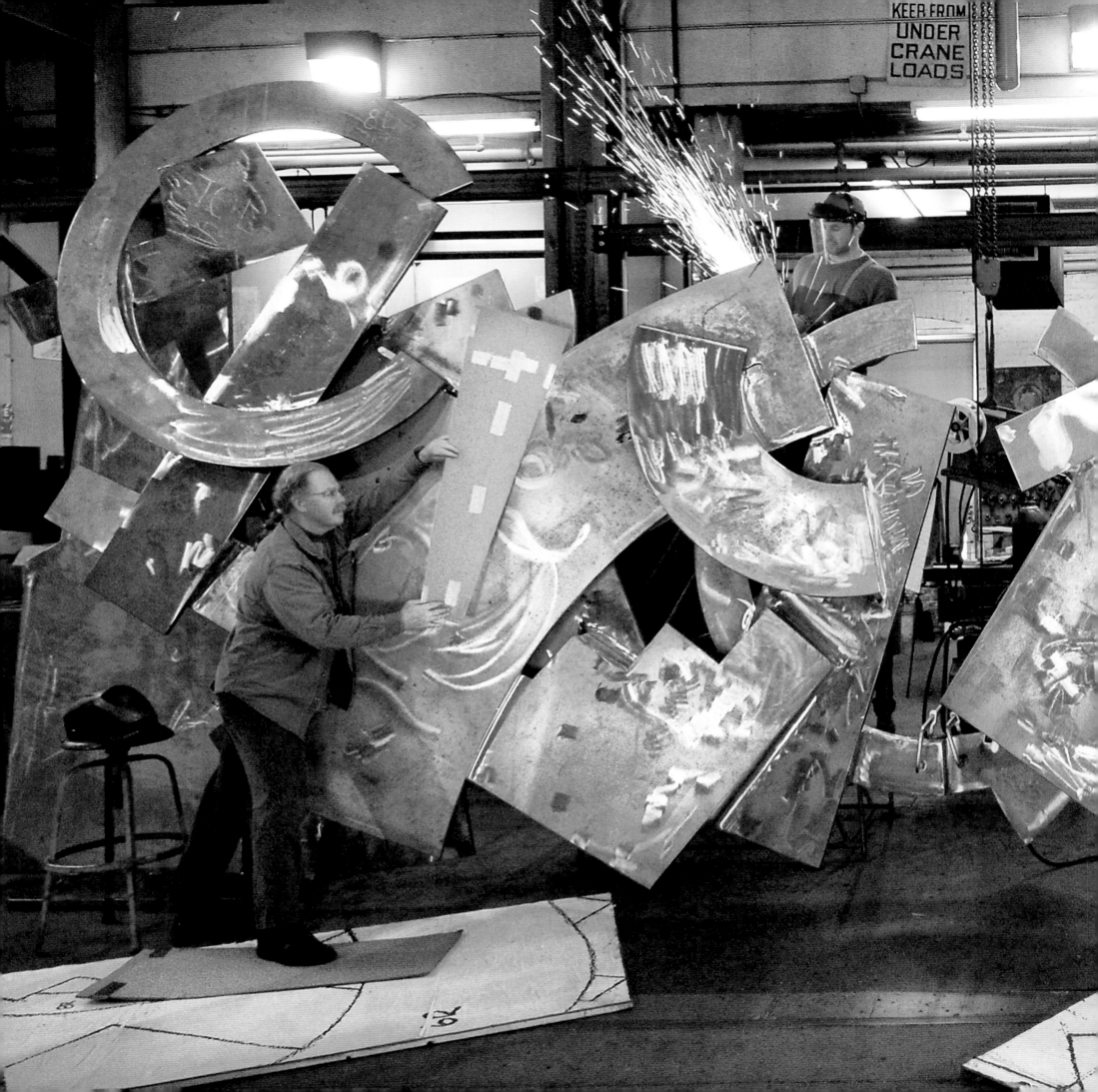

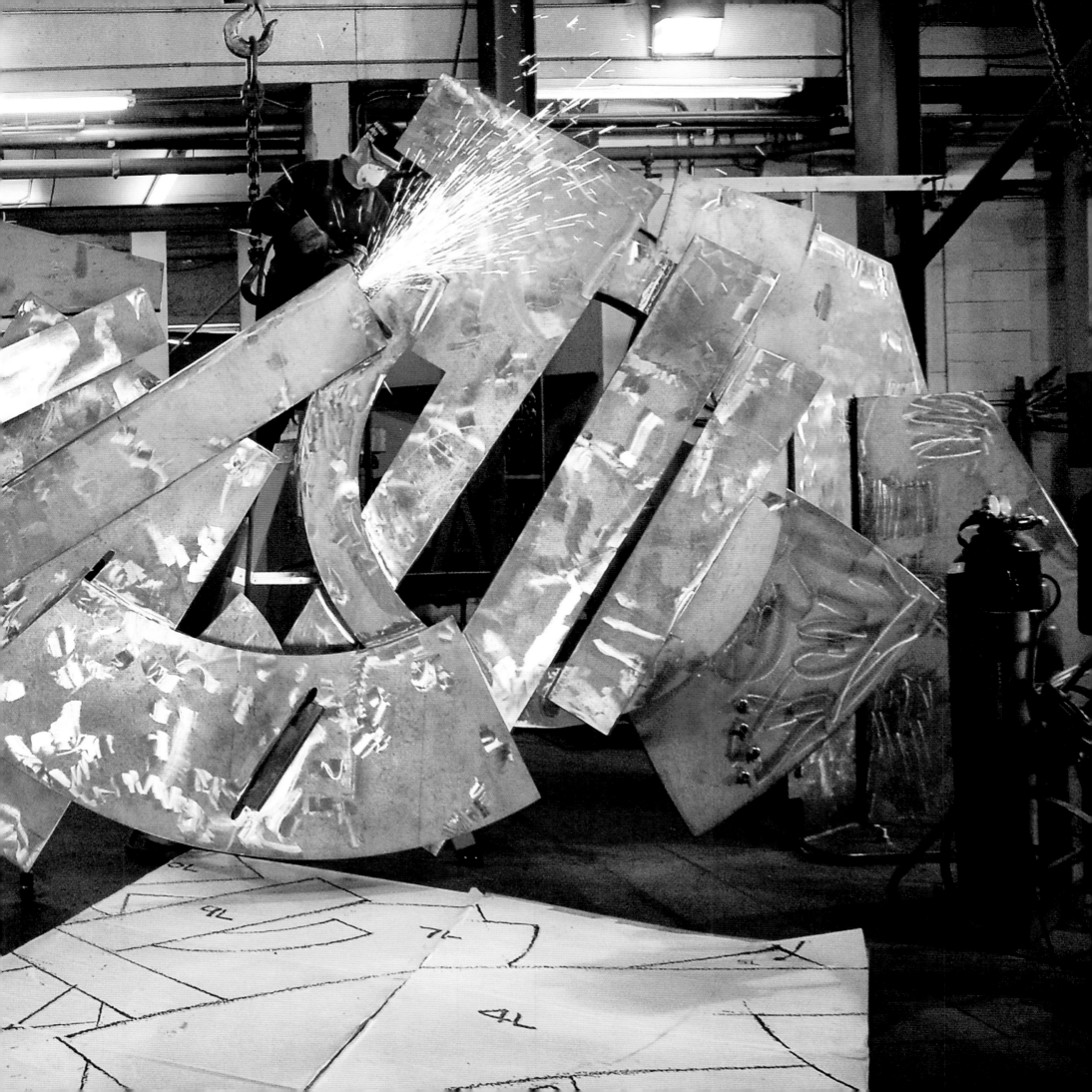

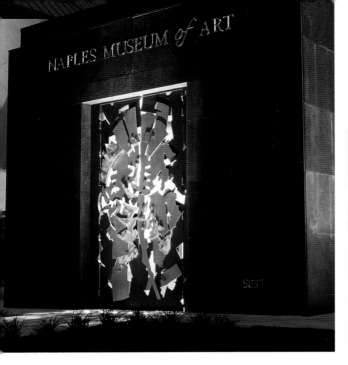

83. *Paley Gates*, 2000
In-Situ at Main Entrance
Naples Philharmonic Center for
the Arts, Naples, Florida

84. *Paley Gates*, 2000
Proposal Drawing
Graphite and Red Pencil on
Transparent Film
24" x 20"
Studio Archive

85. *Paley Gates*, 2000
Formed and Fabricated Cor-ten
and Stainless Steels and Bronze
20' x 10'6" x 1'3"
Naples Philharmonic Center for
the Arts, Naples, Florida

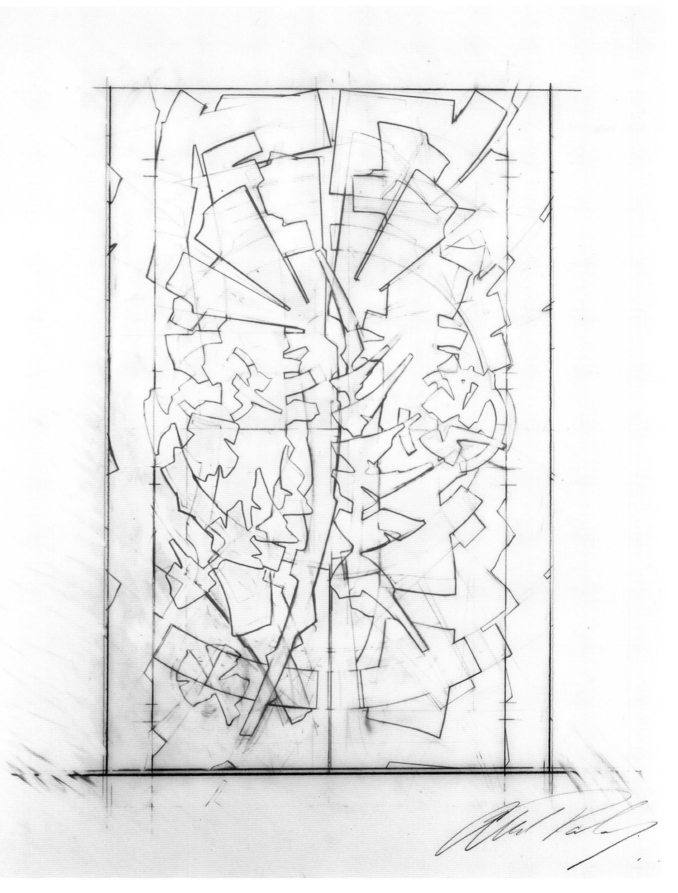

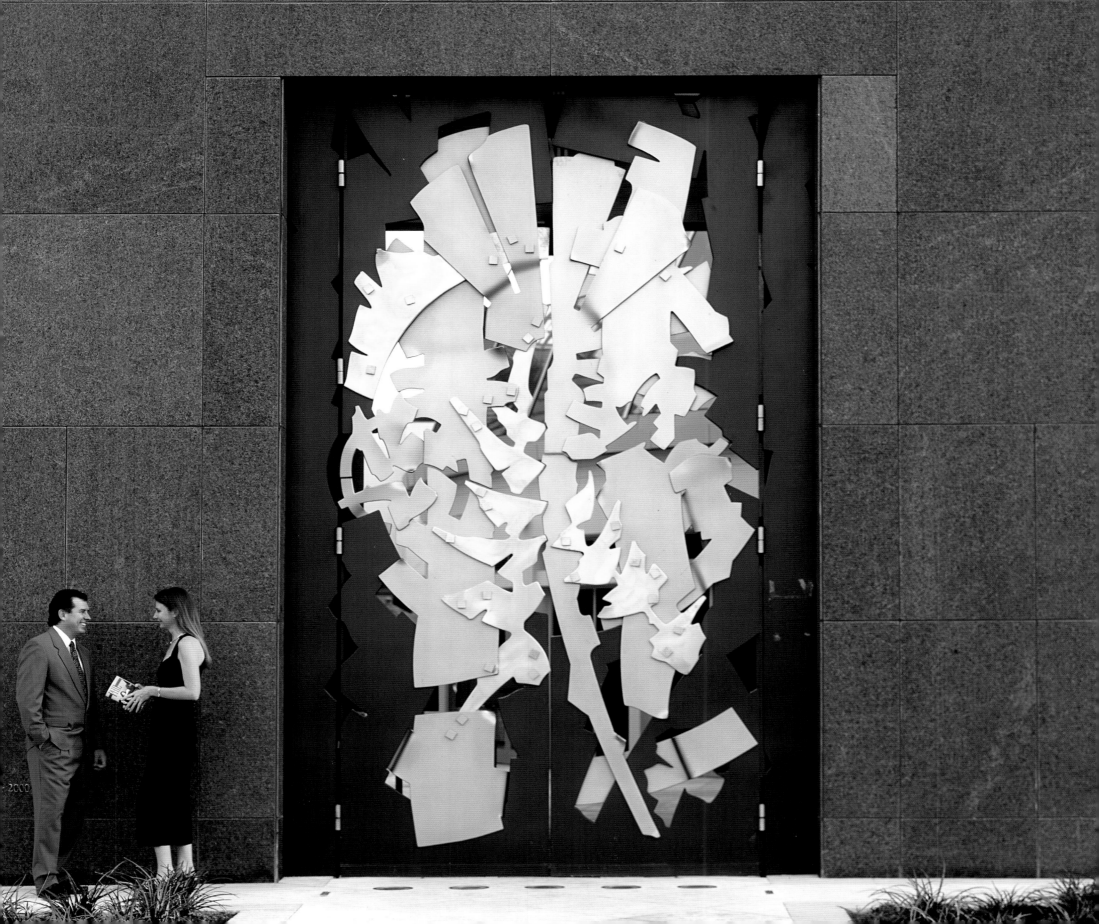

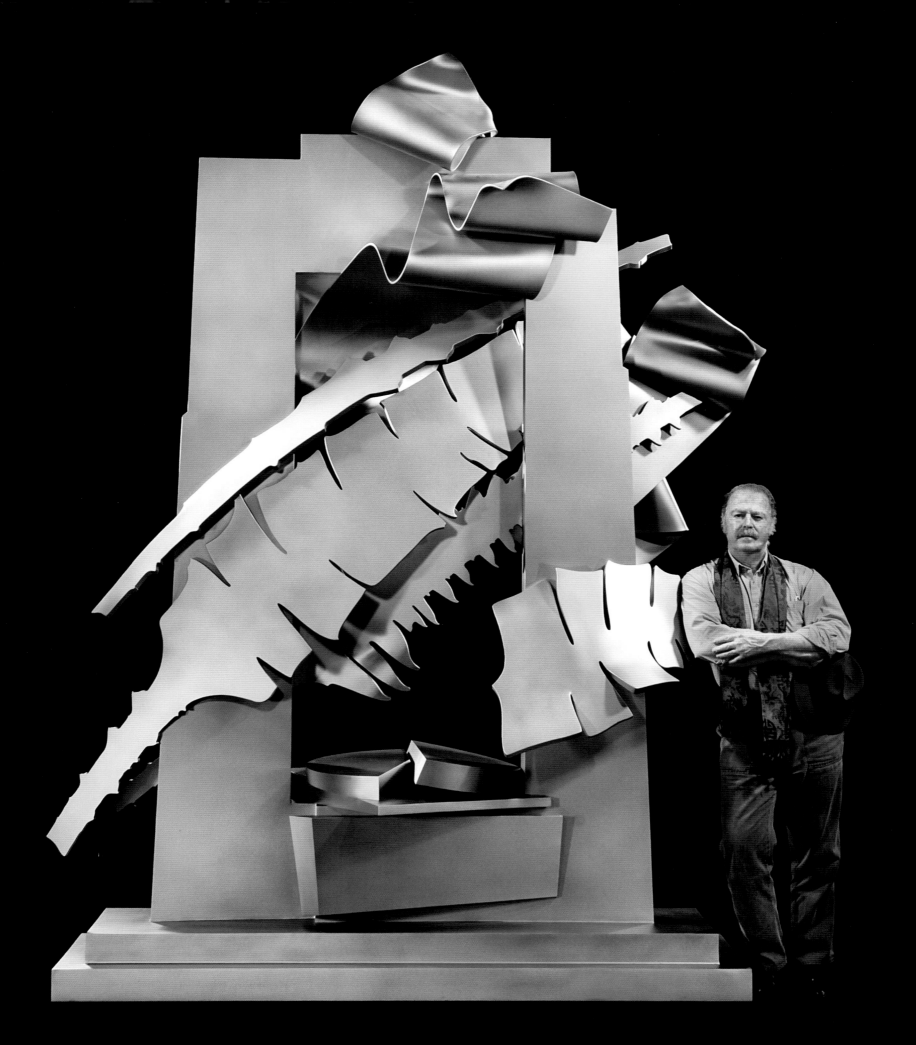

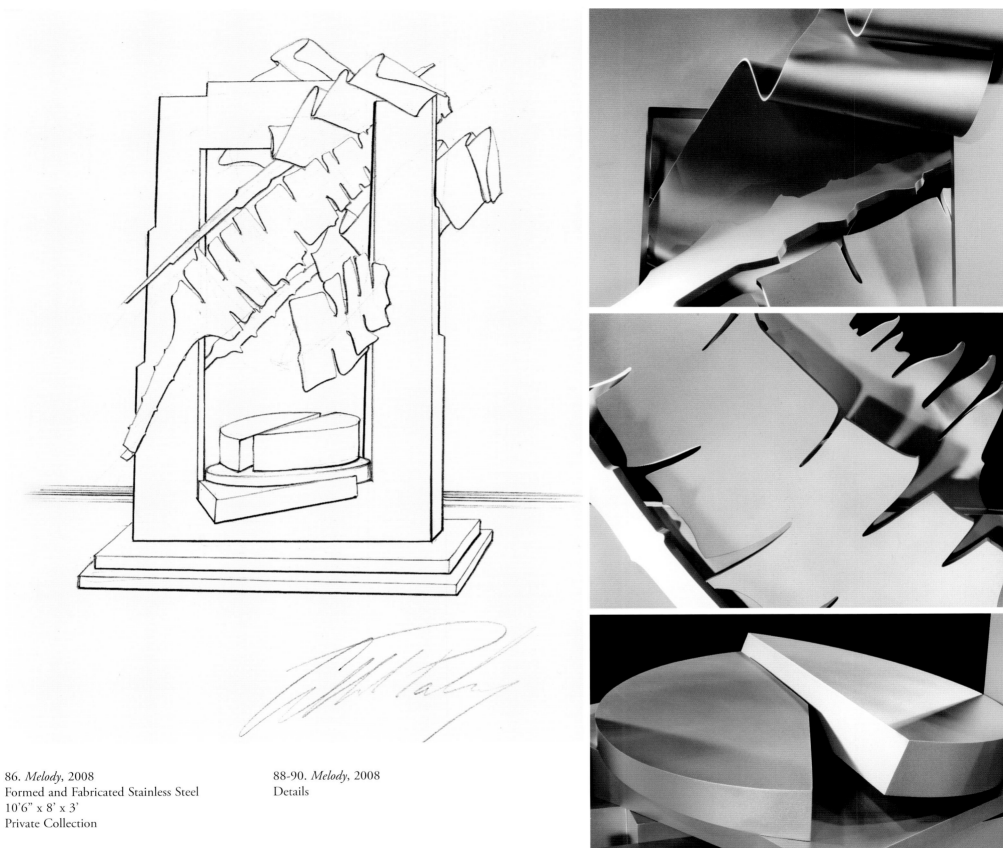

86. *Melody*, 2008
Formed and Fabricated Stainless Steel
10'6" x 8' x 3'
Private Collection

87. *Melody* , 2007
Proposal Drawing
Graphite on Paper
12" x 9"
Studio Archive

88-90. *Melody*, 2008
Details

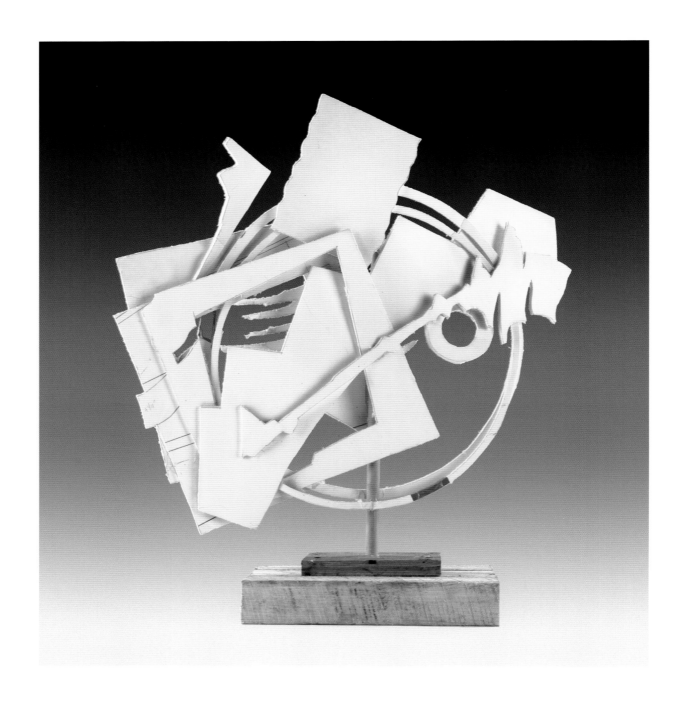

91. *Kodak Diversity Award*, 2000
Developmental Model
Foam Core and Wood
18" x 18" x 2"
Studio Archive

92. *Kodak Diversity Award*, 2000
Formed and Fabricated Stainless Steel
4' x 2' x 6"
Kodak Corporate Headquarters,
Rochester, New York

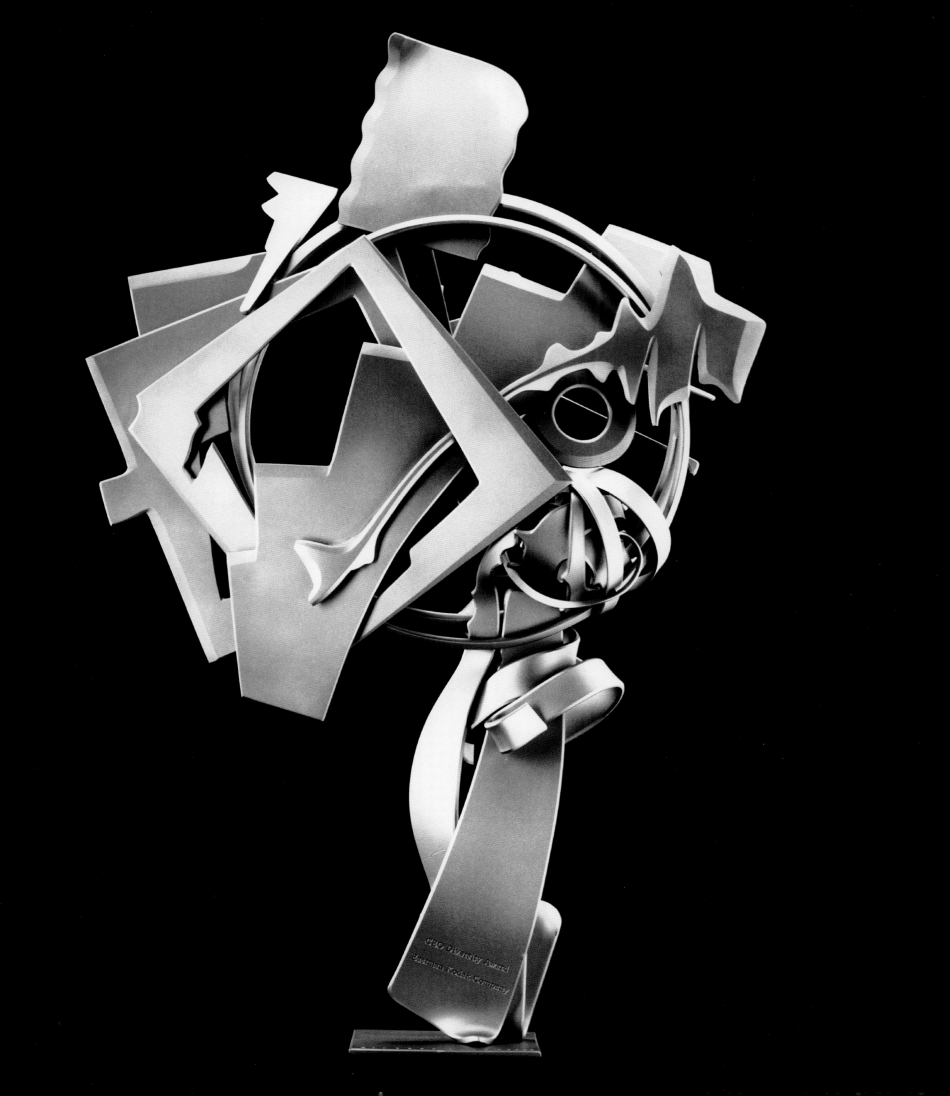

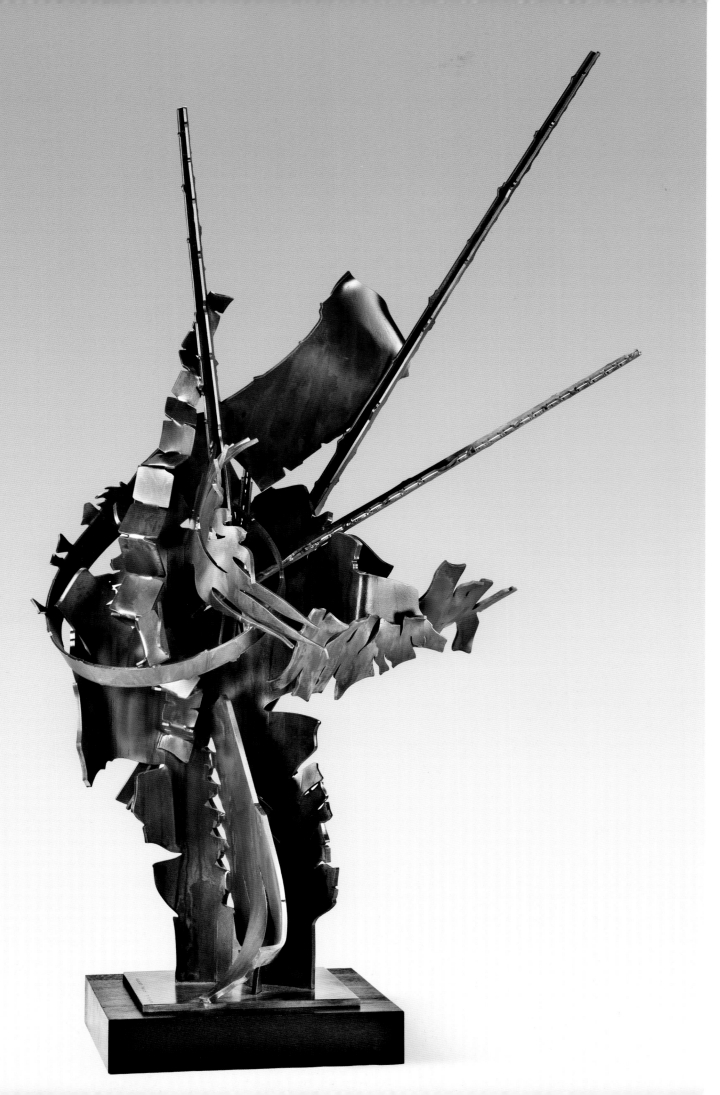

Commissioned for the entrance of a newly created condominium complex is a sculpture entitled Naiad. This polychromed work brings focus, accent and identity to the site.

93. *Naiad*, 2008
Formed, Fabricated and Patinaed Mild
Steel with Wood Base
5'9" x 3'3" x 2'6"
Collection of the Artist

94. *Naiad*, 2008
Formed and Fabricated Mild Steel with
Polychromed Finish
30' x 19' x 12'
St. Tropez Towers, Riviera
Condominiums, Fort Myers, Florida

Images on Pages 80-81
95 - 98. *Naiad*, 2008
Developmental Model
18" x 7" x 6"
Studio Archive

99. *Naiad*, 2008
Detail

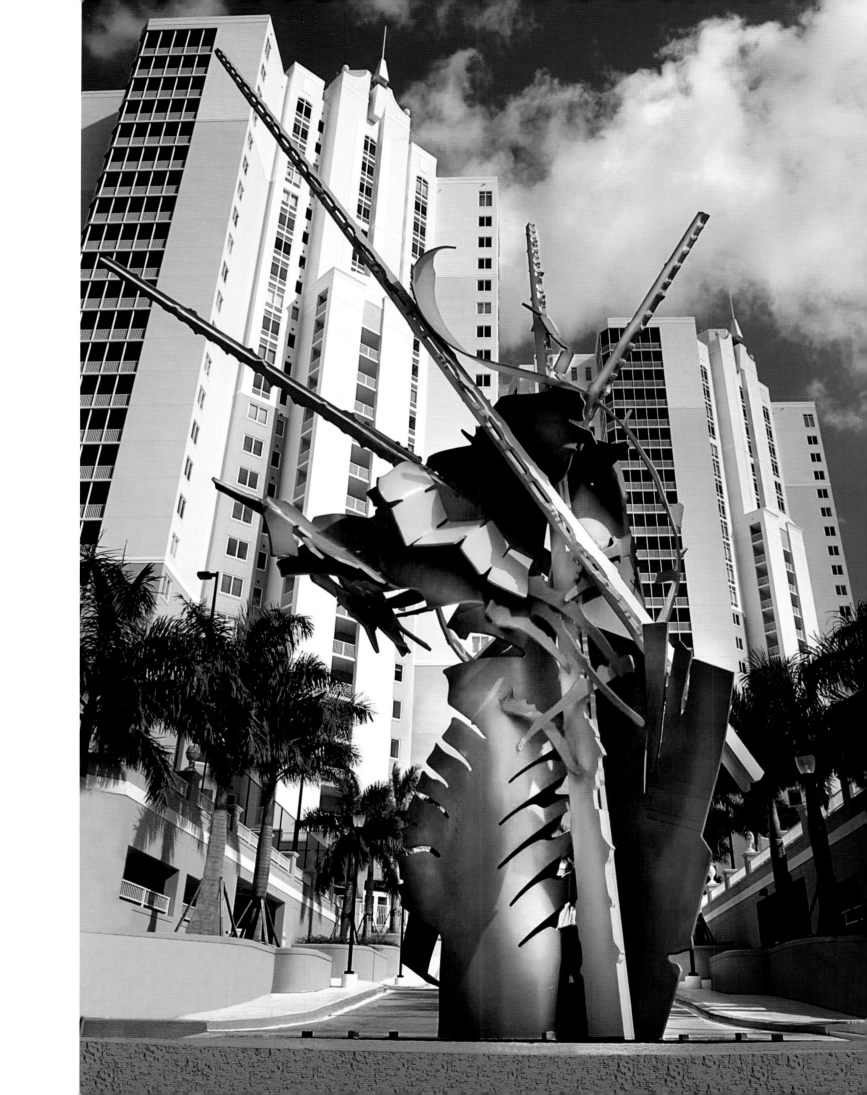

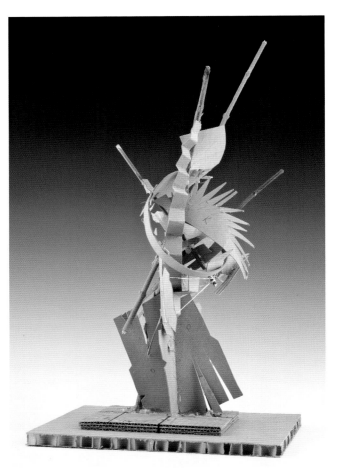
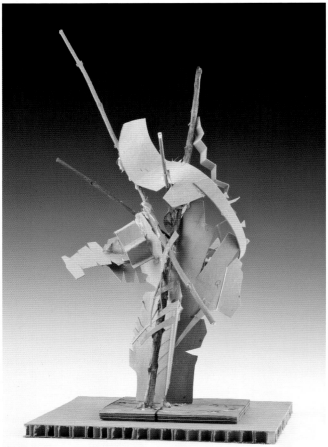
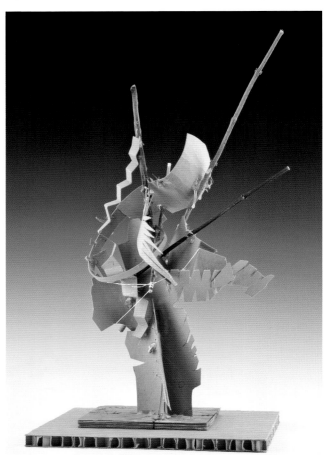

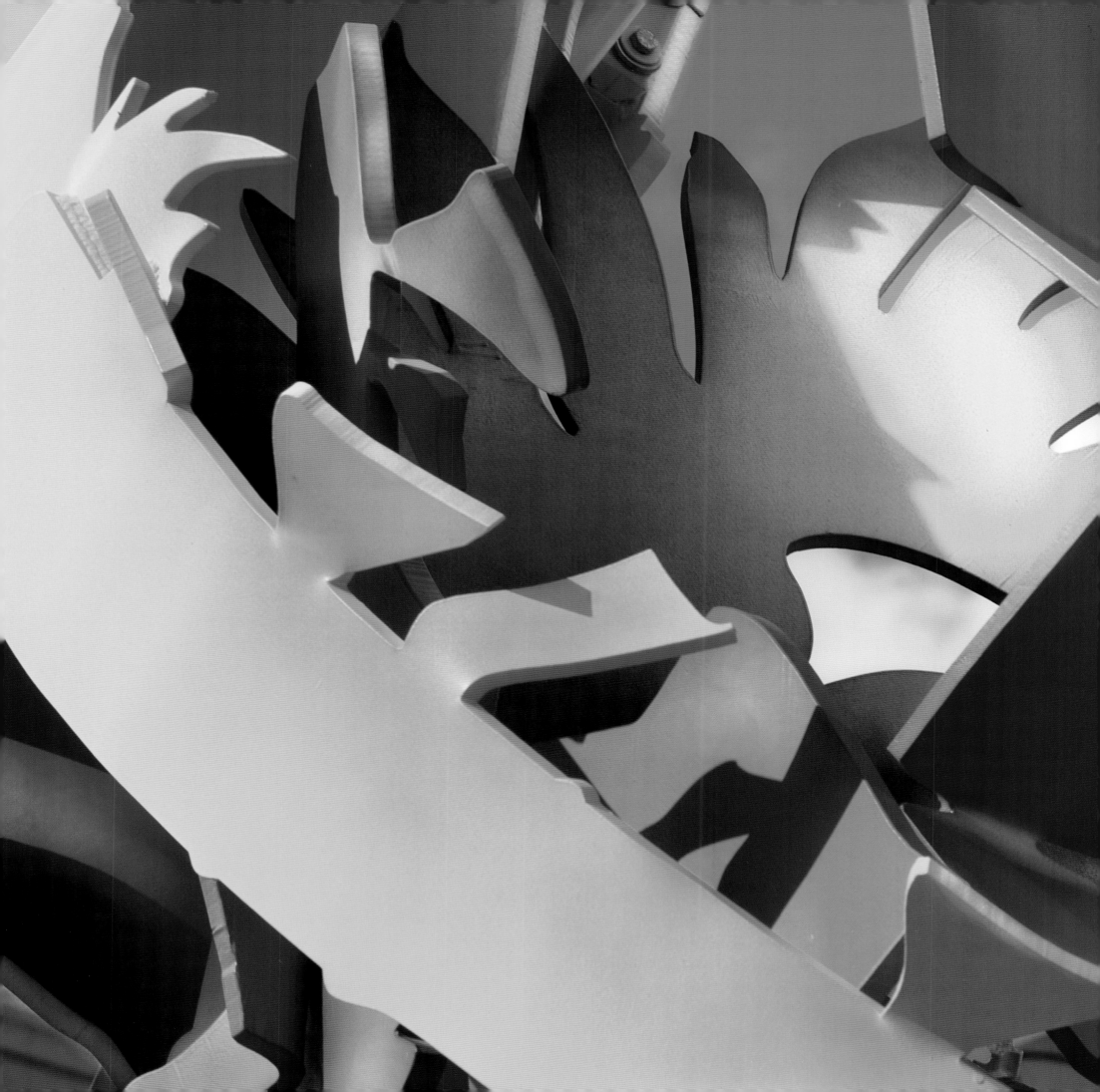

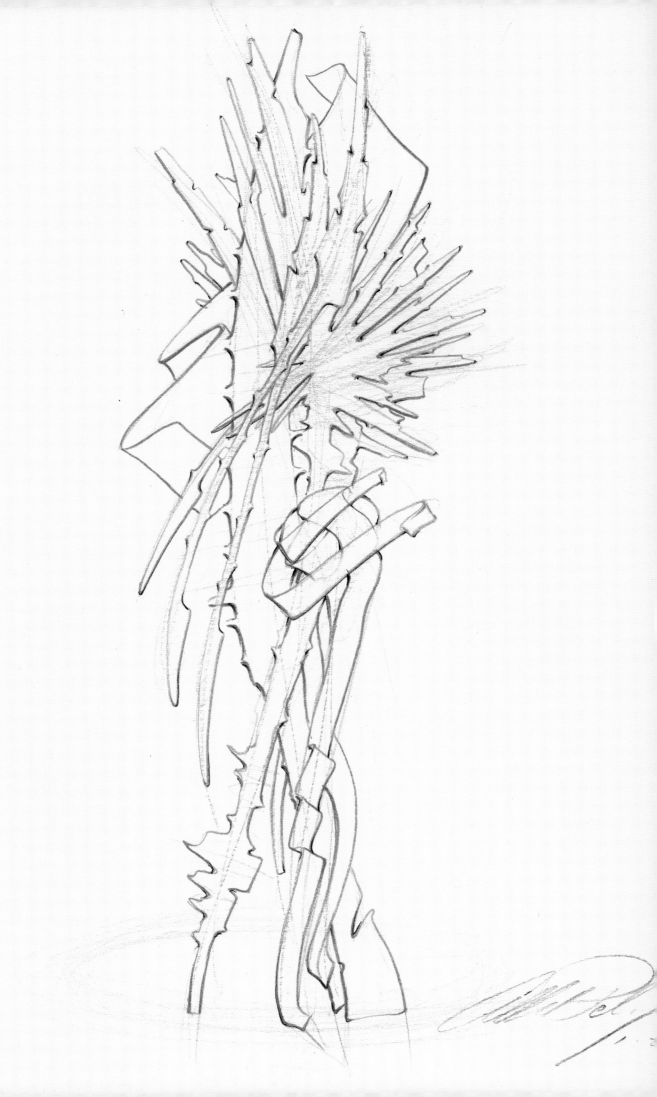

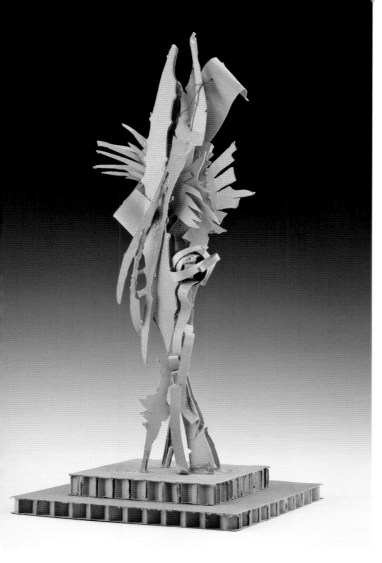

100. *Sylvan*, 2008
Proposal Drawing
Red Pencil on Vellum
12" x 9"
Studio Archive

101. *Sylvan*, 2008
Presentation Model
Cardboard
22" x 6" x 5"
Studio Archive

102. *Sylvan Maquette*, 2009
Formed and Fabricated Mild Steel
4' x 1'6" x 1'3"
Collection of the Artist

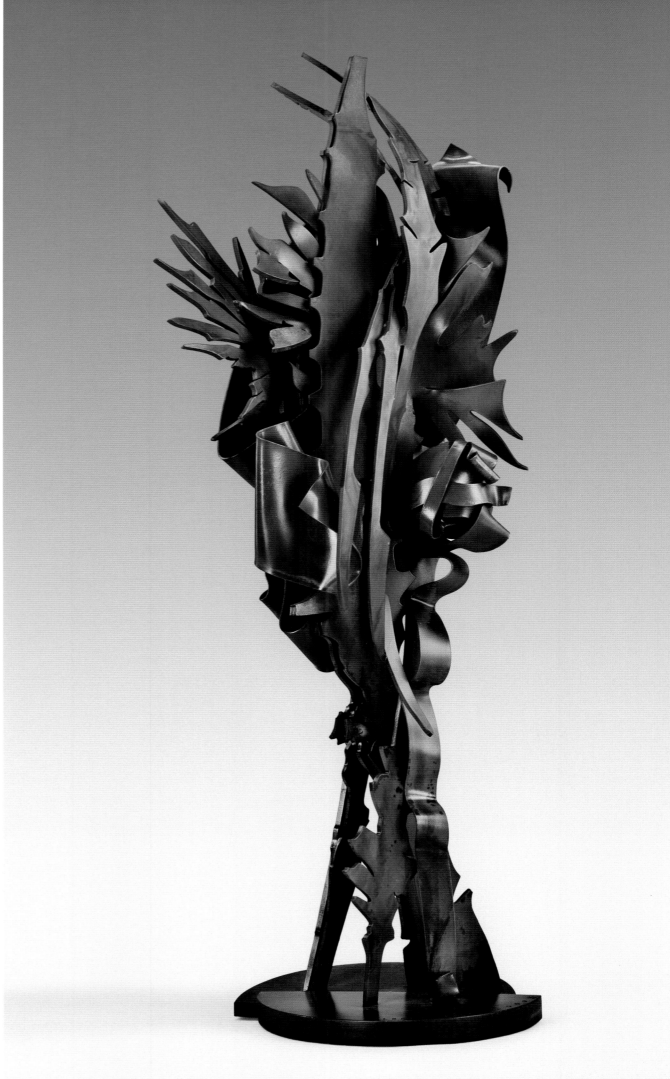

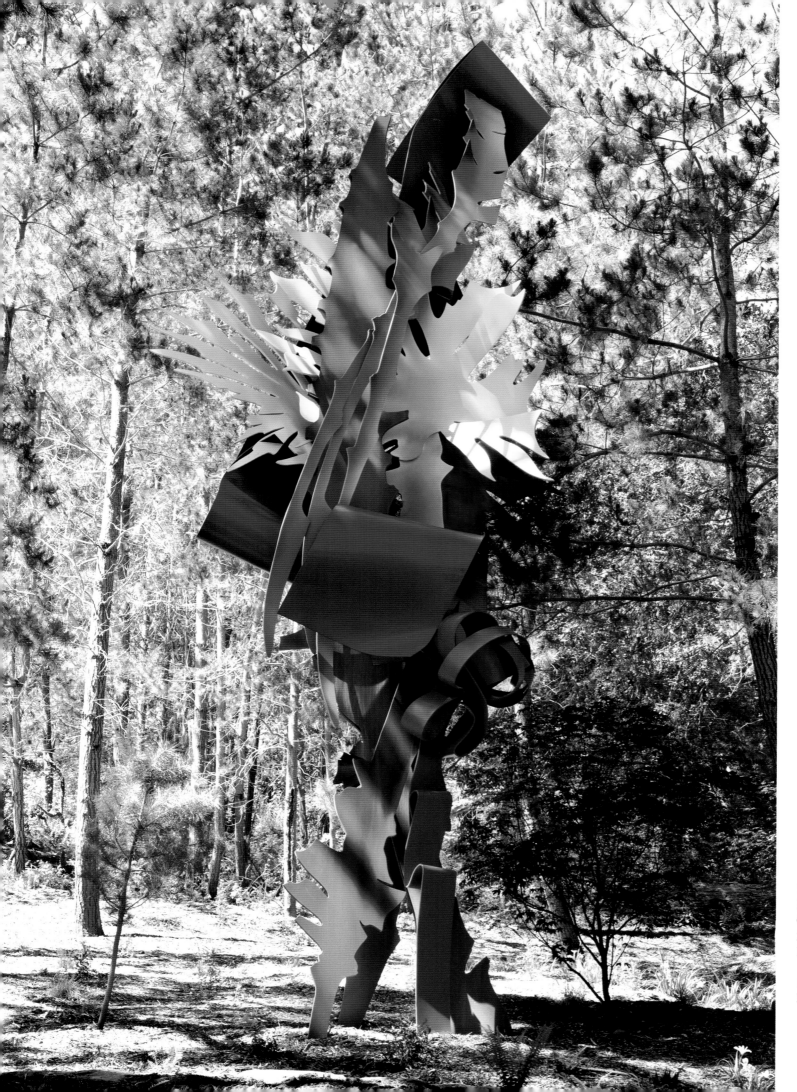

A sculpture entitled Sylvan was a private commission to be placed amidst a grove of trees adjacent to a private residence. The scale and proportion of the work was created with reference to the landscape plan.

103. *Sylvan*, 2009
Formed, Fabricated and Polychromed
Cor-ten Steel
28'6"x 10' x 6'6"
Private Collection, Carmel, California

104 - 107 *Sylvan*, 2009
Details

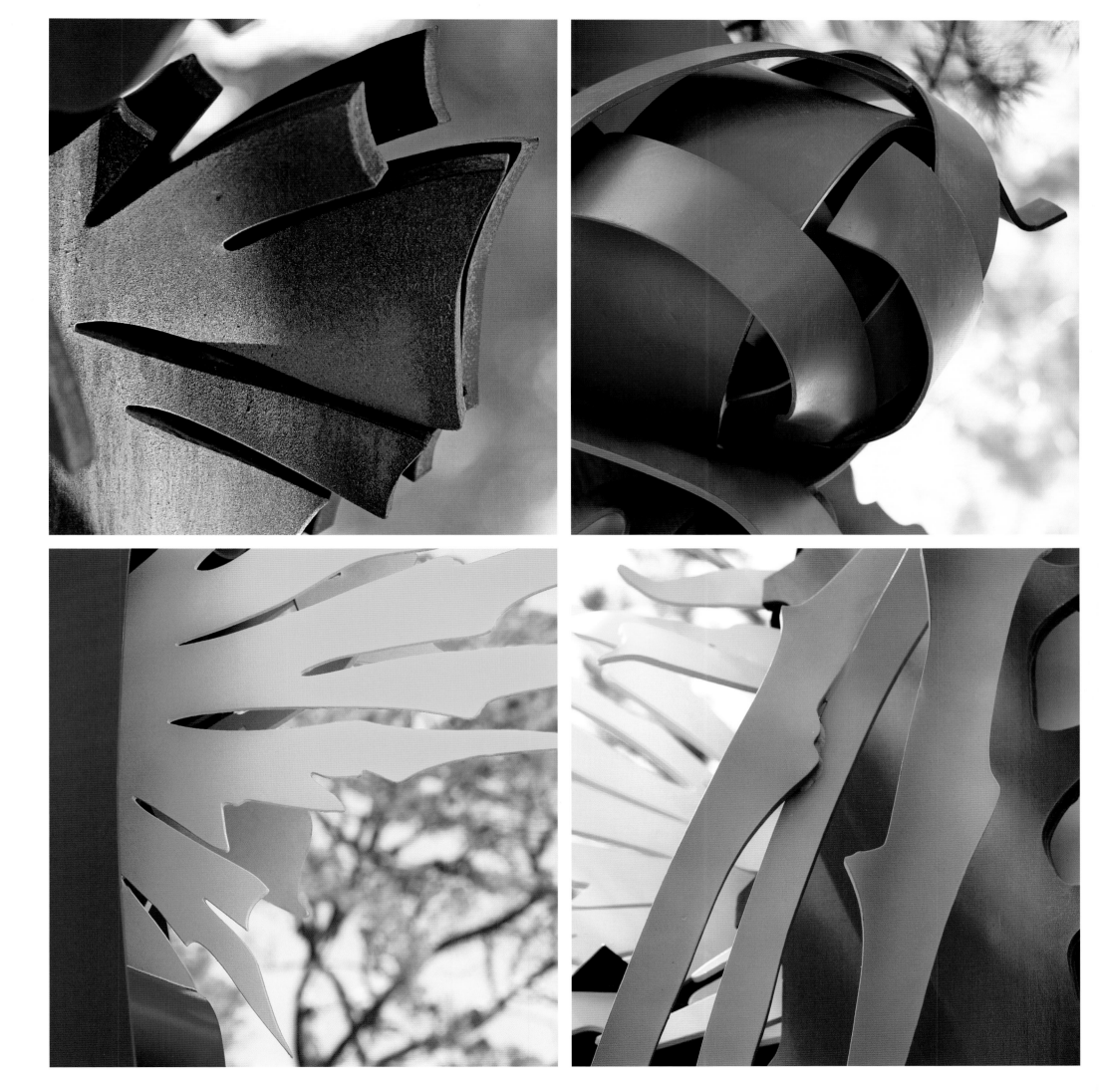

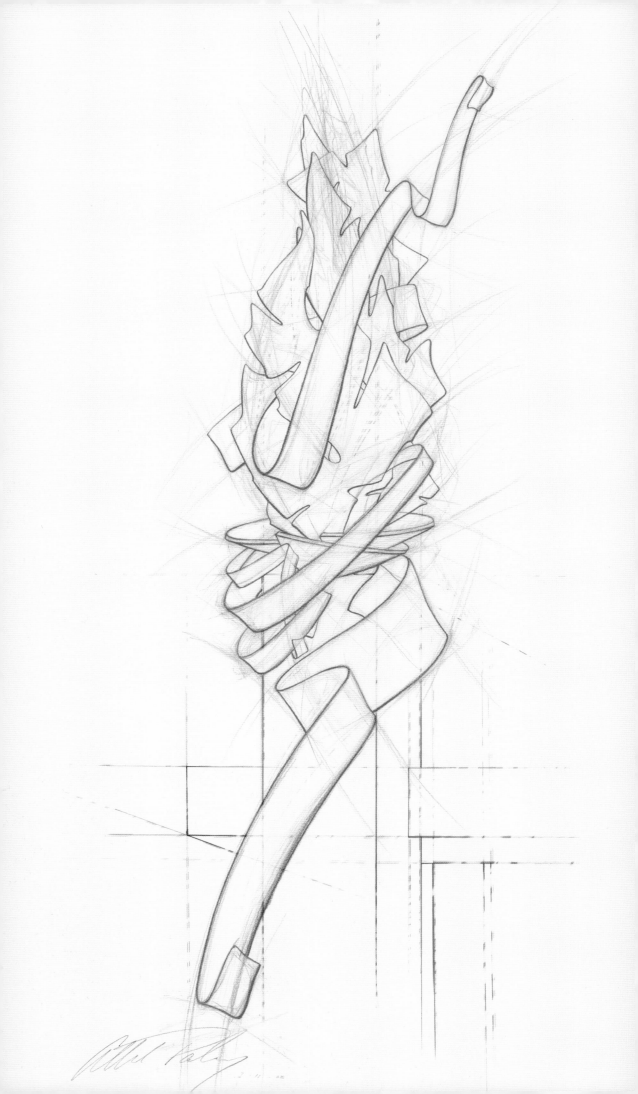

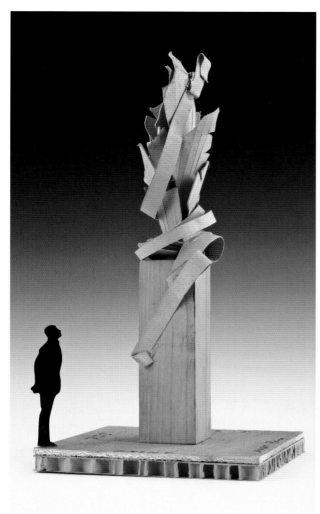

Commissioned by the Jewish Community Center in Cincinnati, Ohio, is a sculpture entitled The Light. A fabricated stainless steel piece engages both the building and the landscape design, bringing focus to the main entrance of the complex.

108. *Jewish Community Center Proposal*, 2007
Proposal Drawing
Red Pencil on Paper
36" x 24"
Studio Archive

109. *Jewish Community Center Model*, 2008
Developmental Model
Cardboard
1'2" x 6" x 6"
Studio Archive

110. *The Light*, 2008
In-situ at Main Entrance Plaza
Mayerson JCC, Cincinnati, Ohio

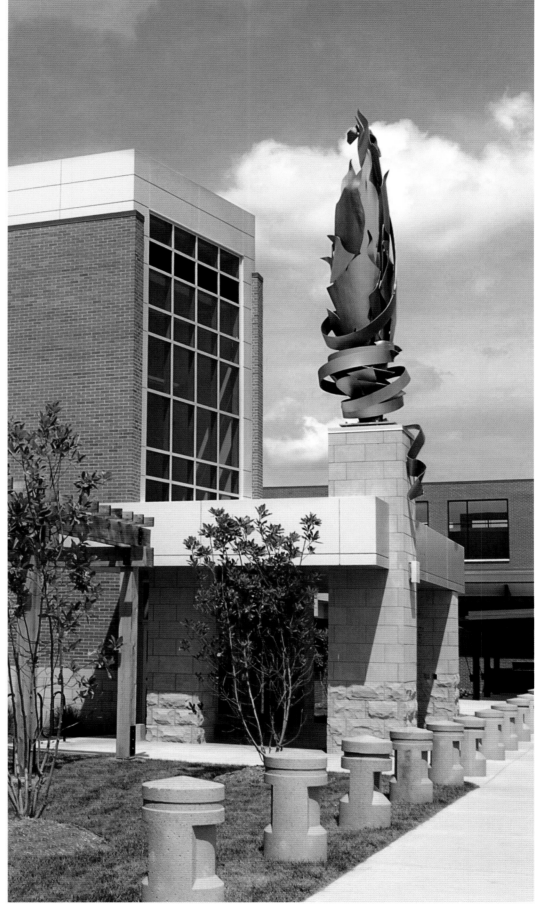

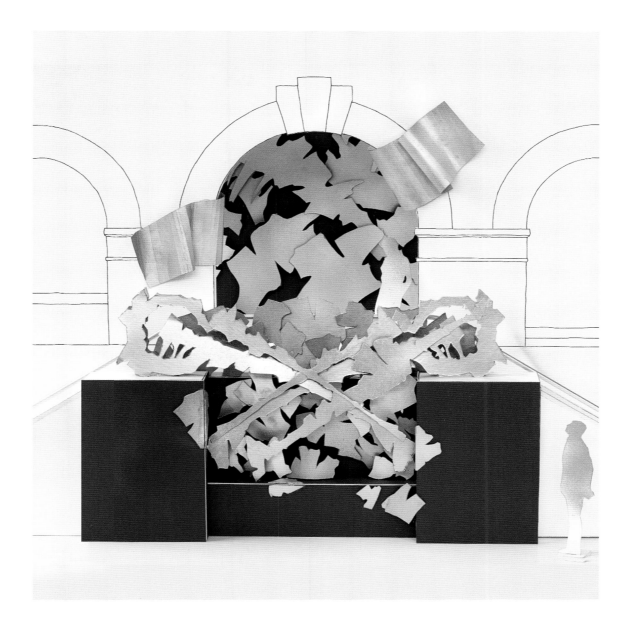

111. *Transformation*, 2005
Proposal Drawing
Graphite and Red Pencil on Paper
40" x 30"
Studio Archive

112. *Transformation*, 2005
Presentation Model for Entrance Sculpture
Cardboard, Foam Core, Plywood, Pen and Paint
2' x 4' x 2'
University Museums, Iowa State
University, Ames, Iowa

Images on pages 90-93
113. *Transformation*, 2007
Paley, Fabrication of Laser Cut,
Formed and Welded Stainless Steel
North Washington Street Studio
Rochester, New York

114. *Transformation*, 2007
Wall Relief Detail

115-116. *Transformation*, 2007
Formed and Fabricated Stainless Steel
12' x 16'6" x 2'6"
Morrill Hall, Iowa State University,
Ames, Iowa

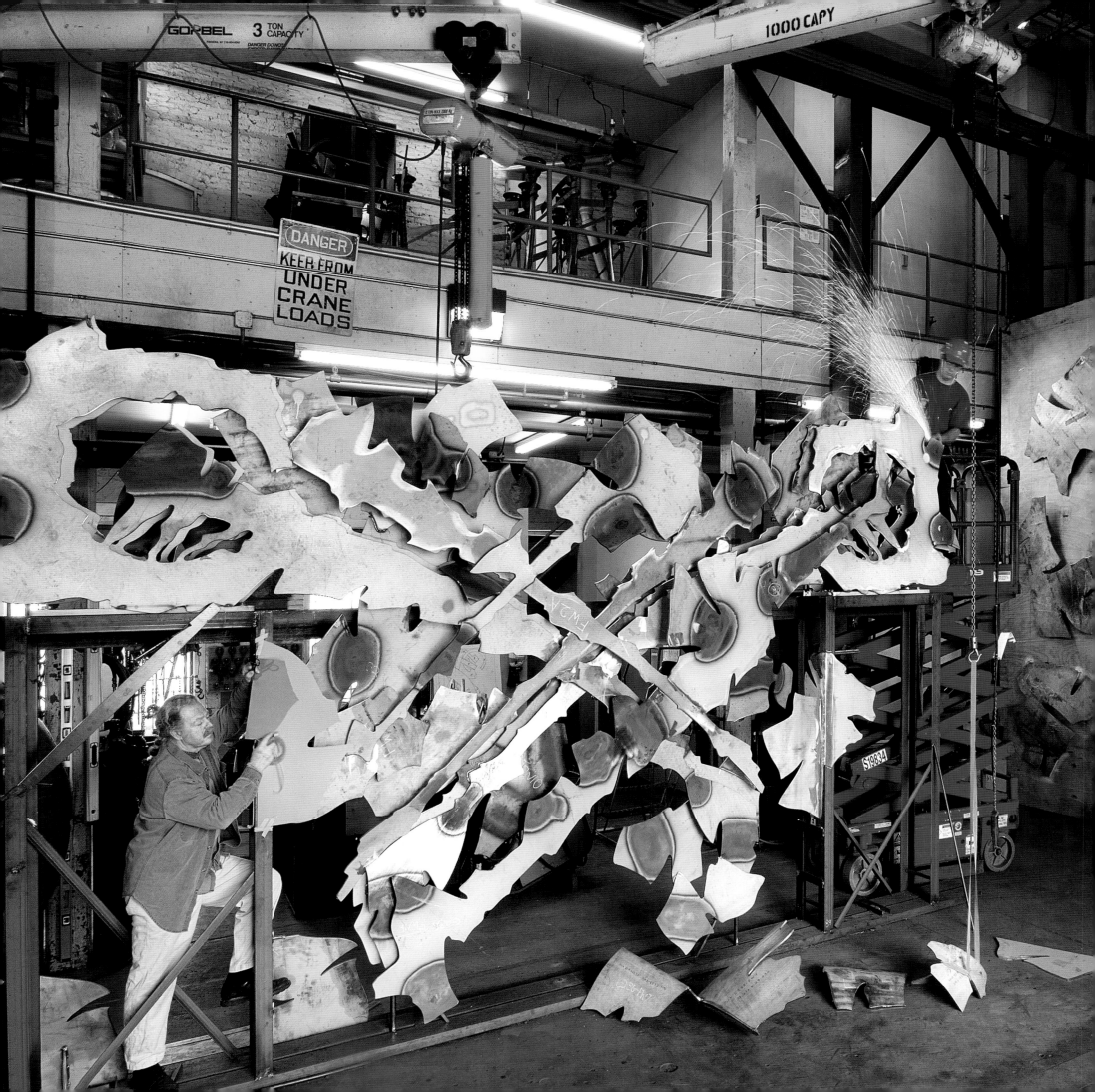

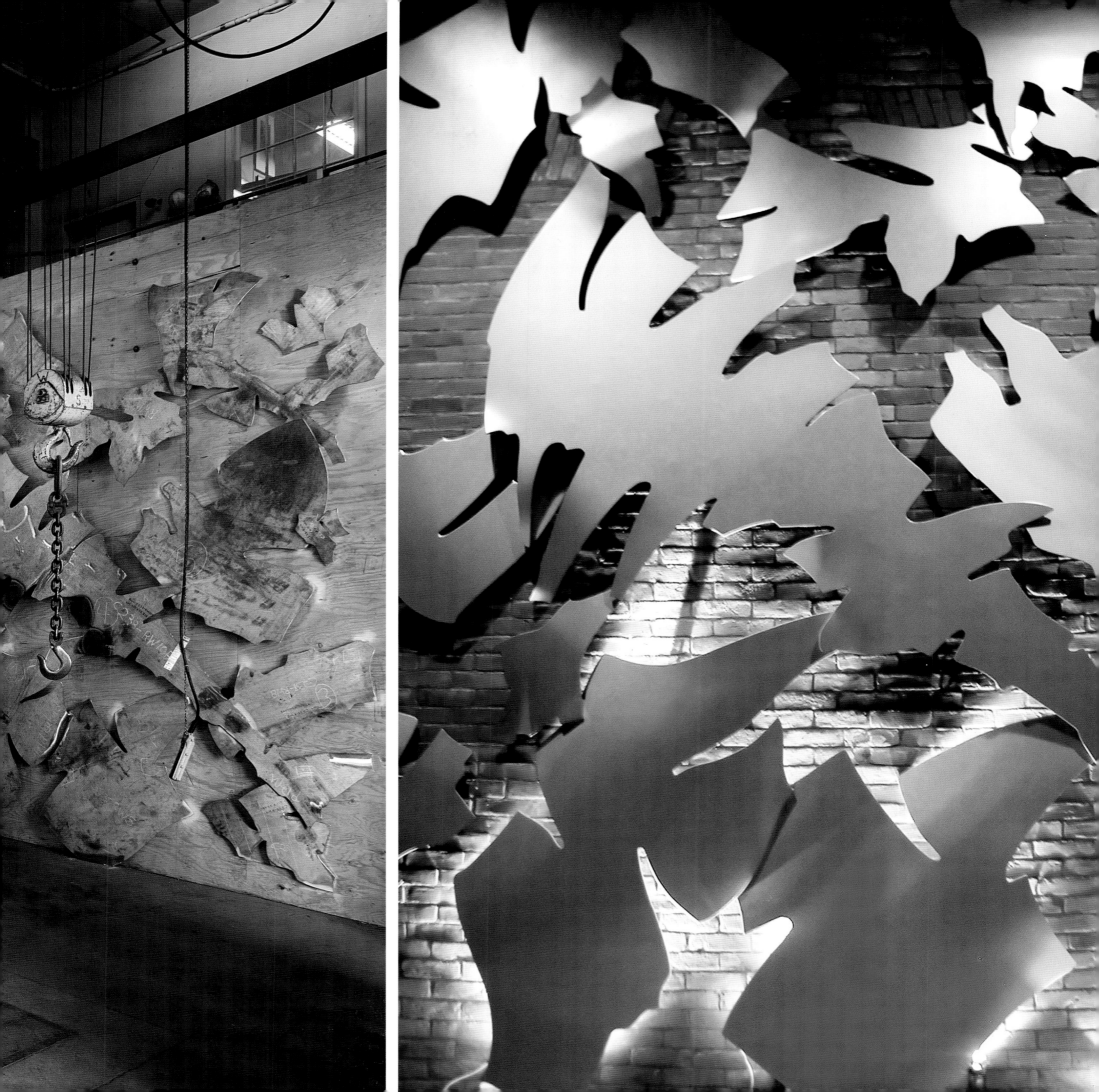

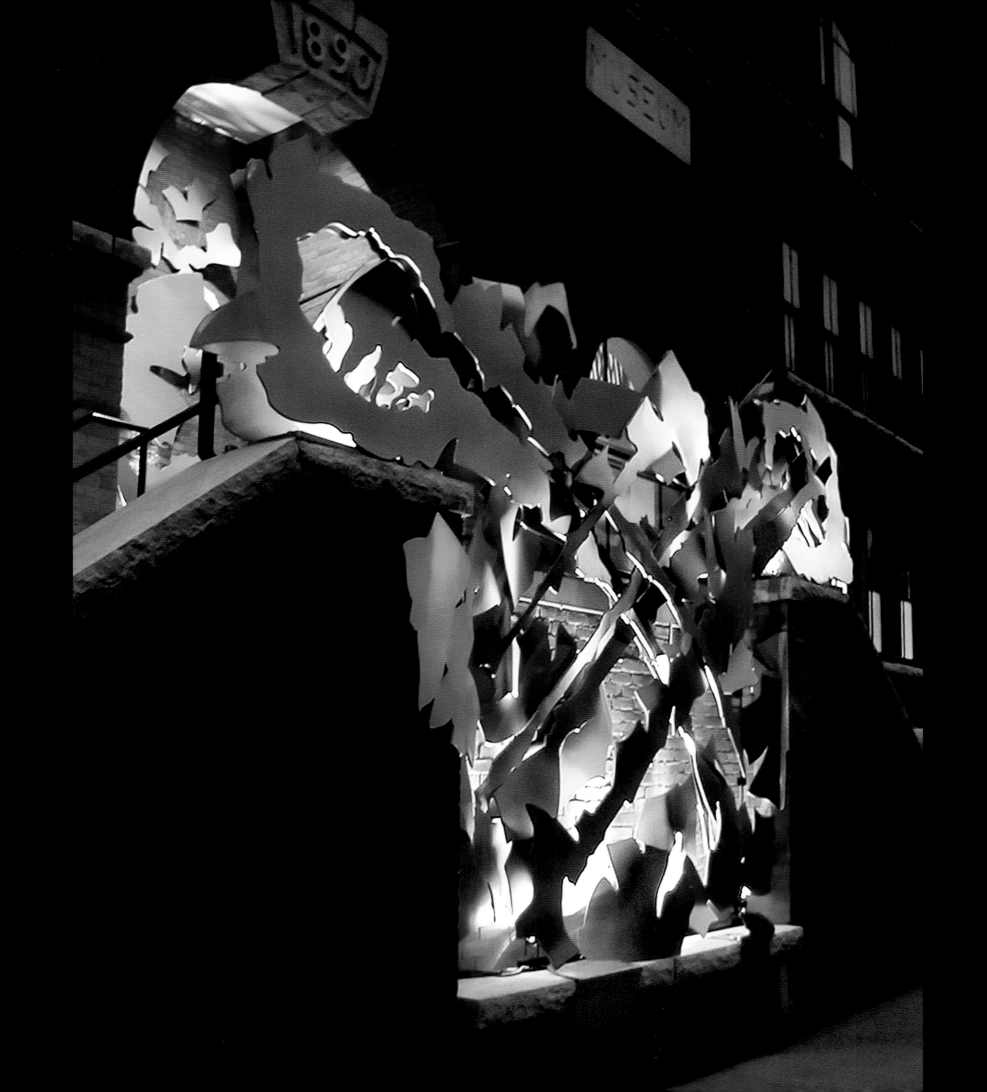

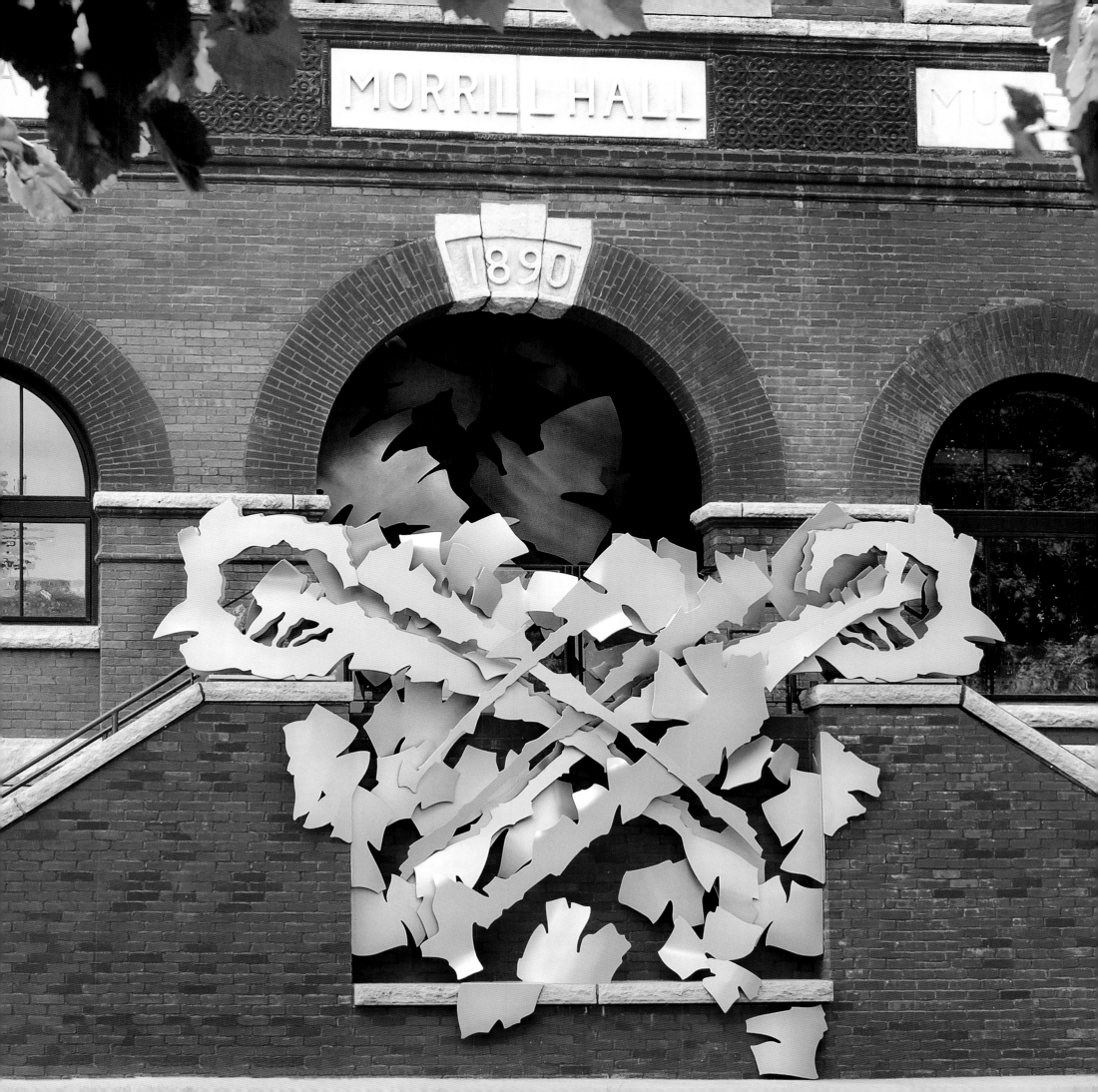

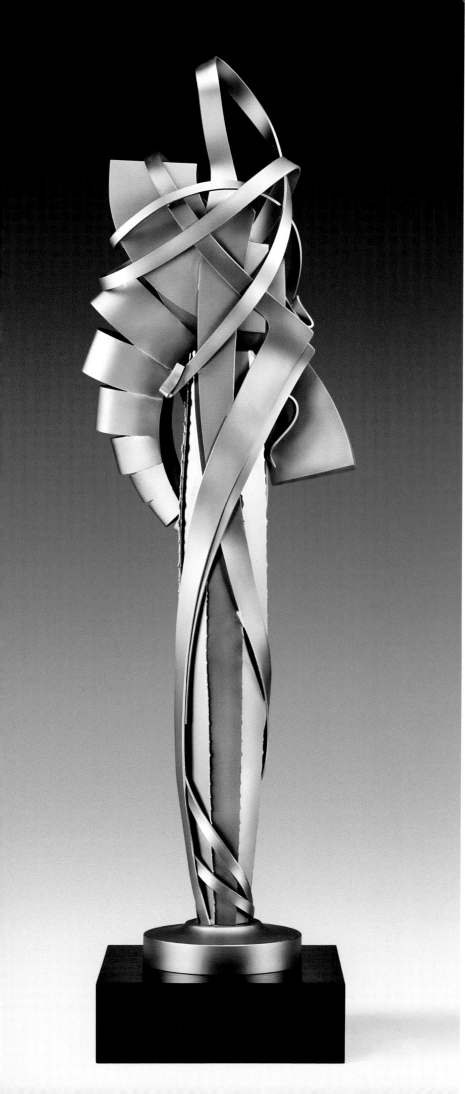

A sculpture entitled Zenith was commissioned for the newly renovated Trenton rail station. In addition to its prominence in the landscape plan it is also the central core for a large pedestrian plaza adjacent to the station.

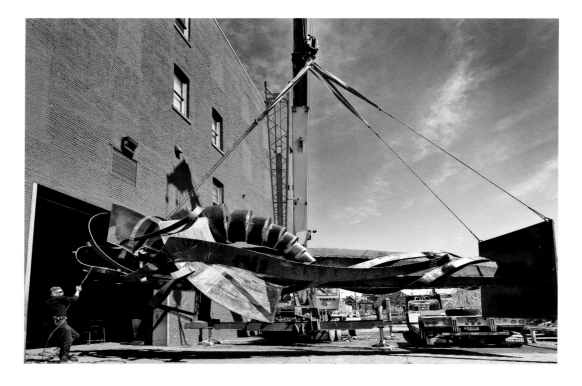

117. *Zenith Maquette (Spiral)*, 2008
Formed and Fabricated
Stainless Steel
6'6" x 1'6"x '6"

118. *Zenith*, 2008
Transportation
North Washington Street Studio
Rochester, New York

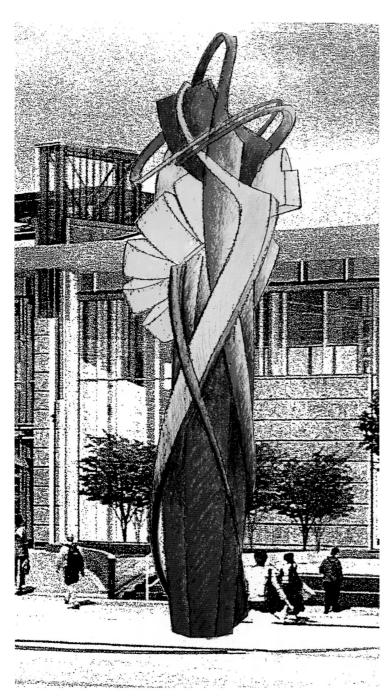

119. *Zenith*, 2007
Color Rendering
Colored Pencil on Photocopy
Studio Archive

120. *Zenith*, 2008
Formed, Fabricated and Polychromed
Mild Steel
33'3" x 9'3" x 8'
Trenton Transit Center, Trenton,
New Jersey

Image on pages 96-97
121. *Zenith*, 2008
Fabrication
North Washington Street Studio
Rochester, New York

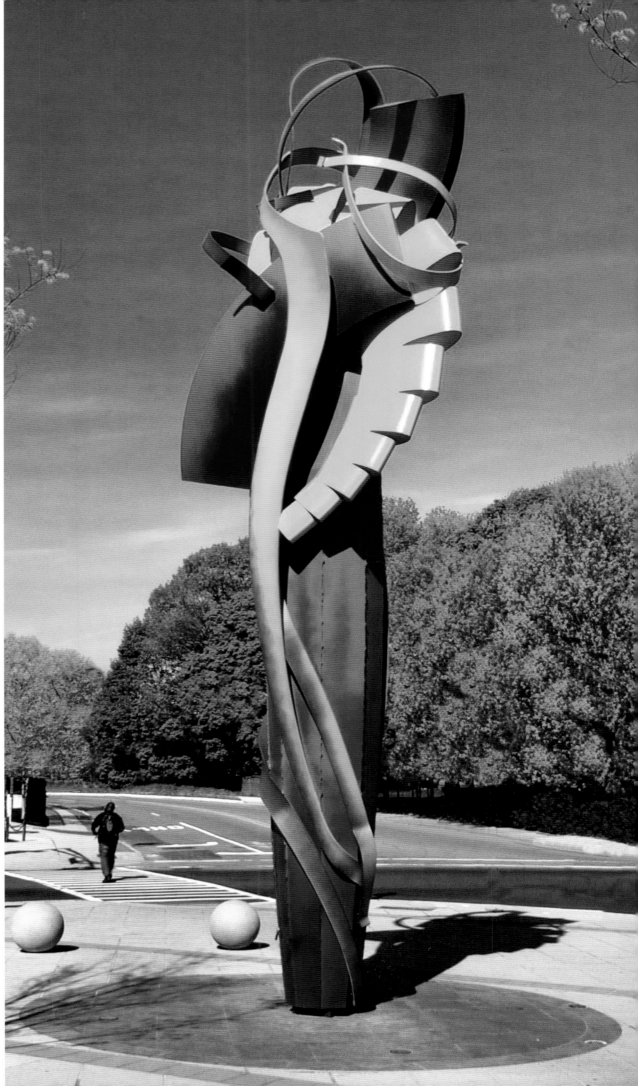

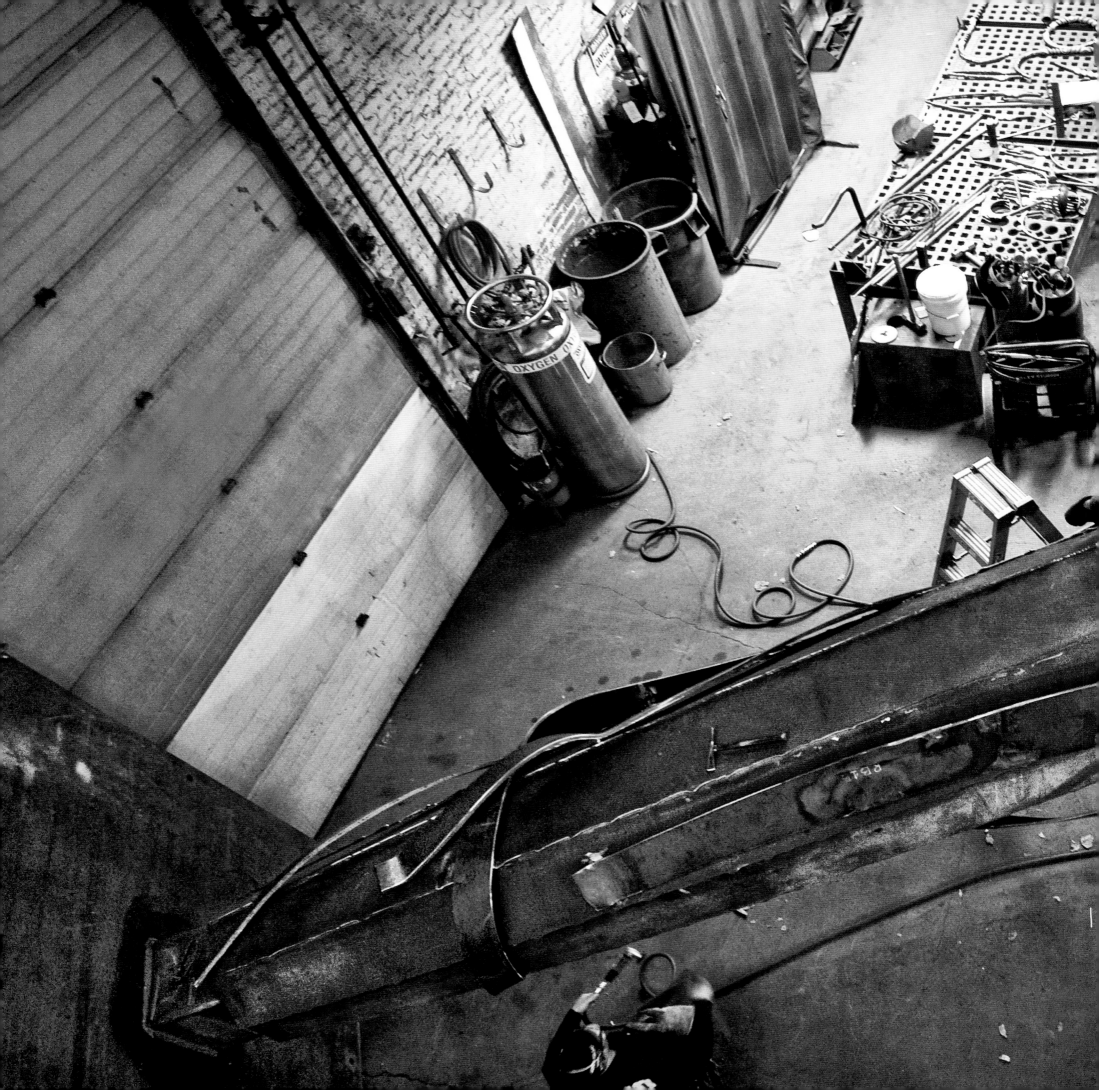

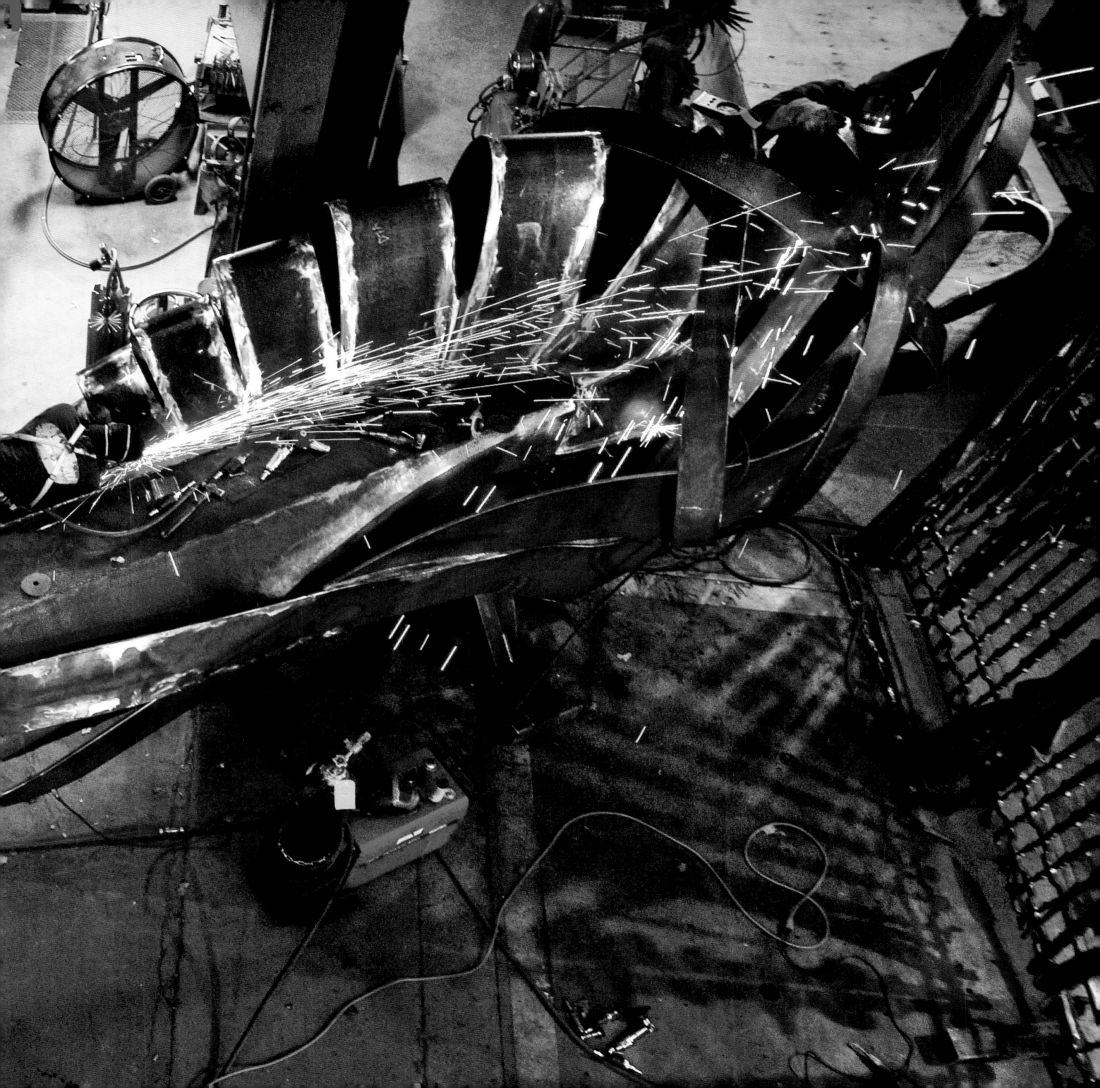

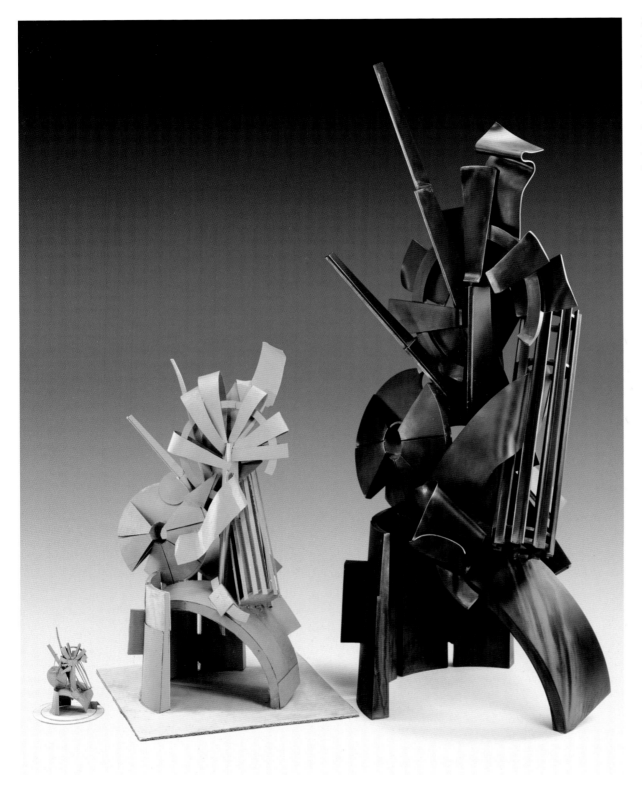

Sentinel, a sculpture commissioned by the Rochester Institute of Technology in Rochester, New York, is positioned in a newly developed pedestrian plaza. Over the years, this educational institution has grown considerably. The development of this pedestrian plaza was seen to establish the symbolic core of the architectural plan. The symbolism of the sculpture helps reflect the relationship between the arts and the sciences and aids in defining the cultural profile of this educational institution. Opened at the base, the sculpture has become a gathering place and ceremonial arena.

122. *Sentinel*, 2001
Developmental Models
Cardboard to Steel
6" - 36" tall
North Washington Street Studio
Rochester, New York

123. *Sentinel*, 2001
Presentation Model
Formed and Fabricated Cor-ten and
Stainless Steels with Bronze
4'3" x 2'6"
Rochester Institute of Technology,
Rochester, New York

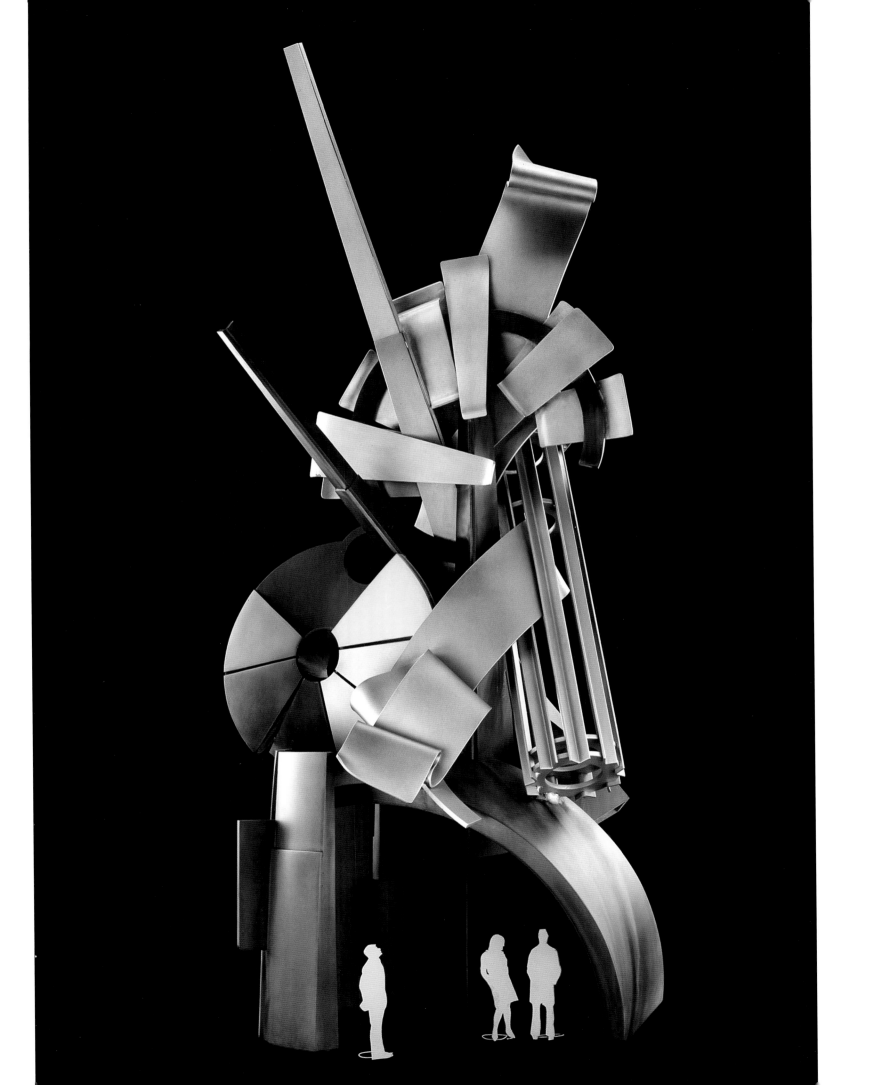

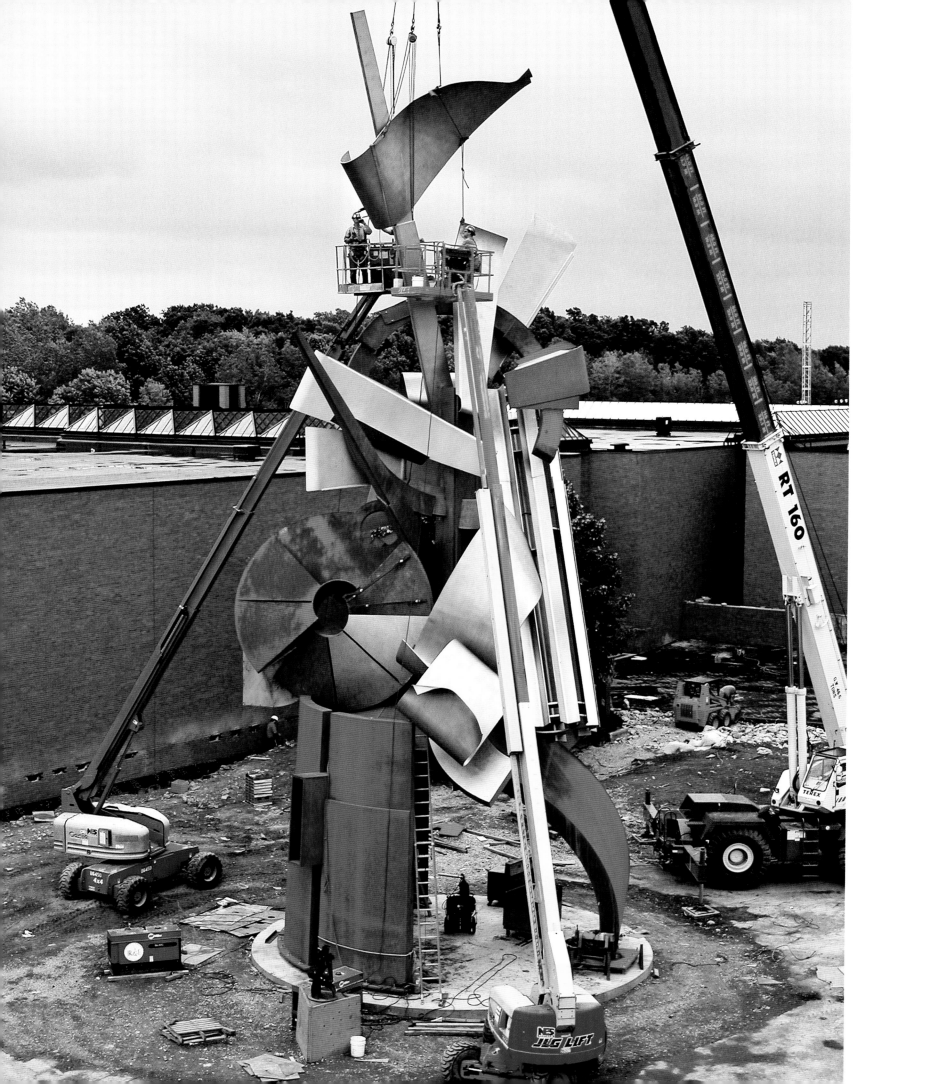

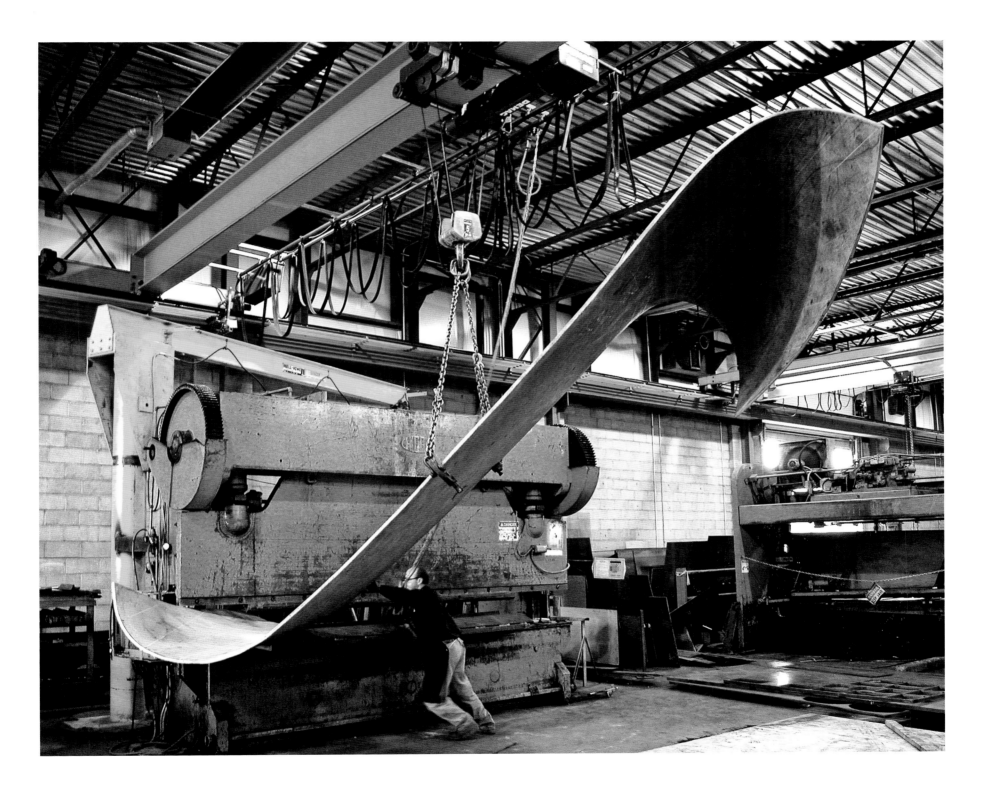

124. *Sentinel*, 2003
Paley, Installation
Rochester Institute of Technology Campus
Rochester, New York

125. *Sentinel*, 2003
Paley, Forming of Stainless Steel Plate
Steel Work, Inc.
Rochester, New York

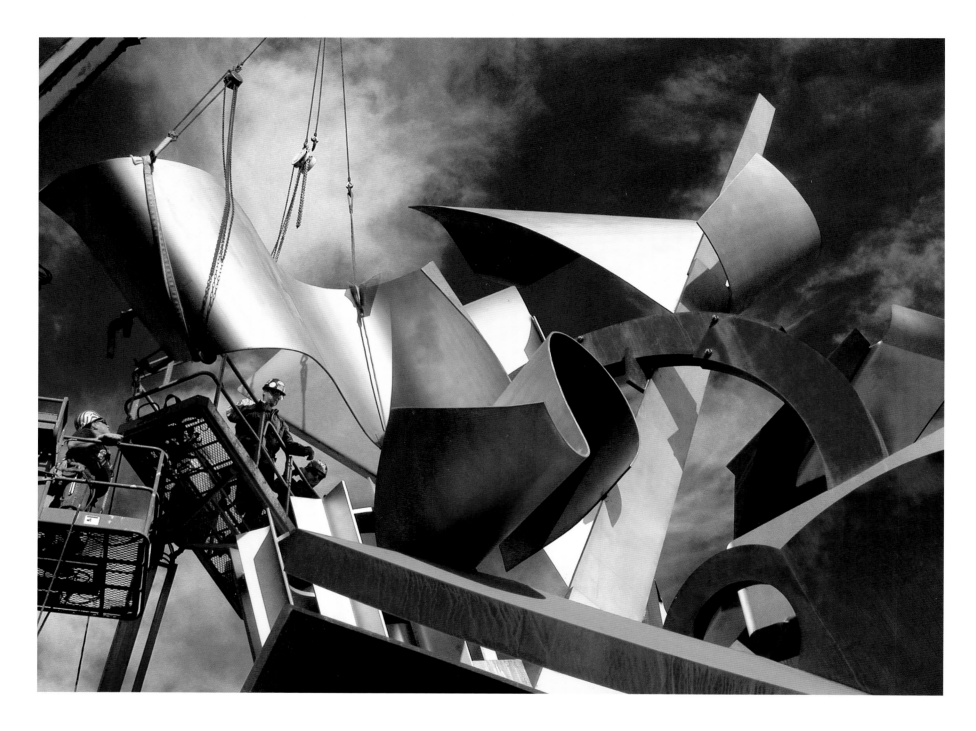

126. *Sentinel*, 2003
Paley, Installation
Rochester Institute of Technology
Campus
Rochester, New York

127. *Sentinel*, 2003
Formed and Fabricated Cor-ten,
Stainless Steel and Bronze
73' tall
Rochester Institute of Technology,
Rochester, New York

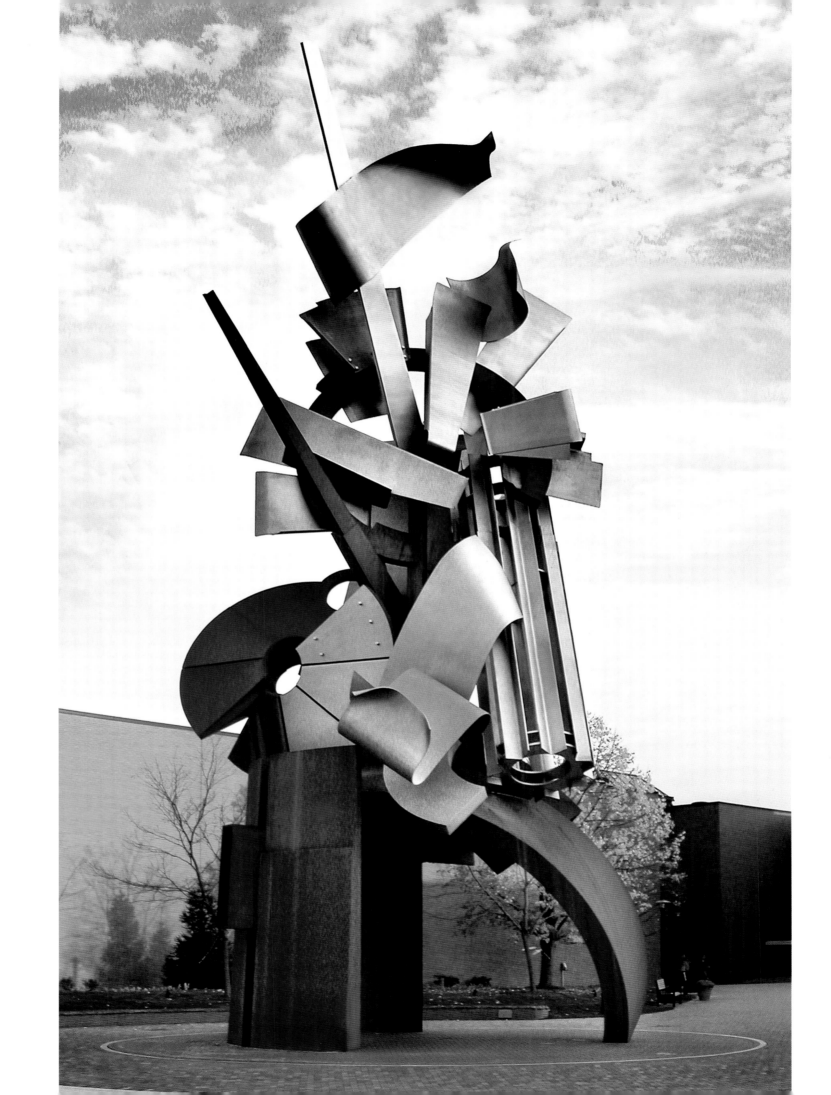

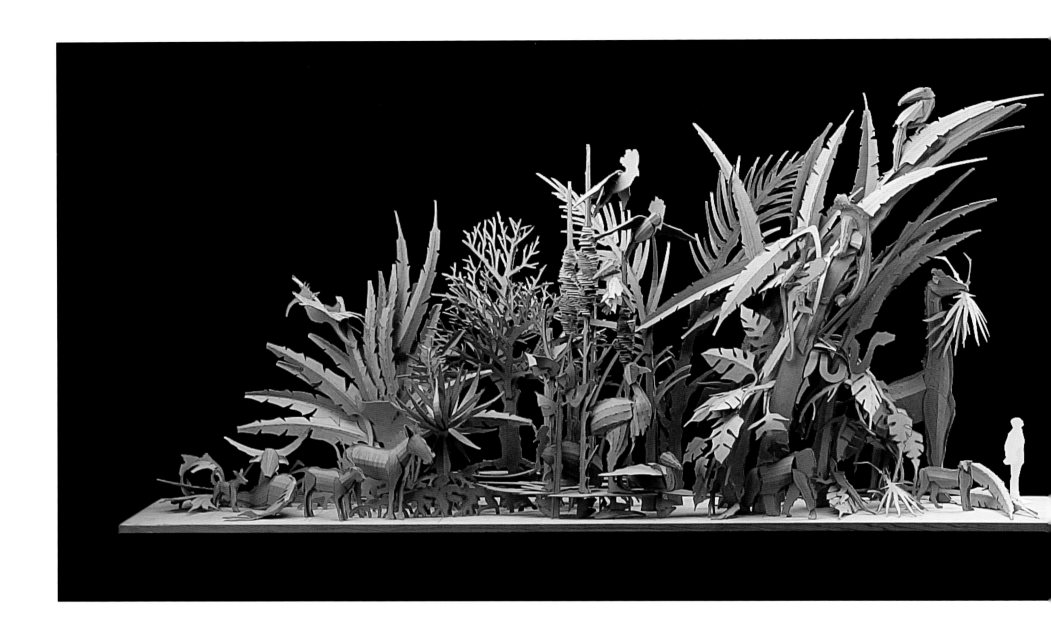

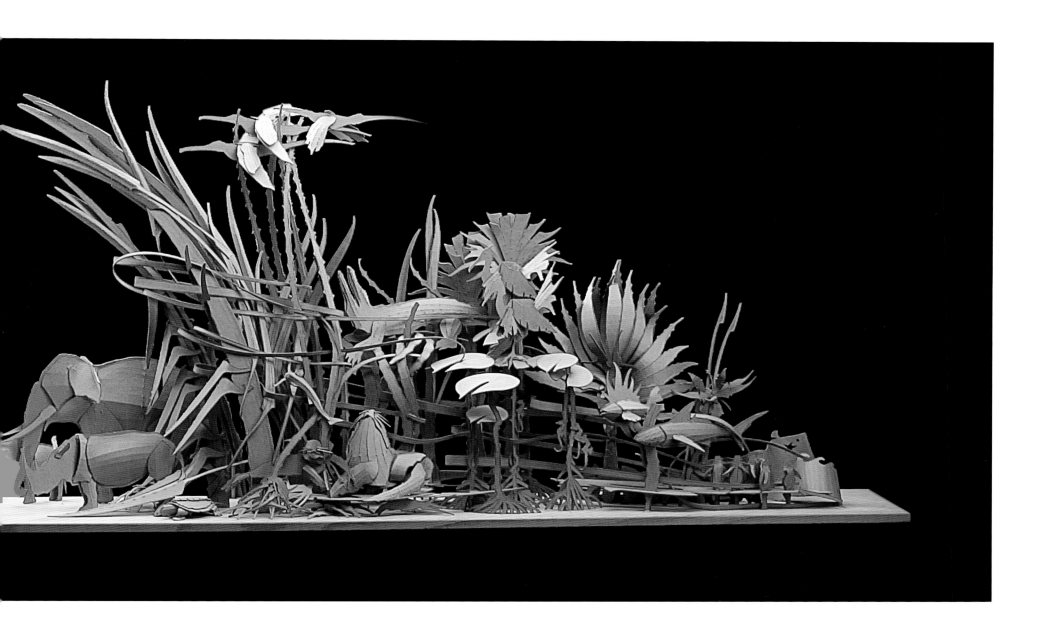

Animals Always, a commission of a ceremonial archway for the St. Louis Zoo, had its genesis in an unrealized project dating back to 1983. The St. Louis project embraced a three and a half year design phase prior to fabrication. This was Paley's first venture into figurative imagery. Although figurative, the stylization of the images has reference to the gestural, abstract and organic quality of his forged work and drawings. The sculpture defines a pedestrian plaza allowing people to pass through and experience the various animals and their related environments.

128-130. *Zoo Gate Sketches*, 1984
Conceptual Drawings
Ink on Tracing Paper
14" x 16.75"
Studio Archive

131. *Ceremonial Archway Zoo*, 2004
Presentation Model
Cardboard, Red Pencil and Wood
2'6" x 10' x 1'
Studio Archive

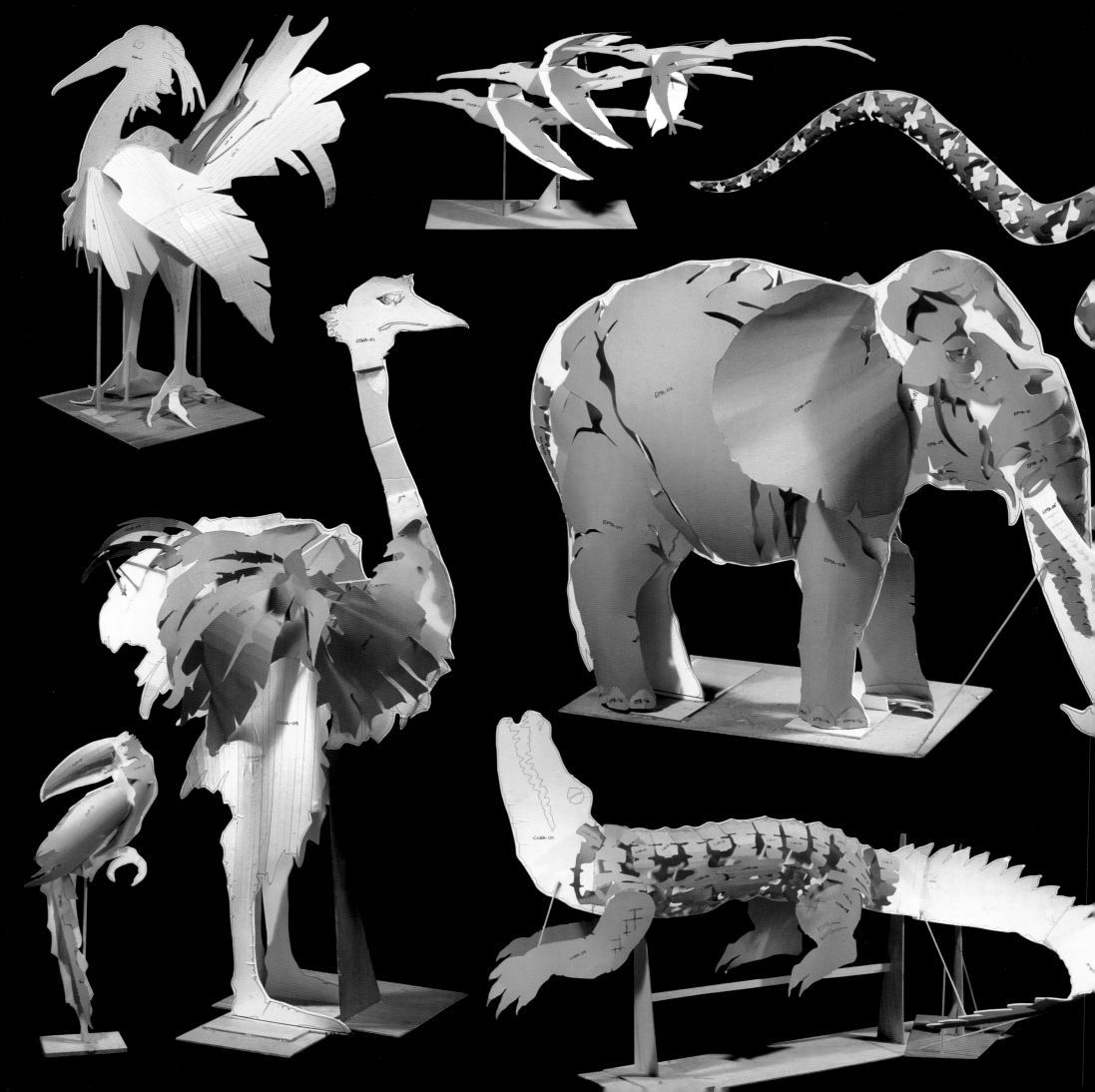

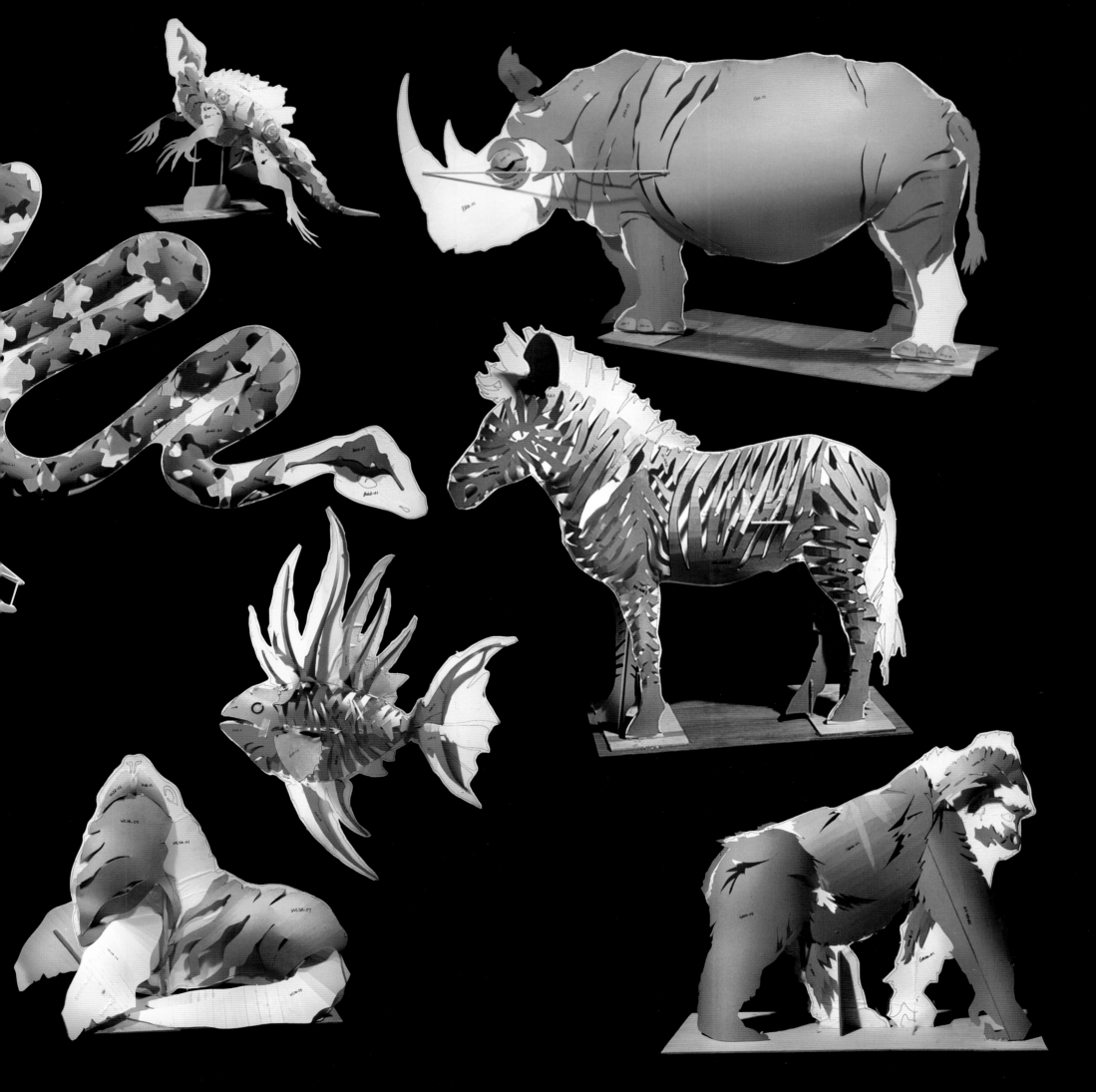

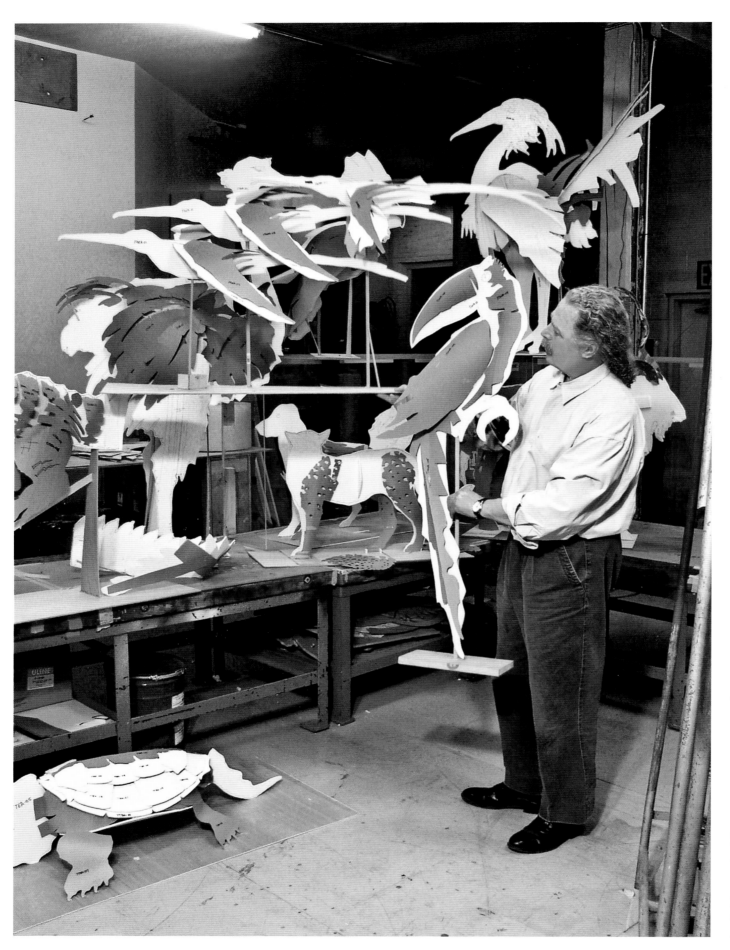

Image on pages 106-107
132. *Animals*, 2005
Cardboard, Styrofoam and Wood
Models
Sizes Range From 1' to 8'
Models allow for pattern development,
which in turn allows for cutting of
Steel plates for fabrication

133. Paley, Design and Pattern
Development
North Washington Street Studio
Rochester, New York

134. *Animals Always*, 2006
Paley, Fabrication of Elephants
General Welding
Attica, New York

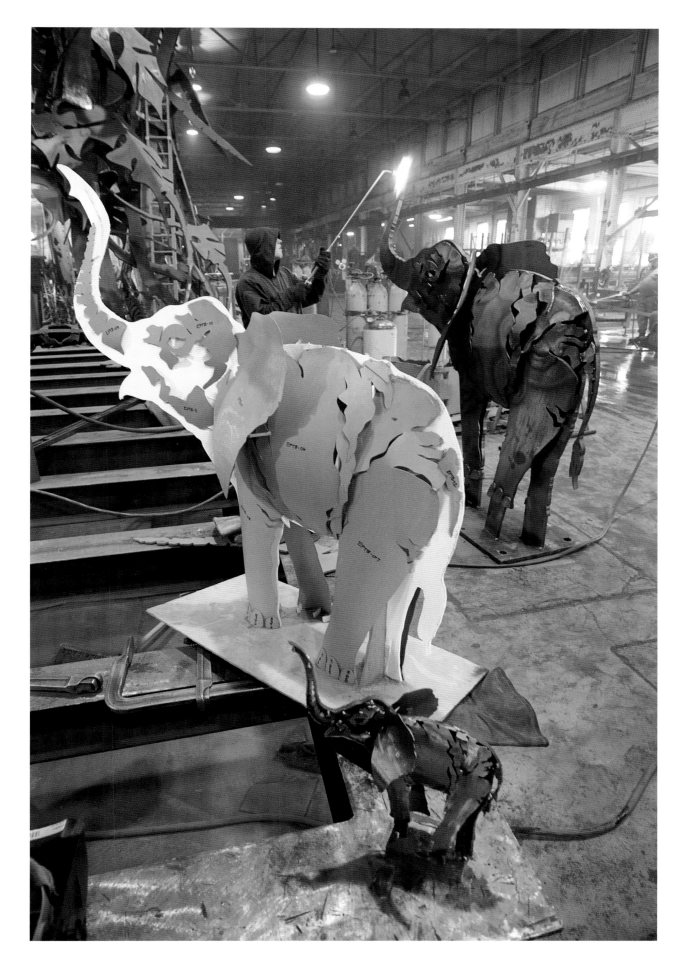

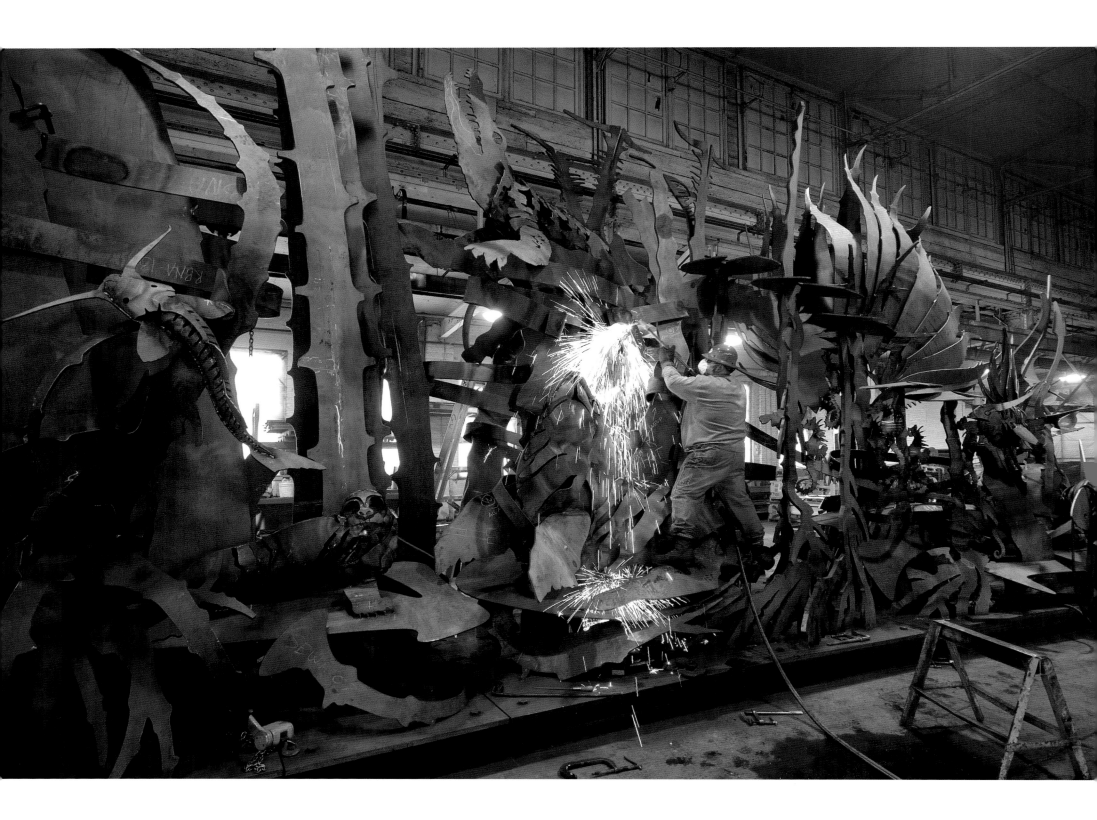

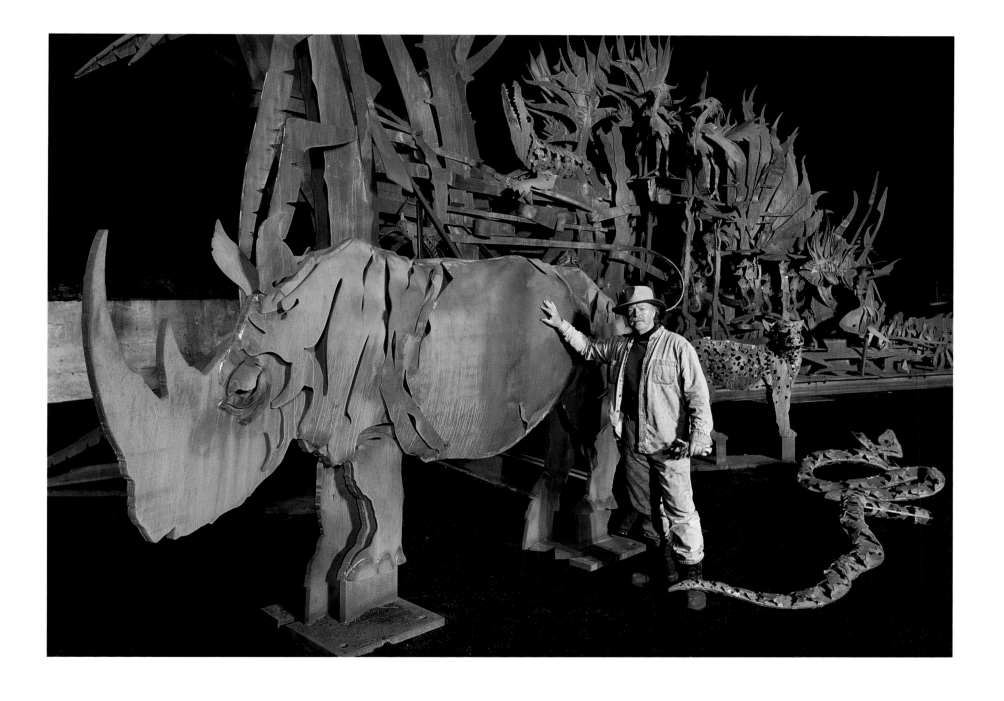

135. *Animals Always*, 2006
Ceremonial Archway
Paley, Fabrication
General Welding
Attica, New York

136. *Animals Always*, 2006
Paley, Fabrication of Rhino
General Welding
Attica, New York

Image on pages 112-113
137. *Animals Always*, 2006
Forged, Formed and Fabricated Cor-ten Steel
36' x 130' x 8'
St. Louis Zoo, St. Louis, Missouri

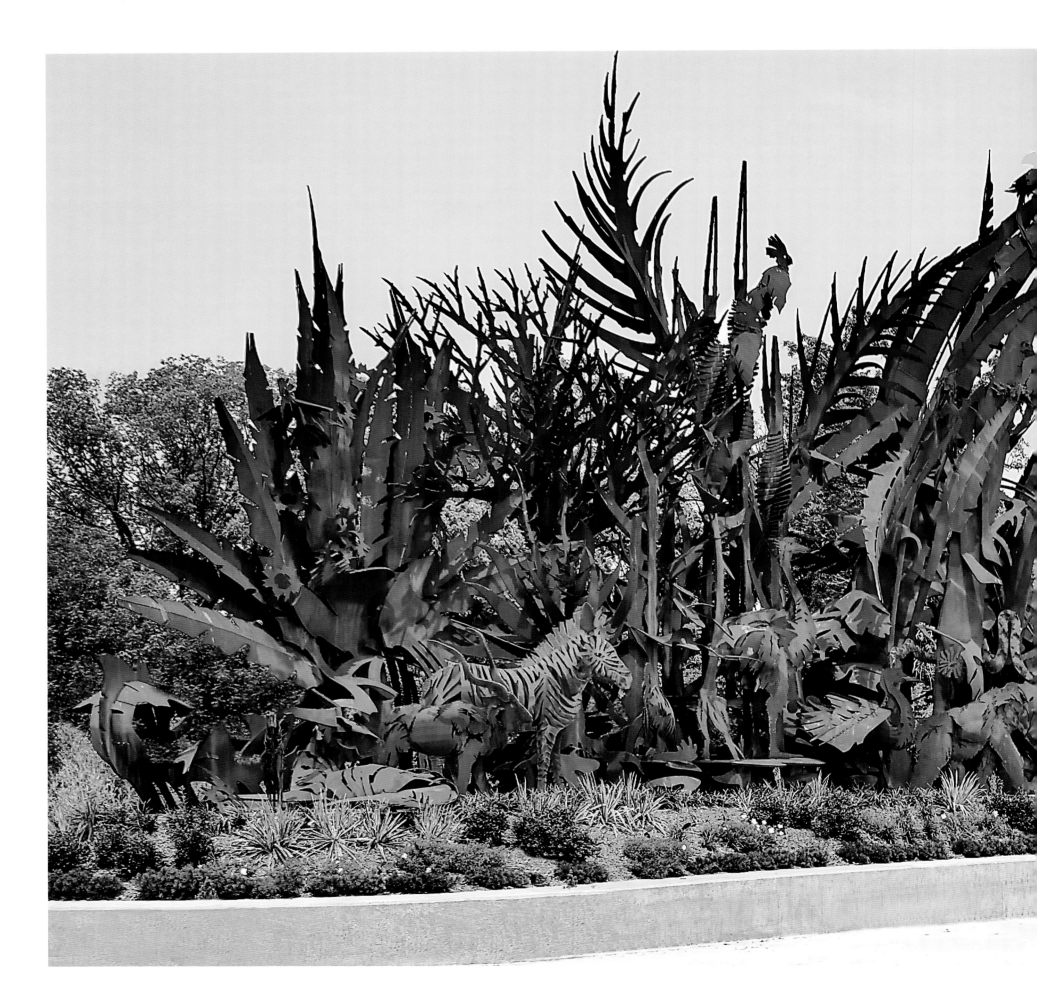

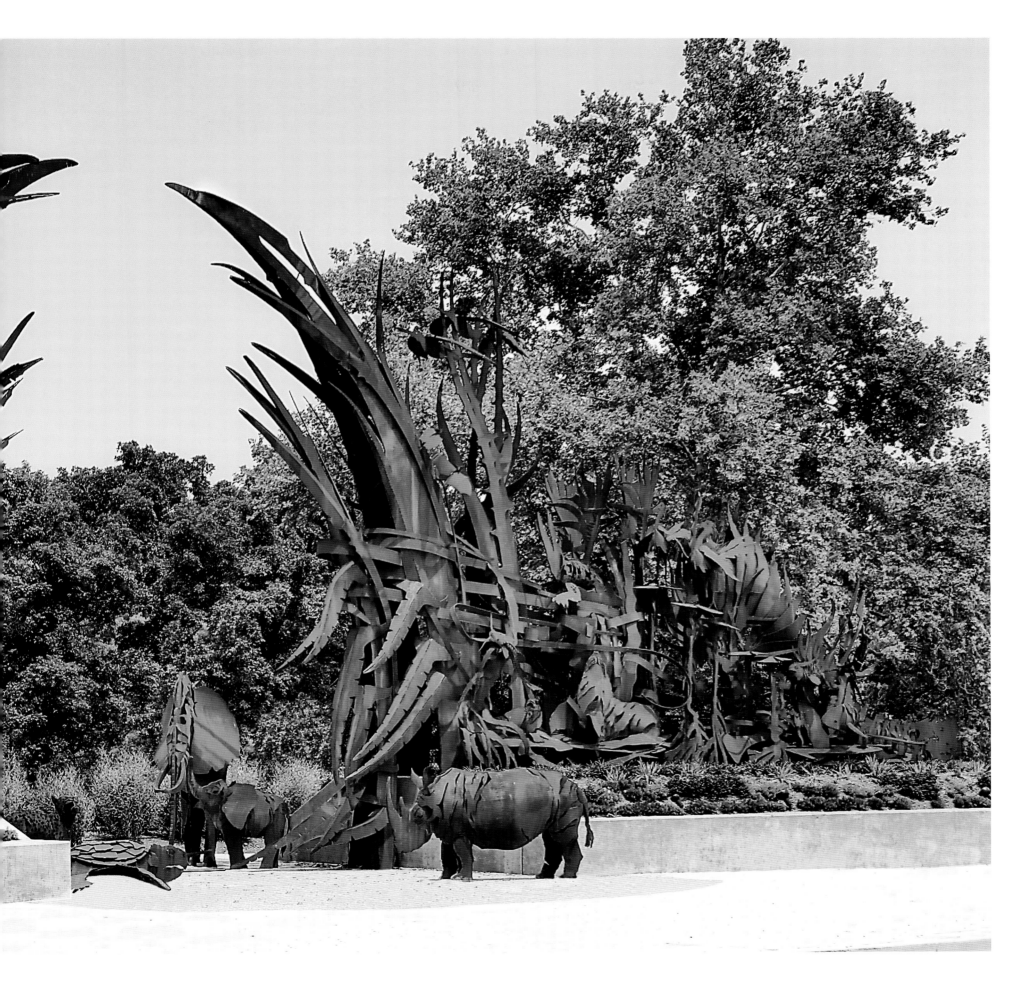

Based on the design development process for the Zoo a series of independent animal sculptures were created. As with the Zoo each sculpture is a vignette placing the animal within its associated environment. These works were improvisational. There were no drawings or models developed. They were solely based on the experience of the Zoo project.

138. *Giraffe*, 2006
Photo Documentation, Bruce Miller
North Washington Street Studio
Bruce Miller Photography
Rochester, New York

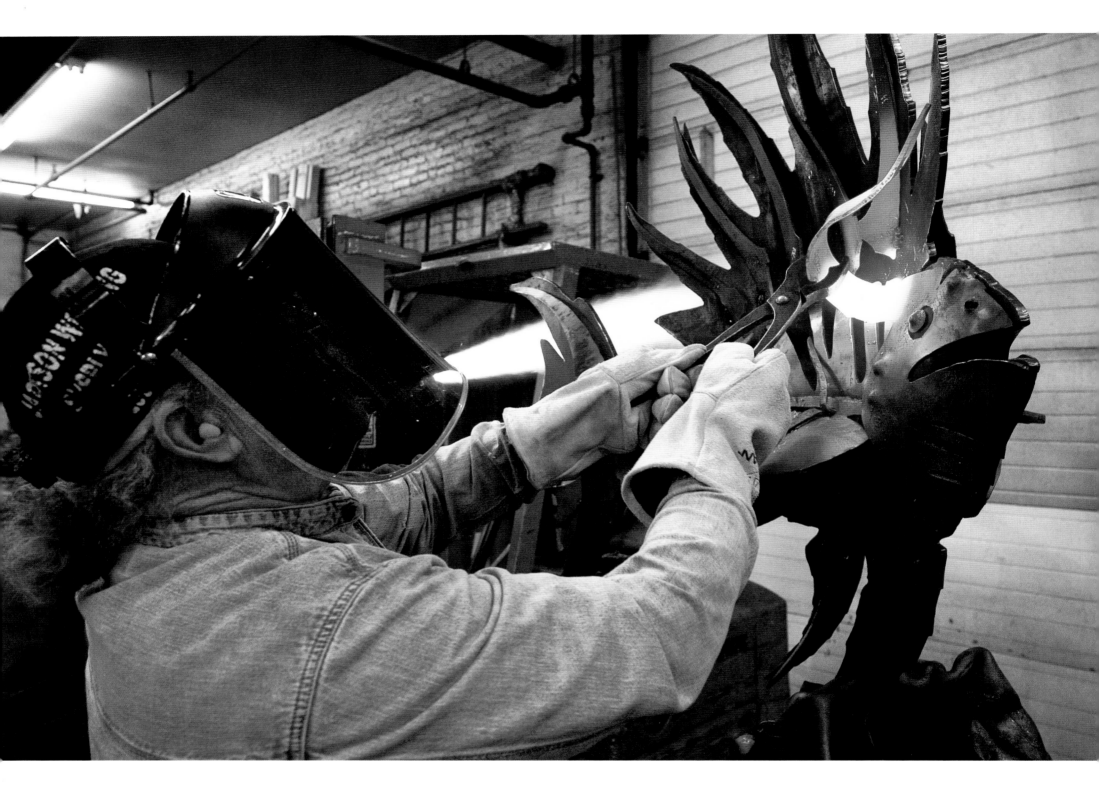

139. *Dragonfish*, 2006
Paley, Heat Forming
North Washington Street Studio
Rochester, New York

140. *Shark with Angel Fish*, 2006
Paley, Welding
North Washington Street Studio
Rochester, New York

Images on pages 118-119
141. *Ostrich*, 2006
Formed, Fabricated and Patinaed Mild
Steel with Wood Base
4'3" x 2'6" x 2'

142. *Giraffe*, 2006
Formed, Fabricated and Patinaed Mild
Steel with Wood Base
7'9" x 4'6" x 2'

Images on pages 120-121
143. *Egrets Pair*, 2006
Formed, Fabricated and Patinaed Mild
Steel with Wood Base
3'6" x 2'9" x 2'6"

144. *Dragonfish*, 2006
Formed, Fabricated and Patinaed Mild
Steel with Wood Base
5'3" x 2' x 2'3"

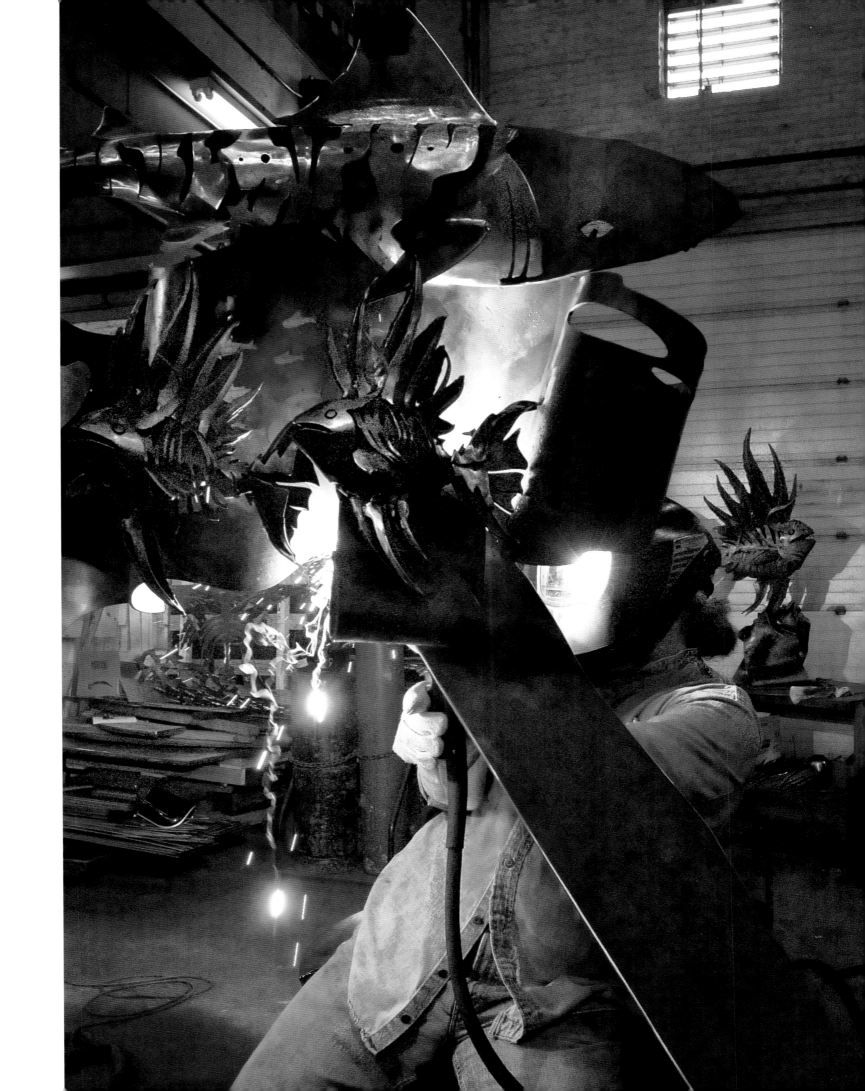

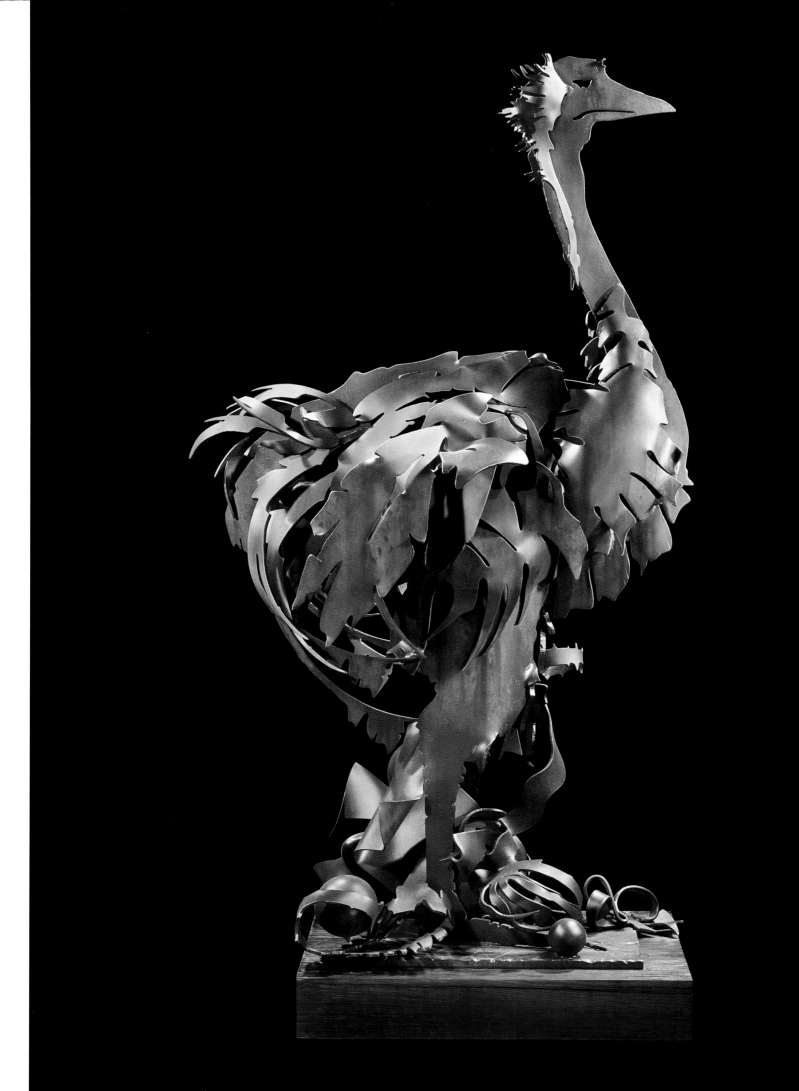

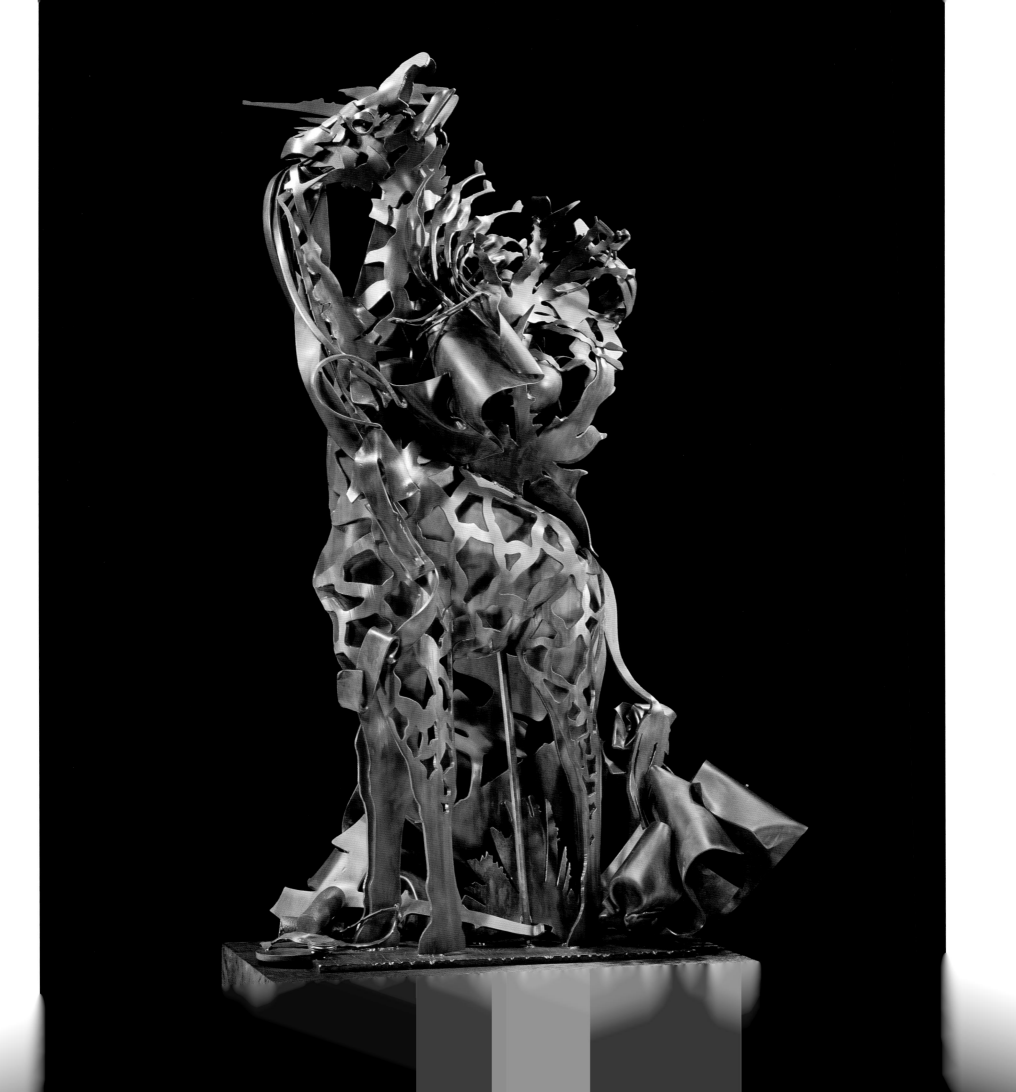

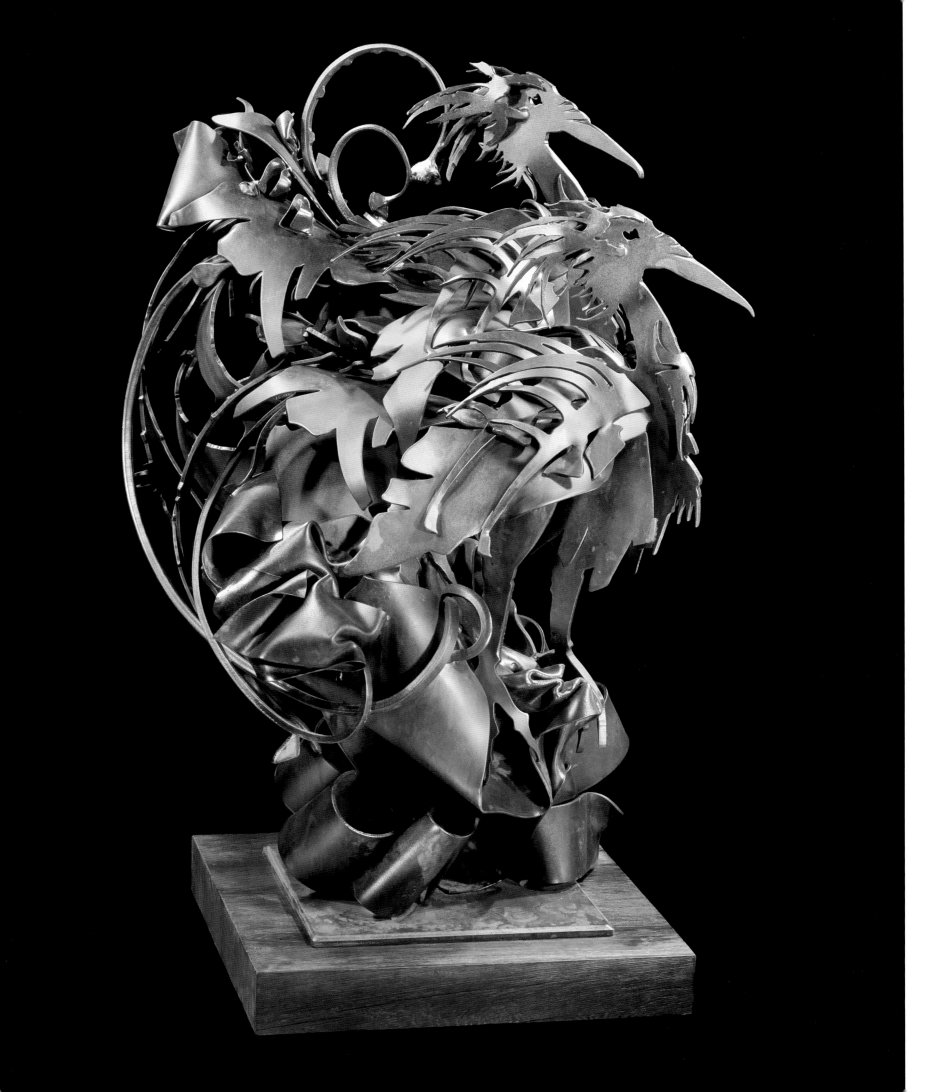

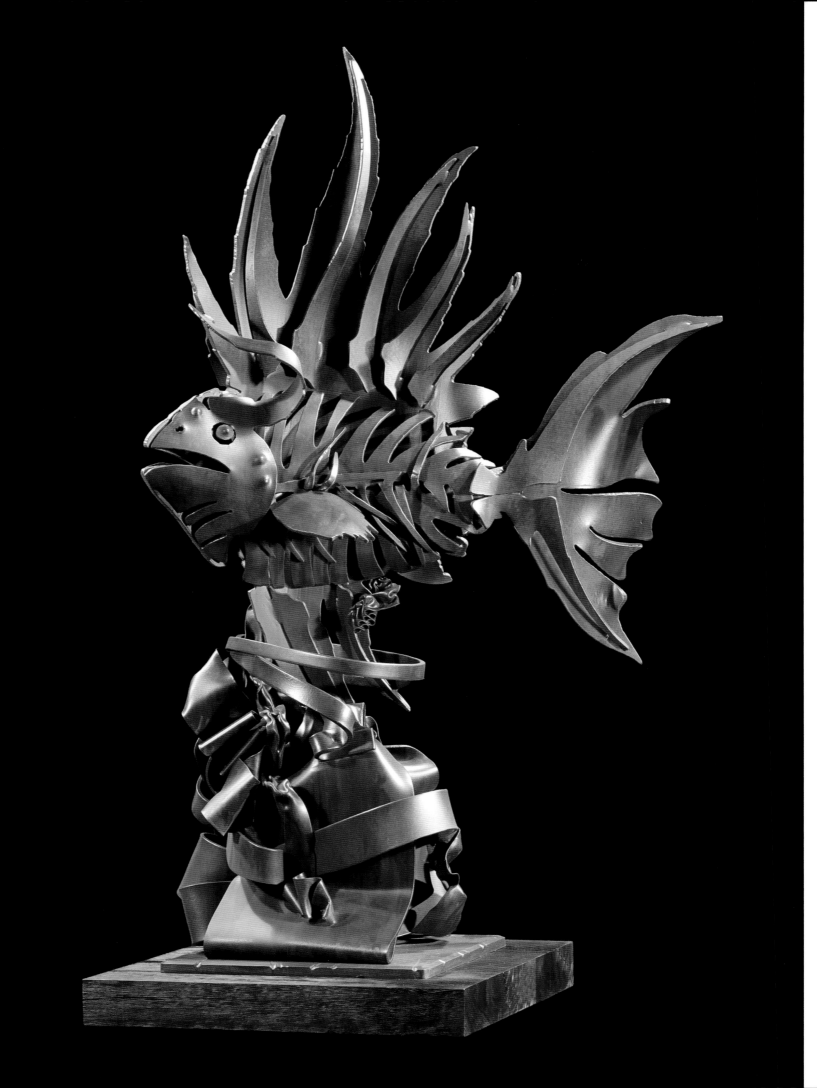

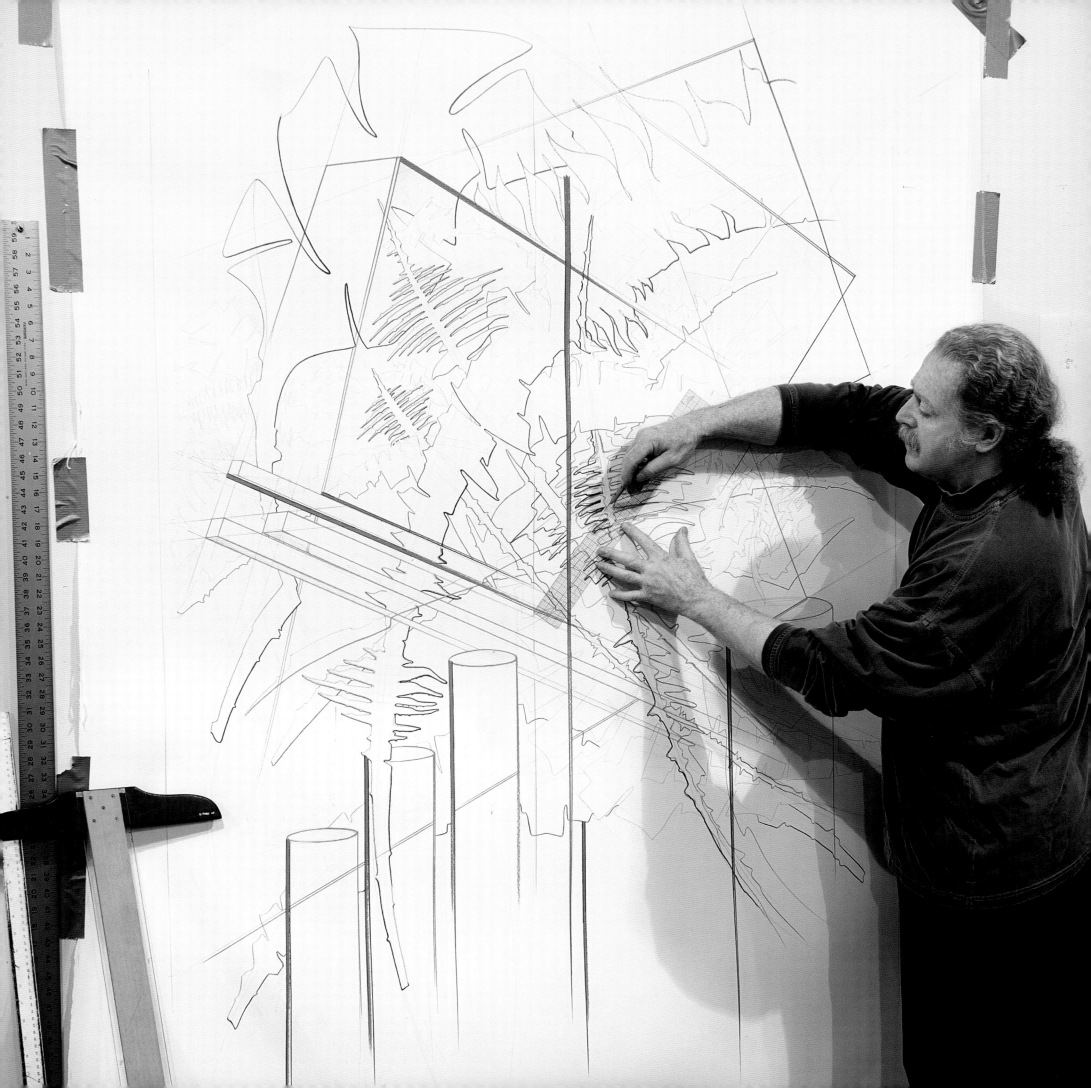

Klein Steel manufacturing and steel distribution center developed their new corporate headquarters in Rochester, New York. Their desire was to commission a sculpture that represented the steel industry and the dynamism and growth of their company. The resulting sculpture, entitled Threshold, utilizes steel products distributed by the company - pipe, beams, square tubing and various structural steel elements. In addition, the manufacturing component of the company is represented by the left over parts from the steel plate burning - these drops or negative shapes were used to create transparent panels that are pierced and interlaced throughout the sculpture. Painted safety yellow, the sculpture reflects the profile of this industrial arena.

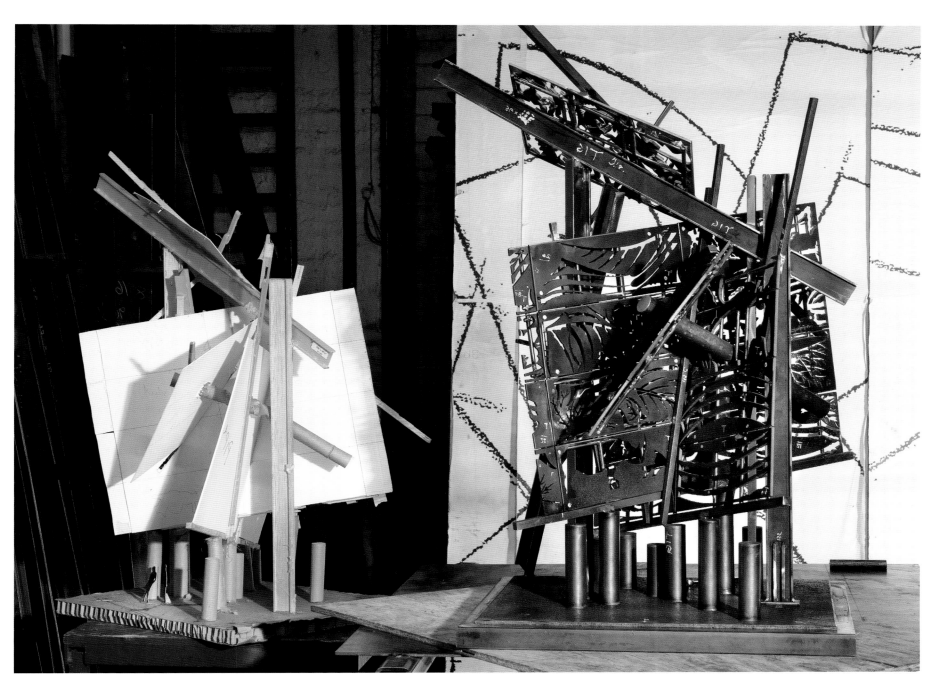

145. *Threshold, The Klein Steel Sculpture*, 2007
Conceptual Developmental Drawing
Graphite and Red Pencil on Paper
6'3" x 4'
Studio Archive

146. *Threshold*, 2006
Developmental Process Models Cardboard
18" x 16" x 14"
Steel
45" x 36" x 28"
North Washington Street Studio Rochester, New York

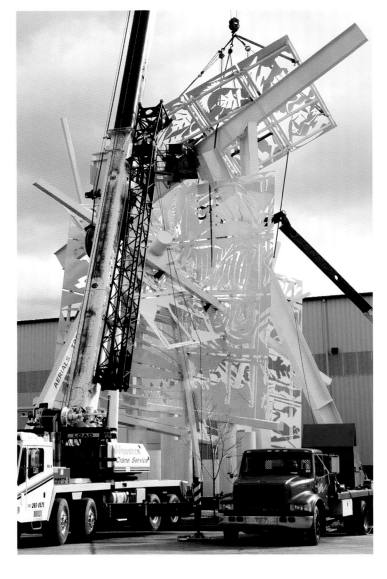

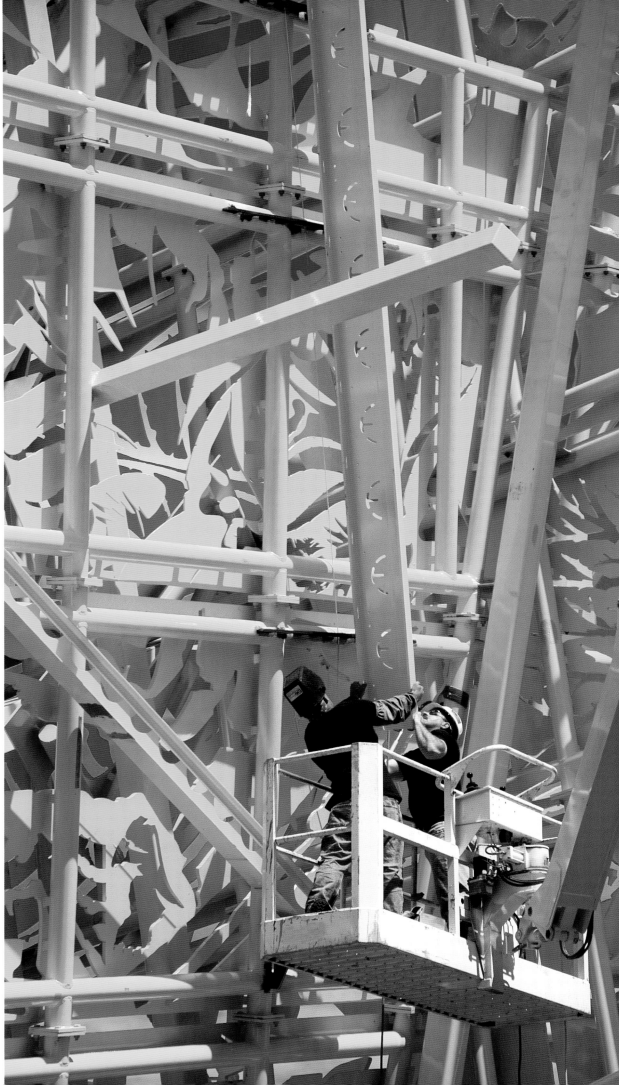

147-148. *Threshold*, 2006
Installation
Klein Steel Corporate Headquarters
Rochester, New York

149. Albert Paley with *Threshold*, 2006
Formed and Fabricated Mild Steel with
Painted Finish
71' x 40' x 40'
Klein Steel Corporate Headquarters,
Rochester, New York

Image on pages 126-127
150. *Threshold*, 2006
Detail

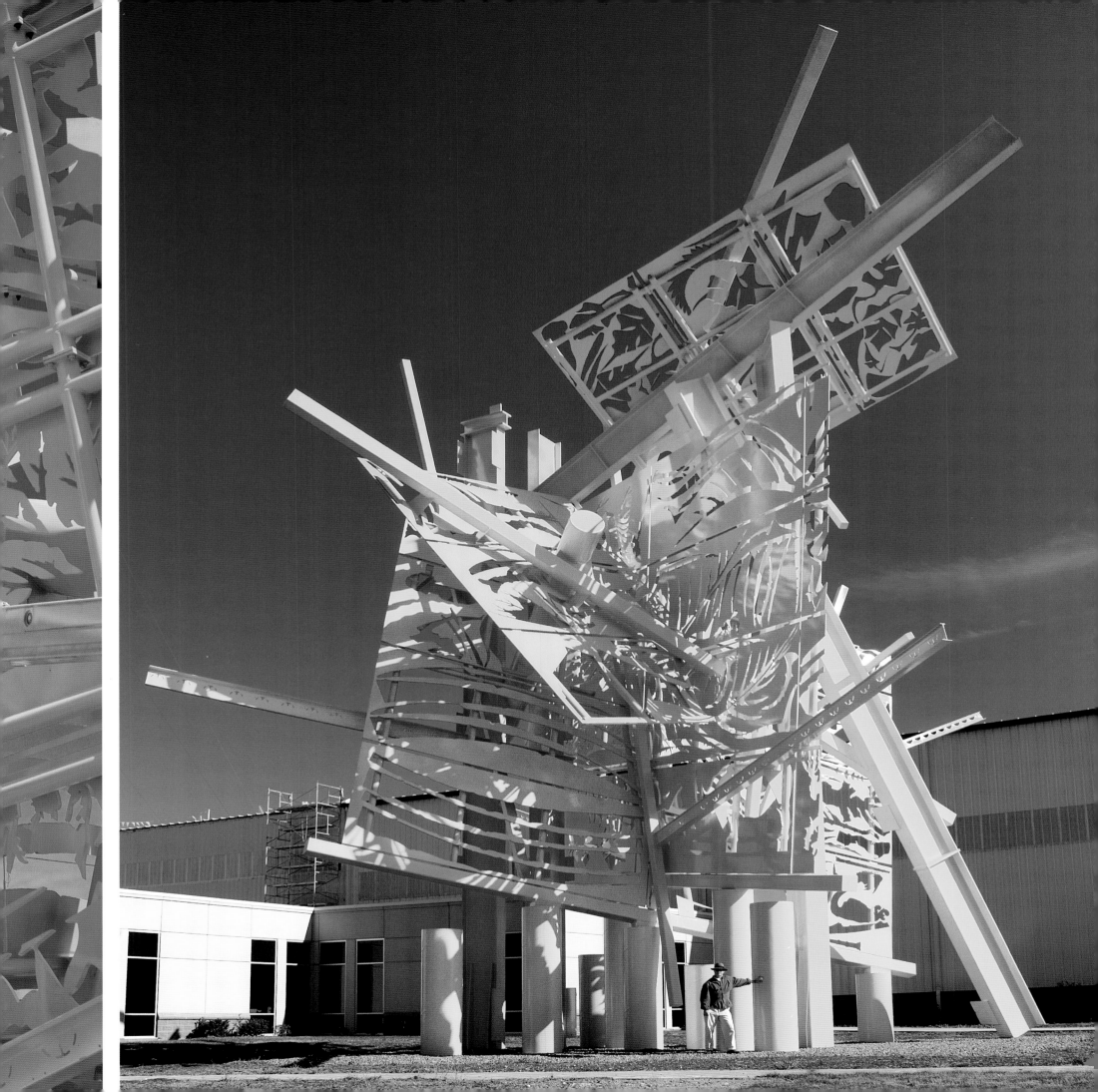

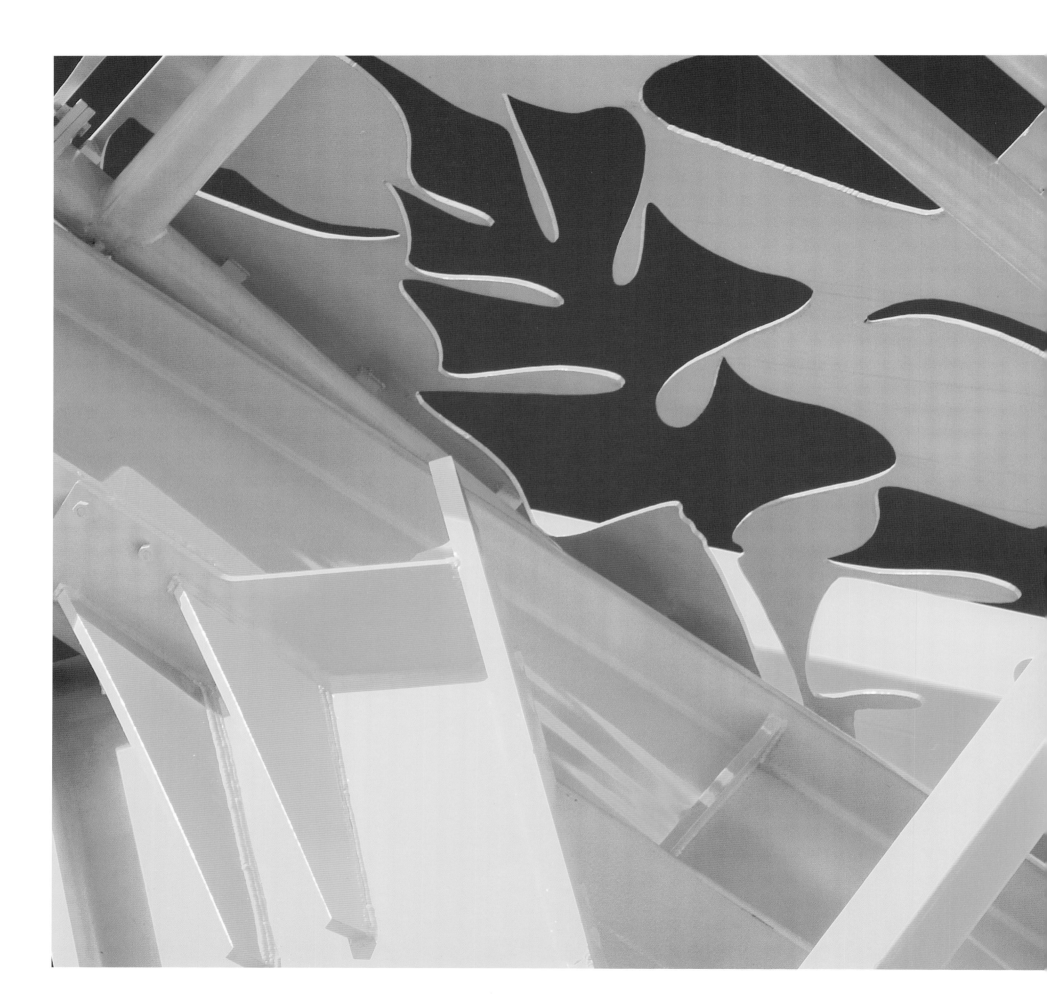

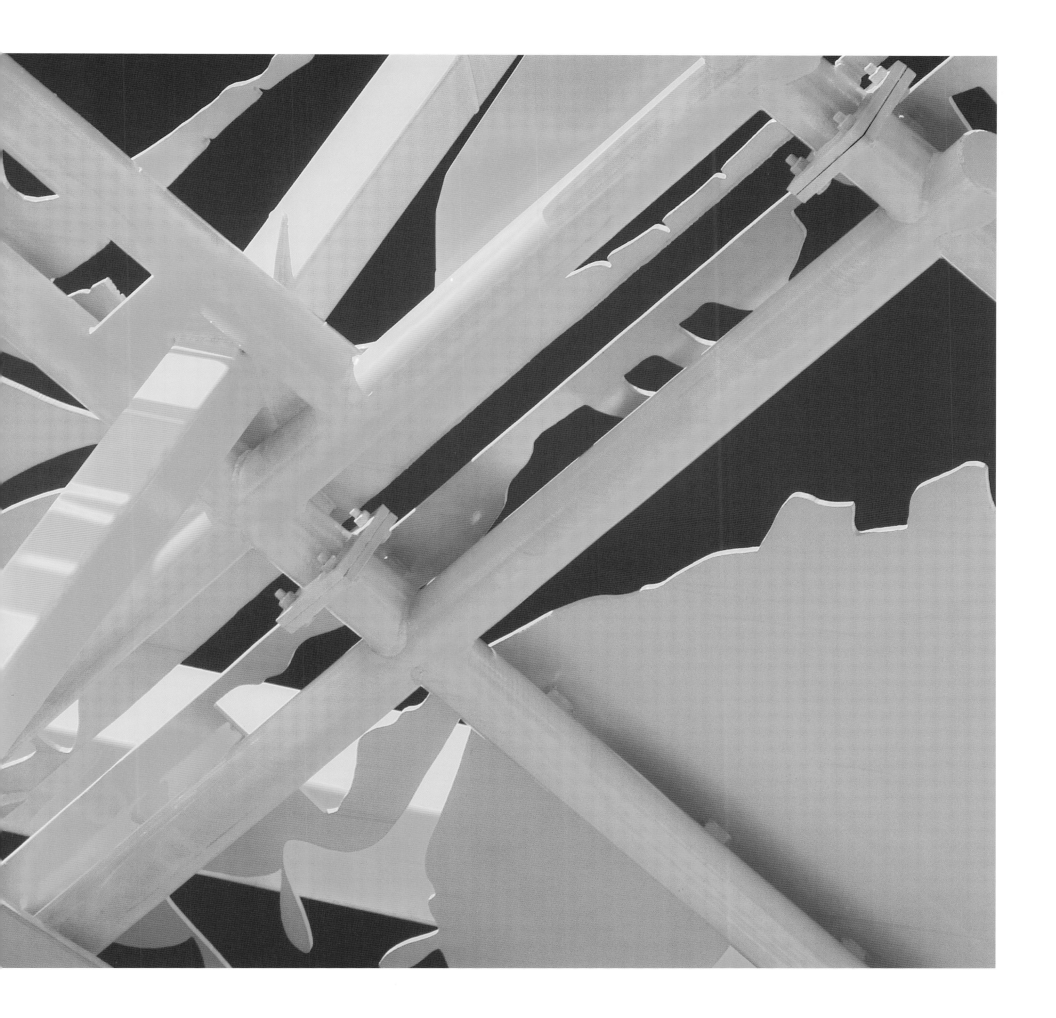

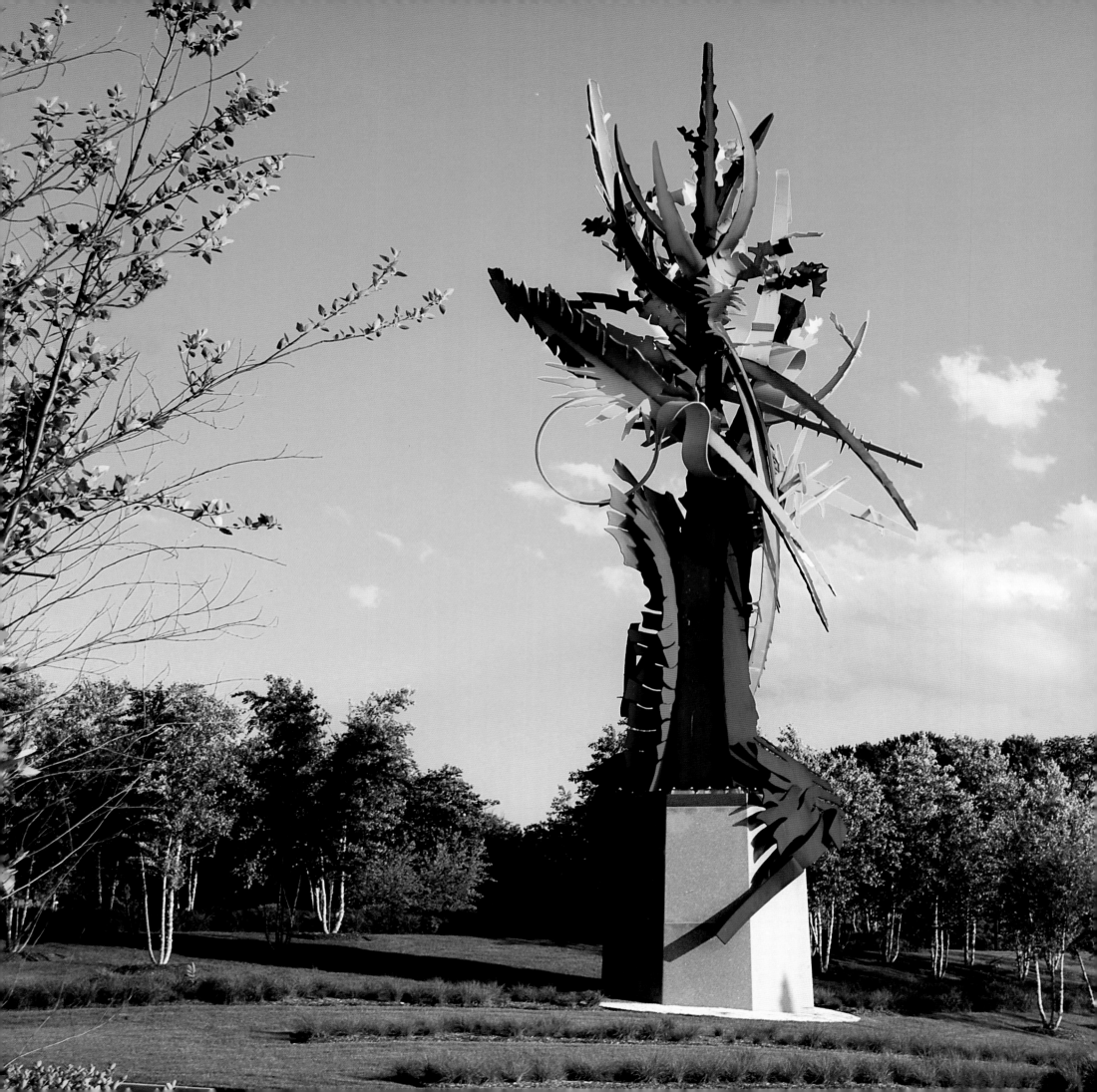

National Harbor, a recently developed complex, marina and conference center, commissioned a sculpture to be placed at the main entrance to help define the character and ambiance of the complex. Positioned adjacent to the Potomac in a landscape and wetland area, the sculpture is the first encountered upon entering. 100' tall and polychromed, its presence dominates the landscape. In the evening, lighting enhances its presence. The sculpture, entitled The Beckoning, was developed in concert with Sasaki Associates from Boston, Massachusetts, in their landscape plan. In addition to the main entrance sculpture, two eagles were commissioned for the central plaza along the major axis of the complex.

151. *The Beckoning*, 2008
Formed and Fabricated Cor-ten Steel
with Polychromed Finish
100' x 33'
National Harbor Development,
Oxon Hill, Maryland

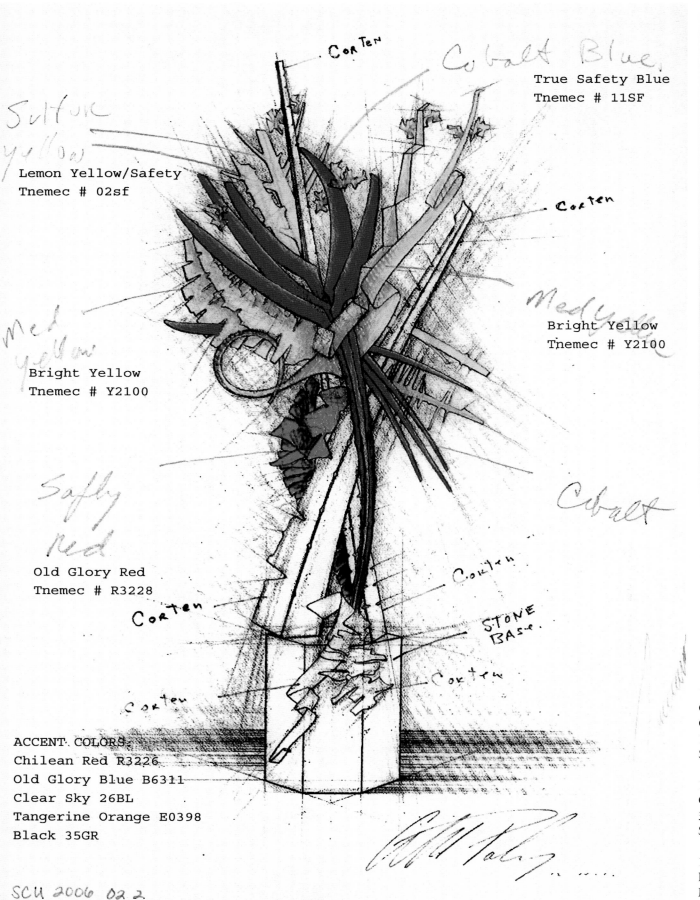

CorTen

Cobalt Blue.

True Safety Blue
Tnemec # 11SF

Sulfur
Yellow

Lemon Yellow/Safety
Tnemec # 02sf

Corten

Med
Yellow

MedYell

Bright Yellow
Tnemec # Y2100

Bright Yellow
Tnemec # Y2100

Cobalt

Safty
Red

Old Glory Red
Tnemec # R3228

Corten

Corten

STONE
BASE.

Corten

Corten

ACCENT COLORS.
Chilean Red R3226
Old Glory Blue B6311
Clear Sky 26BL
Tangerine Orange E0398
Black 35GR

SCU 2006 022

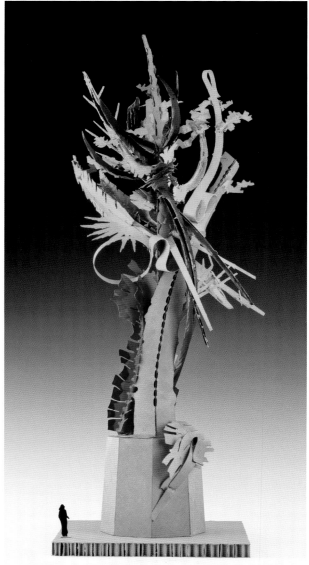

152. *National Harbor Proposal*, 2006
Color Rendering
Colored Pencil on Photocopy
12.5" x 8.75"
Studio Archive

153. *National Harbor Model*, 2006
Cardboard and Paint
3'3" x 1'6" x 1'
Studio Archive

154. *The Beckoning*, 2008
Paley, Fabrication
Maple Grove Enterprises
Arcade, New York

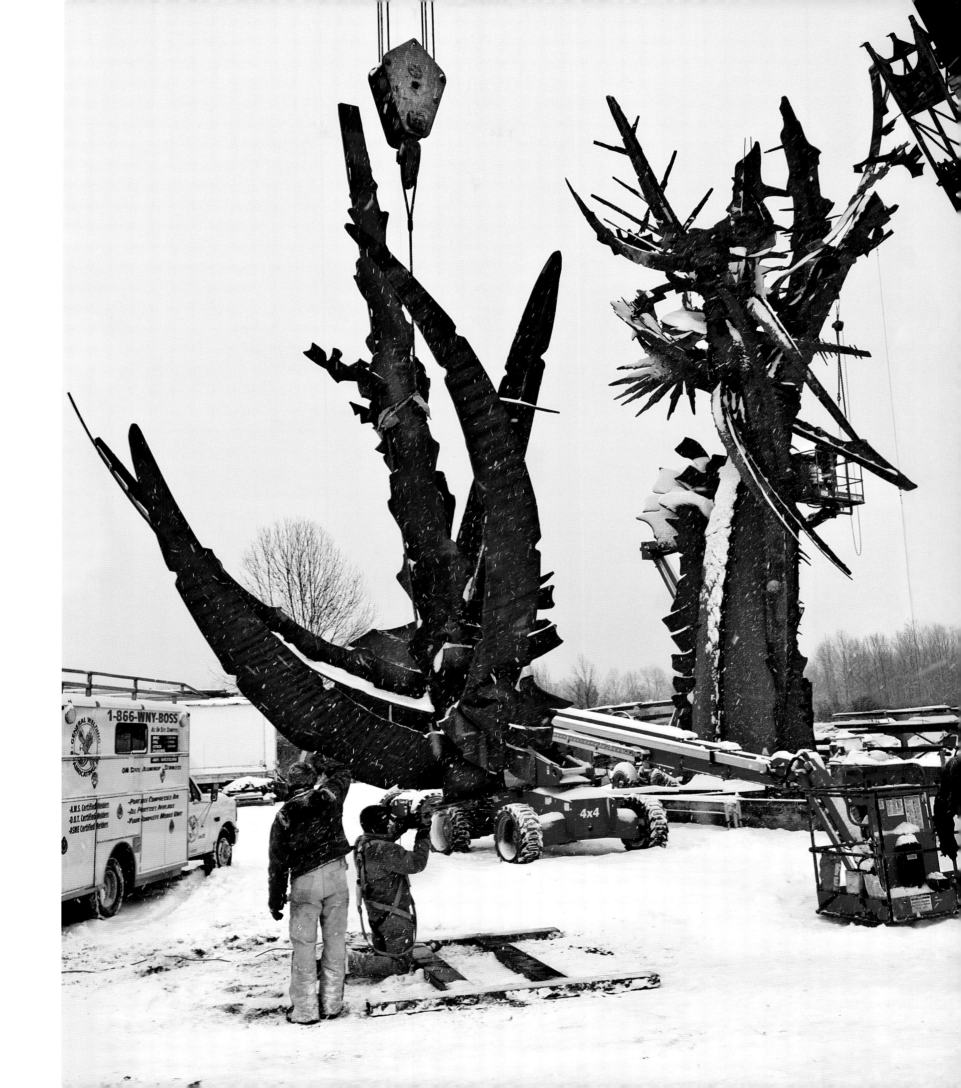

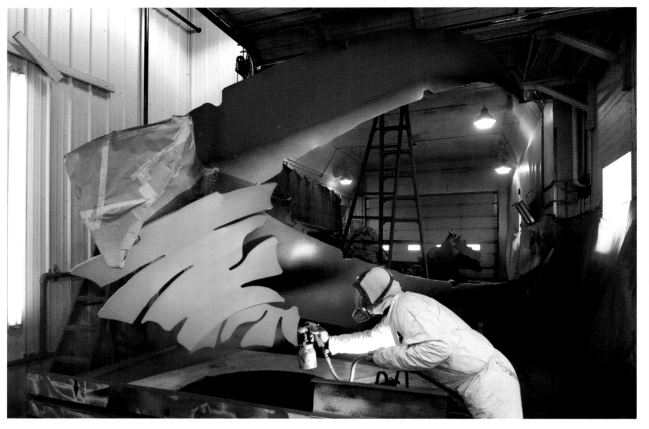

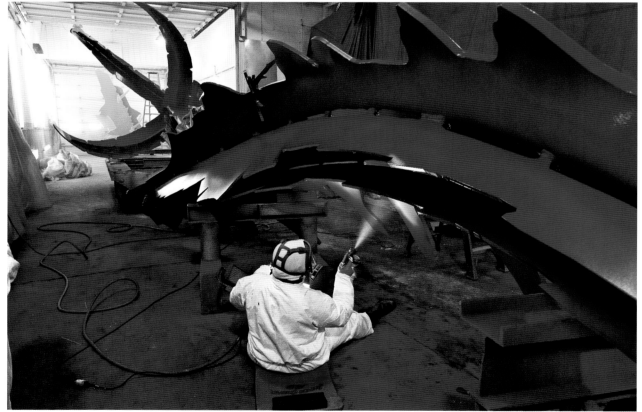

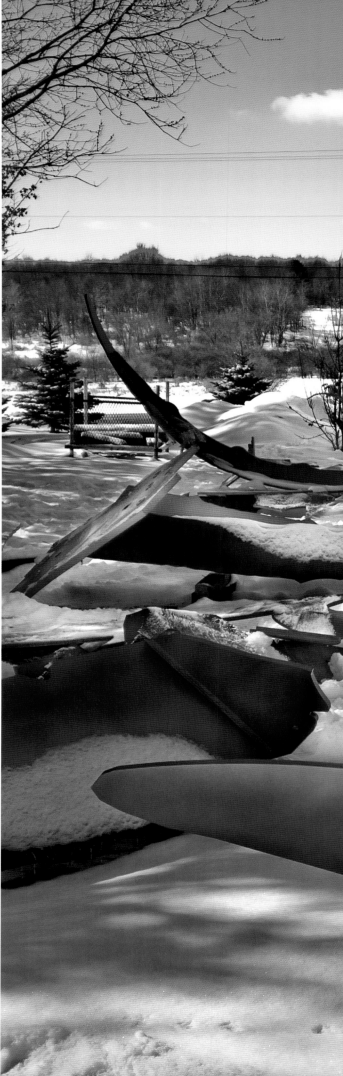

155-156. *The Beckoning*, 2008
Paley, Painting
Maple Grove Enterprises
Arcade, New York

157. *The Beckoning*, 2008
Fabrication Site
Maple Grove Enterprises
Arcade, New York

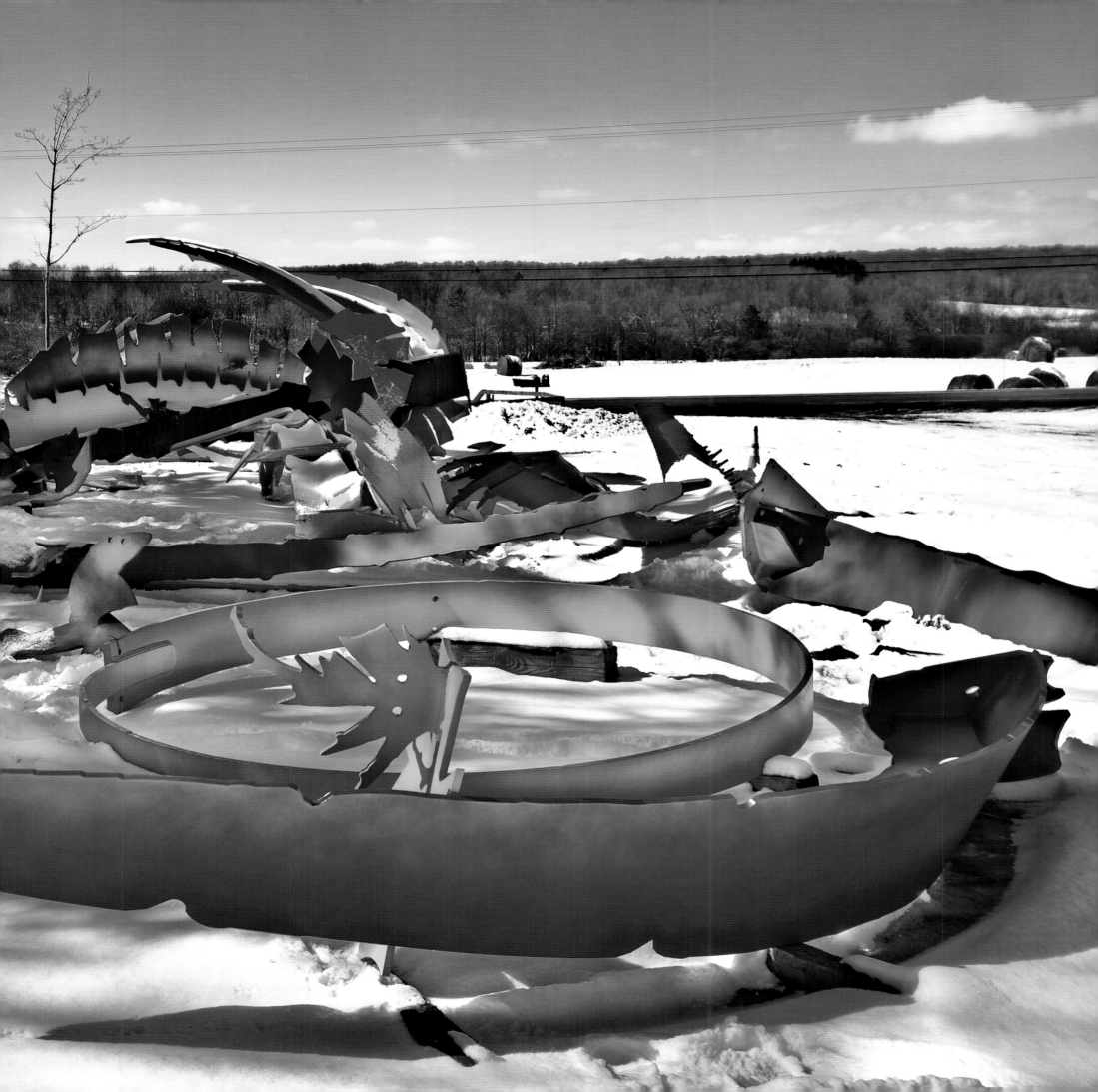

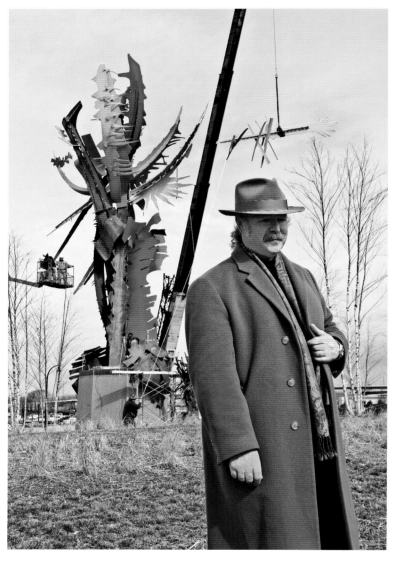

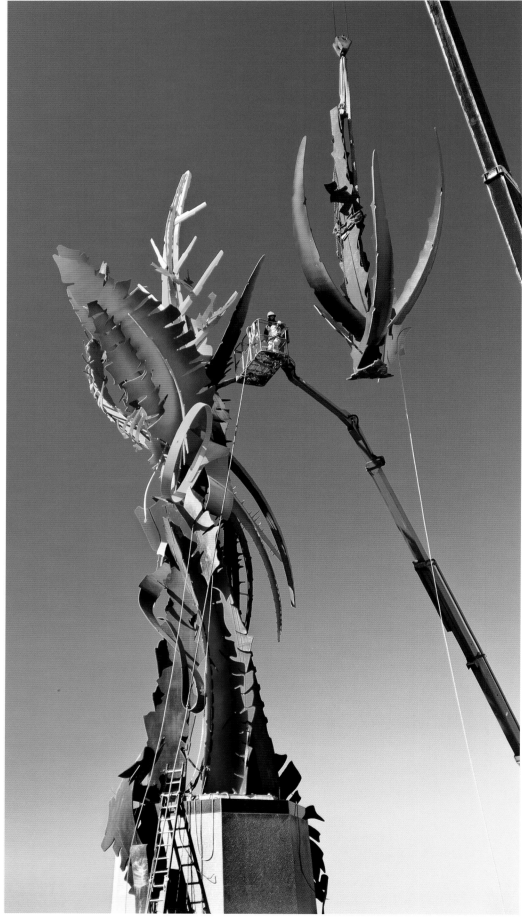

158- 159. *The Beckoning*, 2008
Paley, Installation
National Harbor Development
Oxon Hill, Maryland

160. *The Beckoning*, 2008
Detail

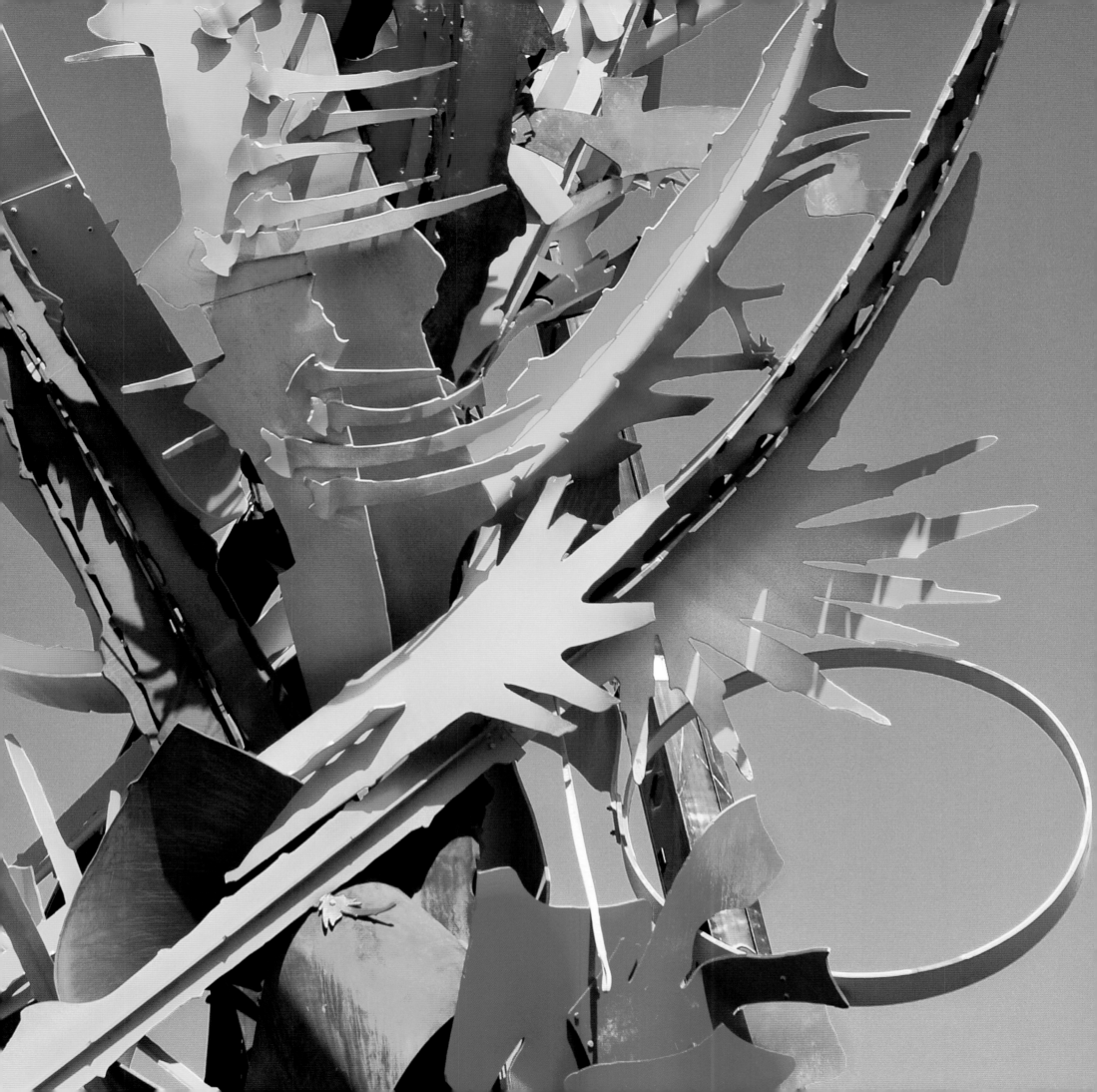

161. *The Beckoning*, 2008
In-situ
National Harbor Development,
Oxon Hill, Maryland

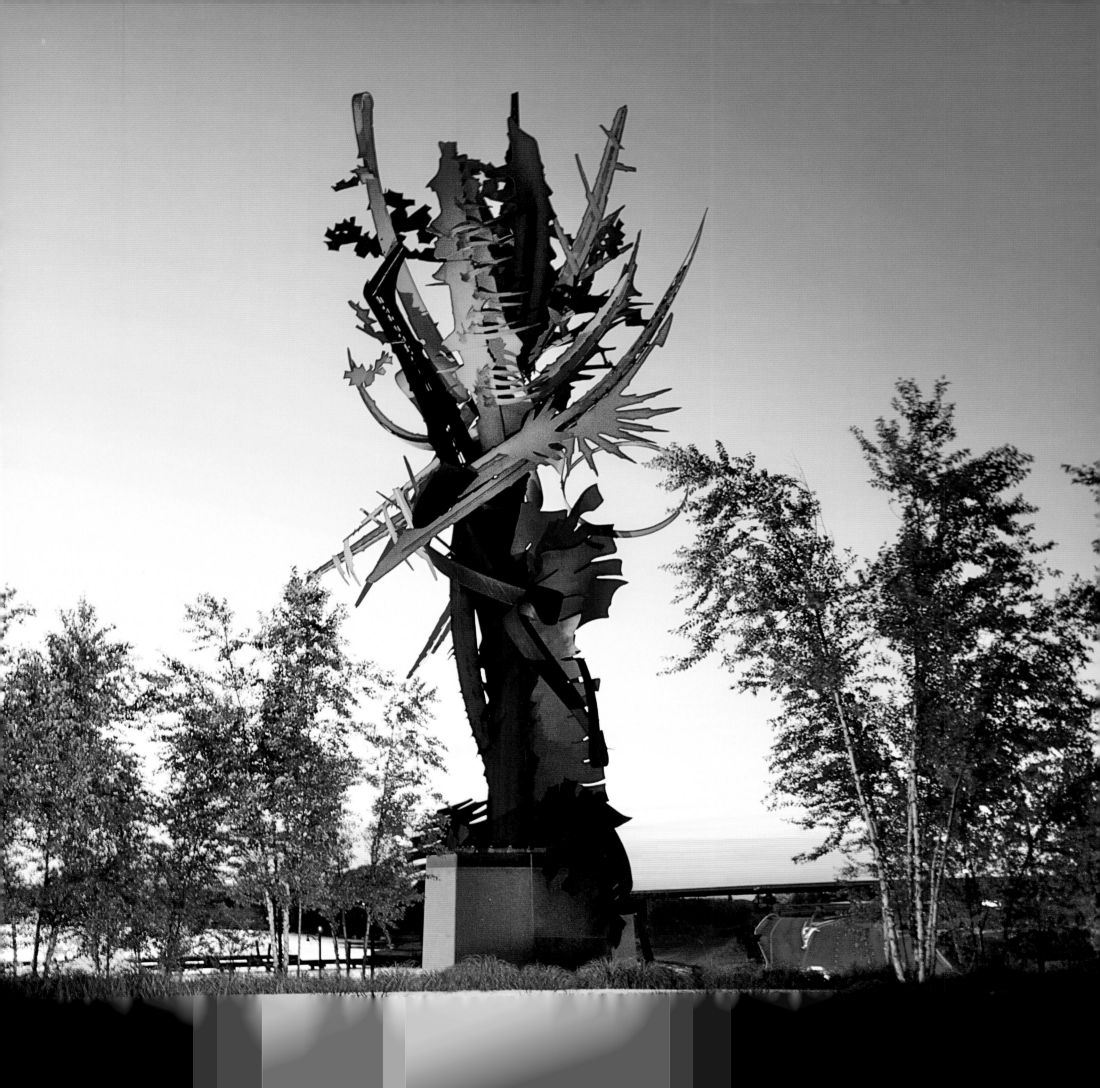

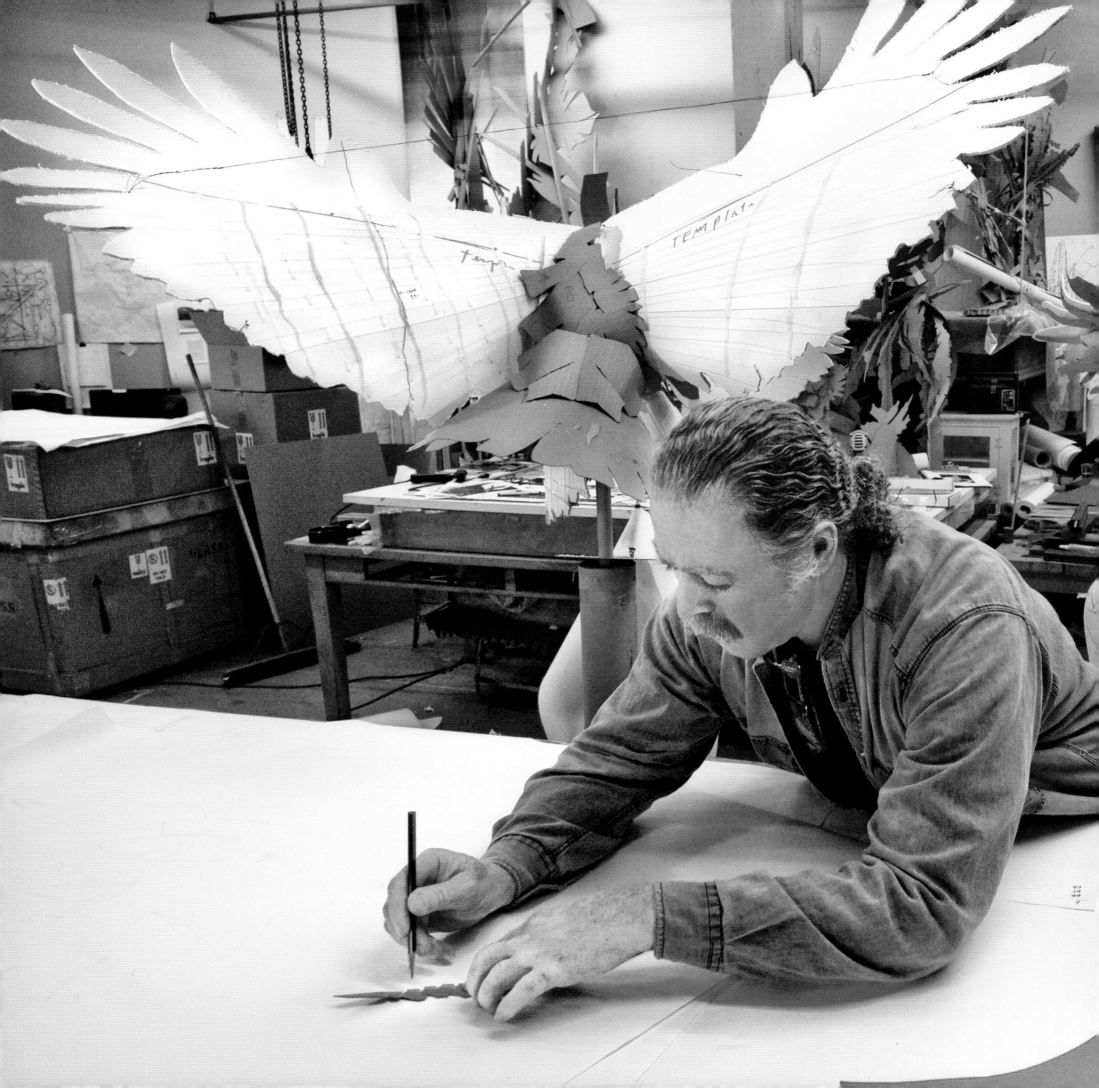

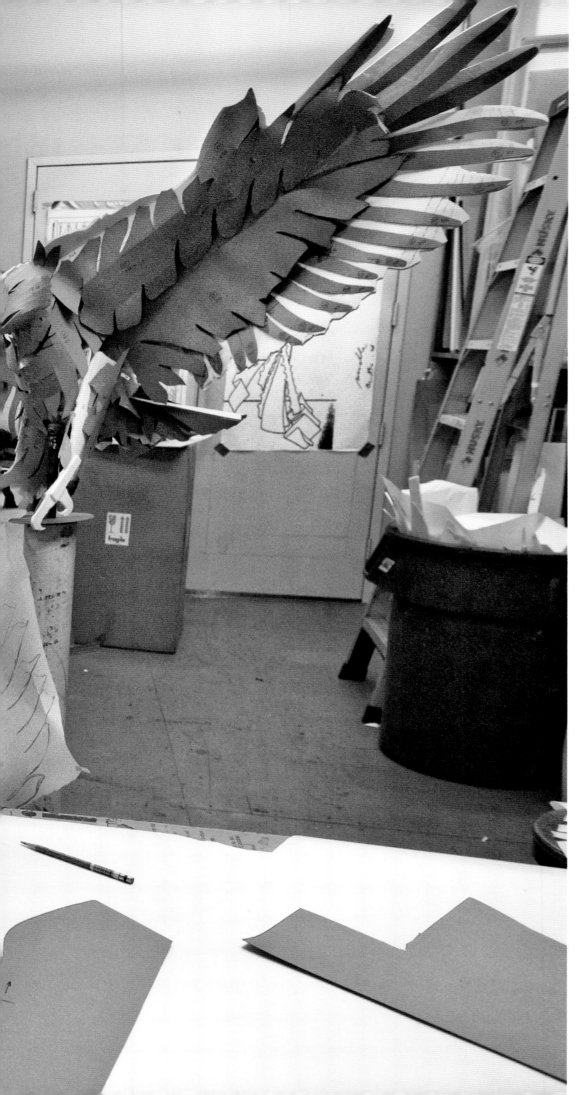

Positioned on the central pedestrian plaza of National Harbor, adjacent to the marina, are two pylons with eagles. As eagles represent our national identity, their presence helps define the complex. The eagles, a matched pair gesturing to one another, bring focus to the major axis of the landscape plan.

162. Paley, Design and Pattern
Development for the National Harbor Eagles
North Washington Street Studio
Rochester, New York

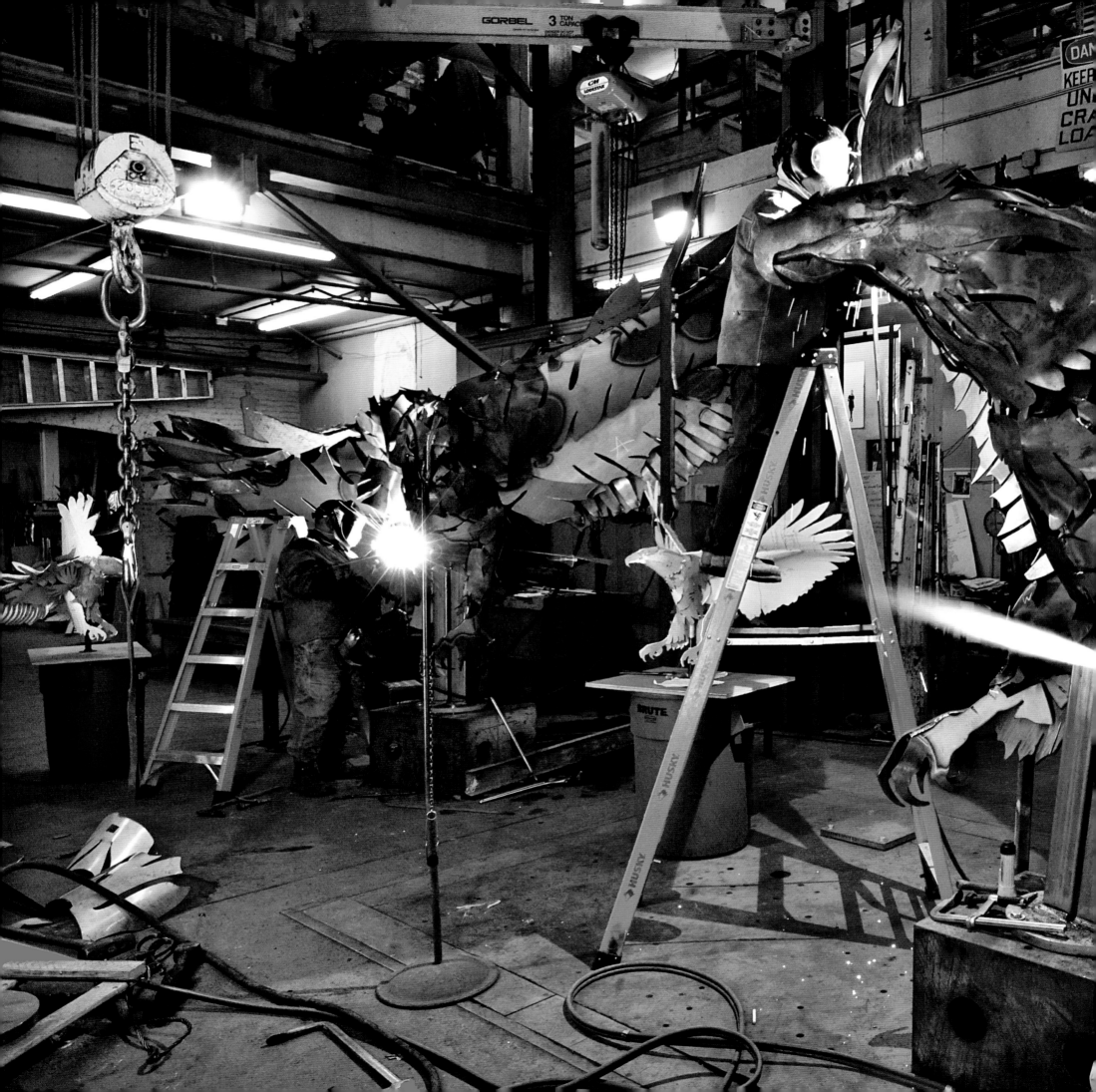

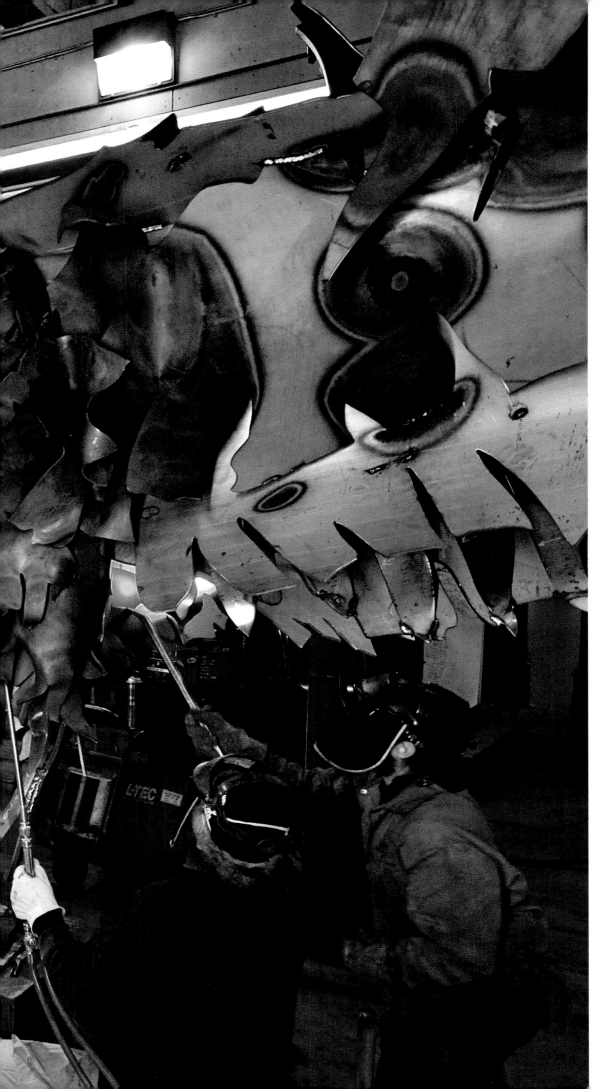

163. *Eagles*, 2008
Paley, Fabrication
North Washington Street Studio
Rochester, New York

Images on pages 142-143
164. *Eagles*, 2008
Paley, Painting
Maple Grove Enterprises
Arcade, New York

165. *Eagles*, 2008
Installation
National Harbor Development
Oxon Hill, Maryland

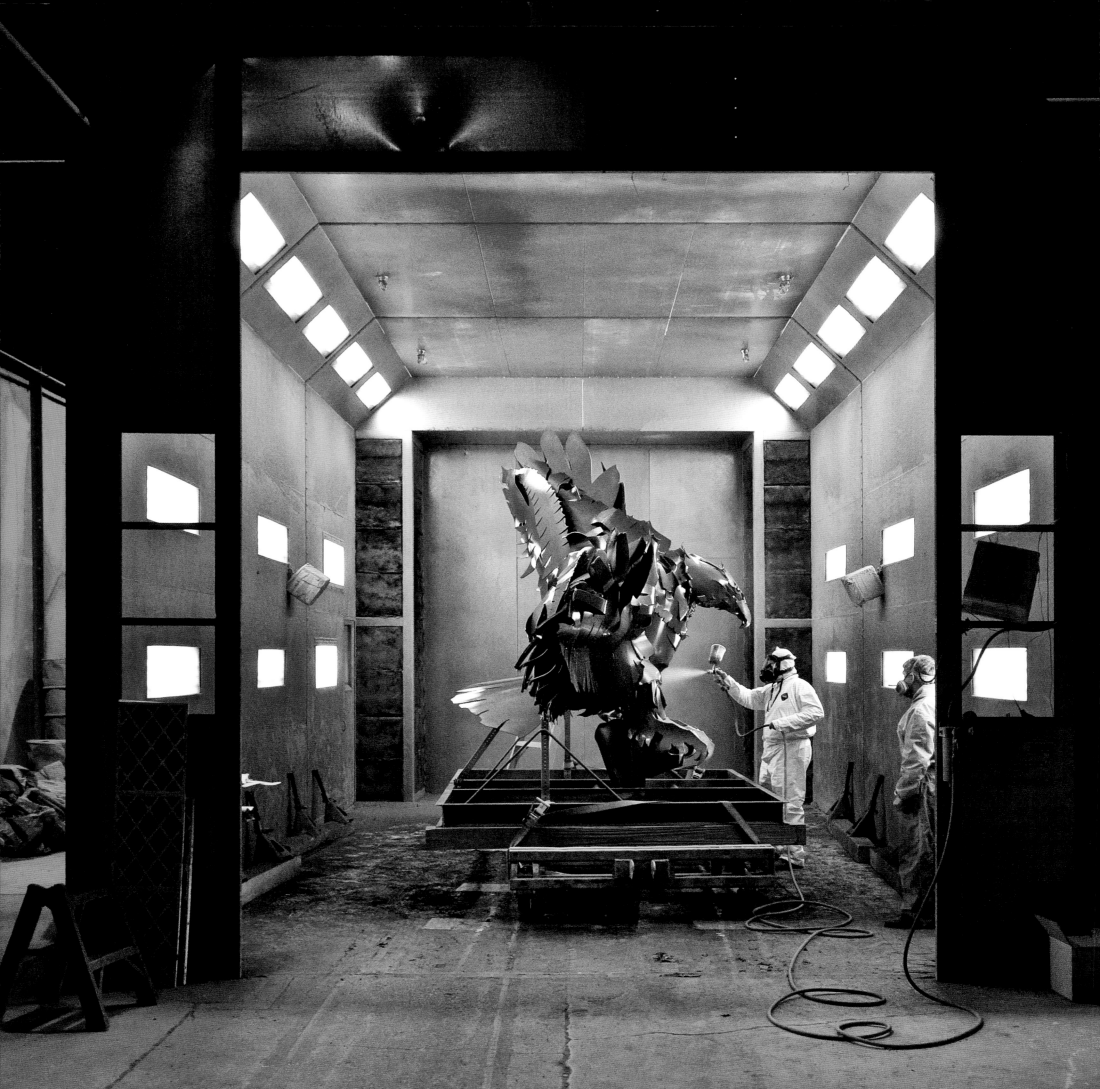

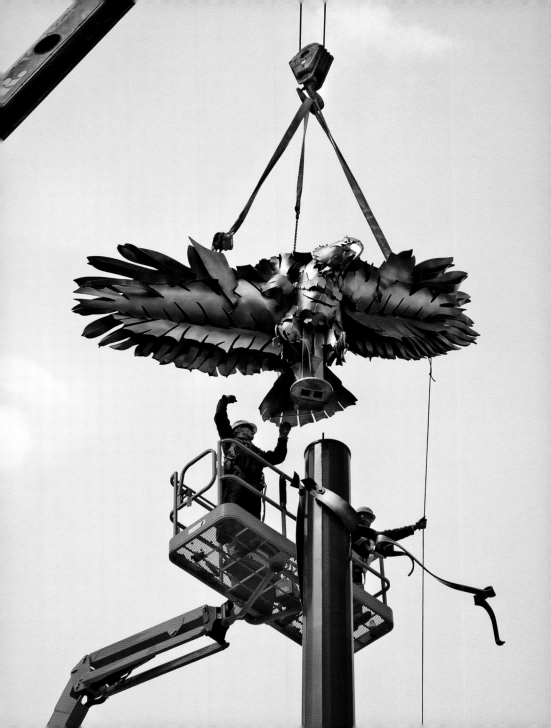

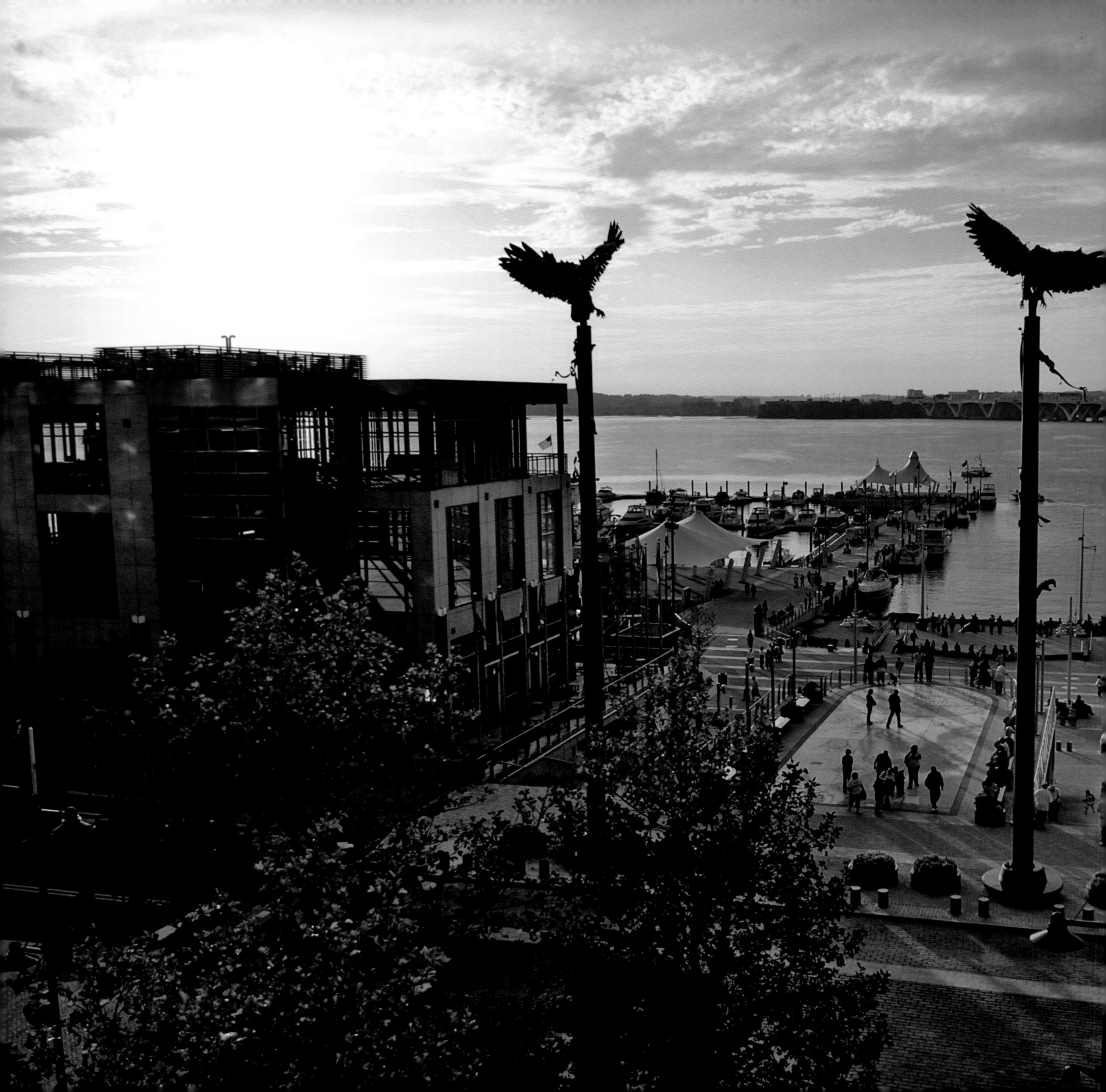

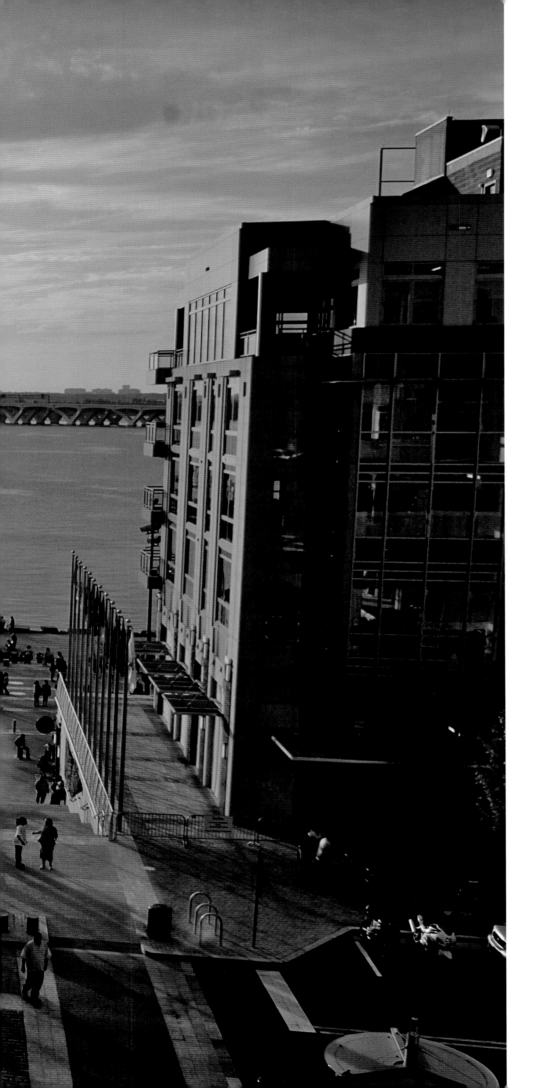

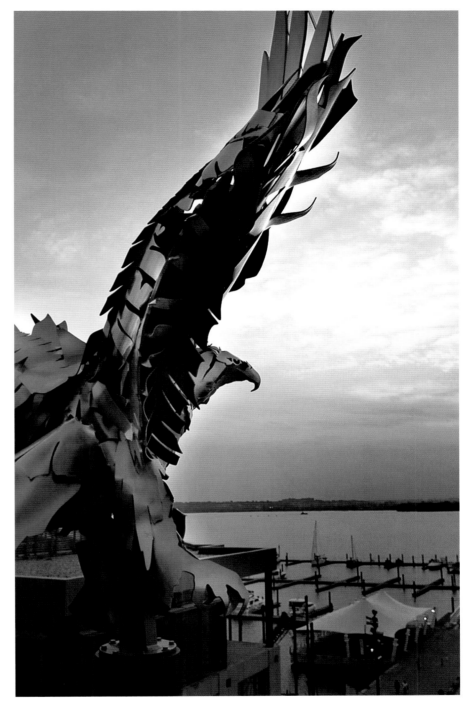

166- 167. *Eagles*, 2008
Formed and Fabricated Stainless
Steel
11' x 16' x 7' Each
National Harbor Development,
Oxon Hill, Maryland

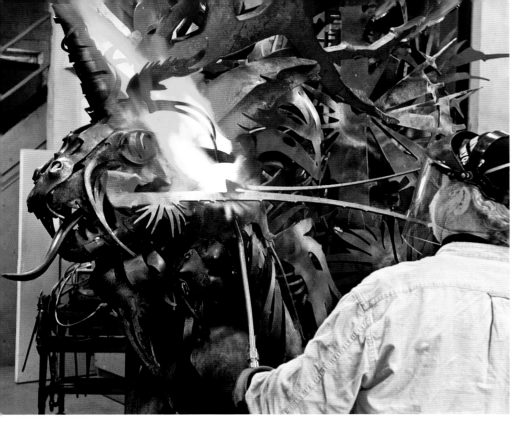

168. *Kirins*, 2009
Paley, Fabrication
North Washington Street Studio
Rochester, New York

169. *Kirin Proposal*, 2009
Presentation Drawing
Red Pencil on Paper
22" x 30" Studio Archive

170. *Kirins*, 2009
Paley, Fabrication
North Washington Street Studio
Rochester, New York

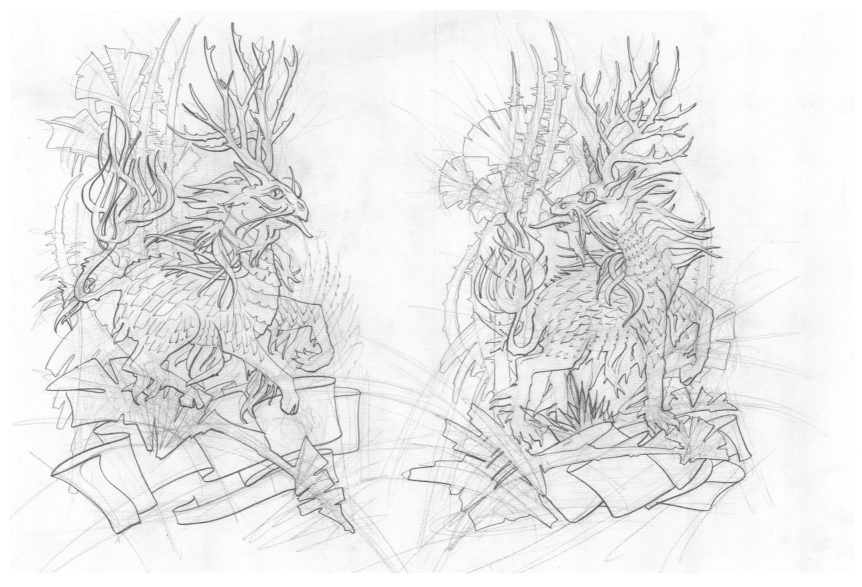

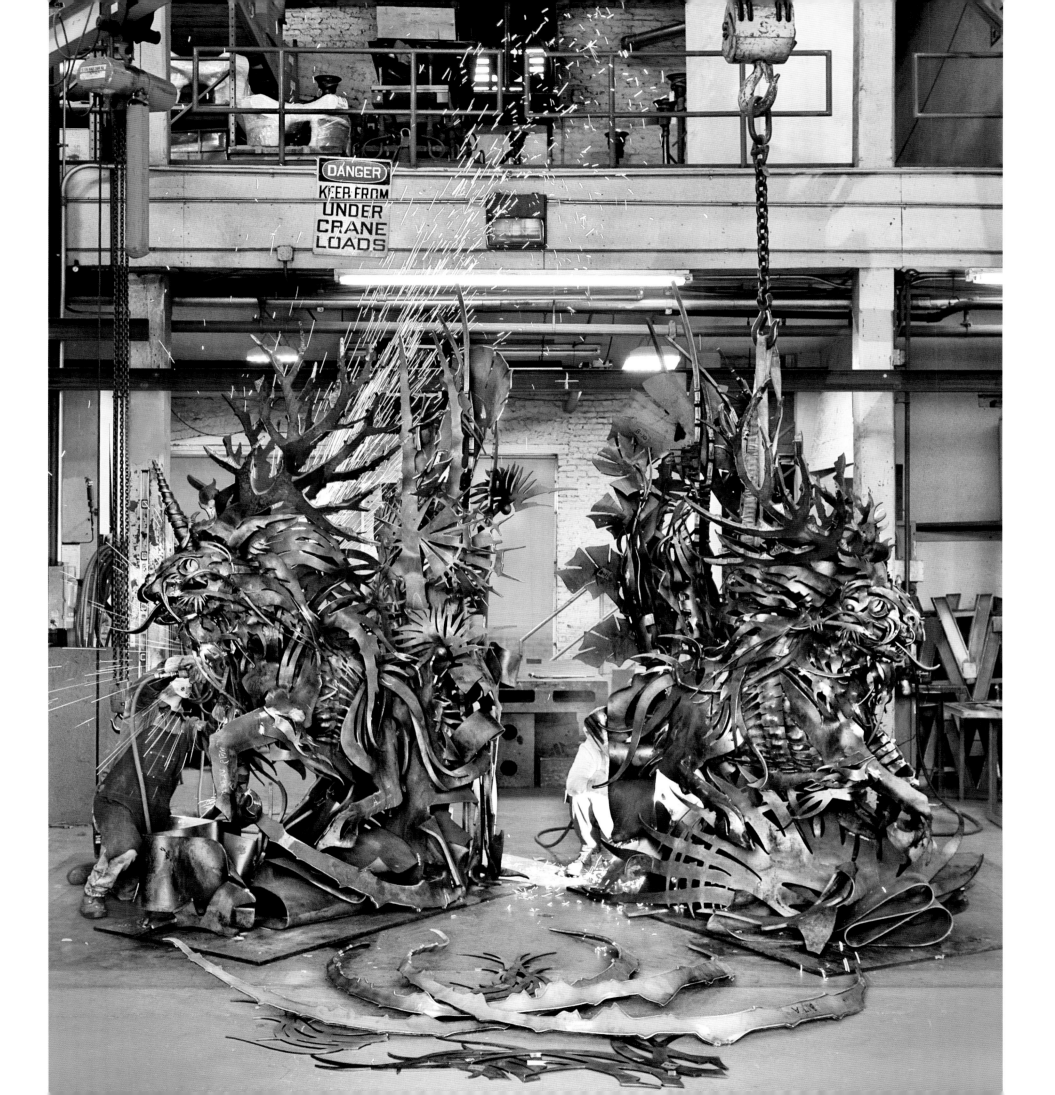

Commissioned by MGM Grand for the Aria casino in Las Vegas, Nevada are two Kirins – Asian dragons. The two sculptures, male and female, are positioned left and right of the main entrance of the casino as good luck. The Kirin, a celestial deity, embodies good fortune and incorporates favorable attributes from the animal kingdom - the elk, ox, lion, deer, fish and the head of a dragon. The unicorn horn defines the male.

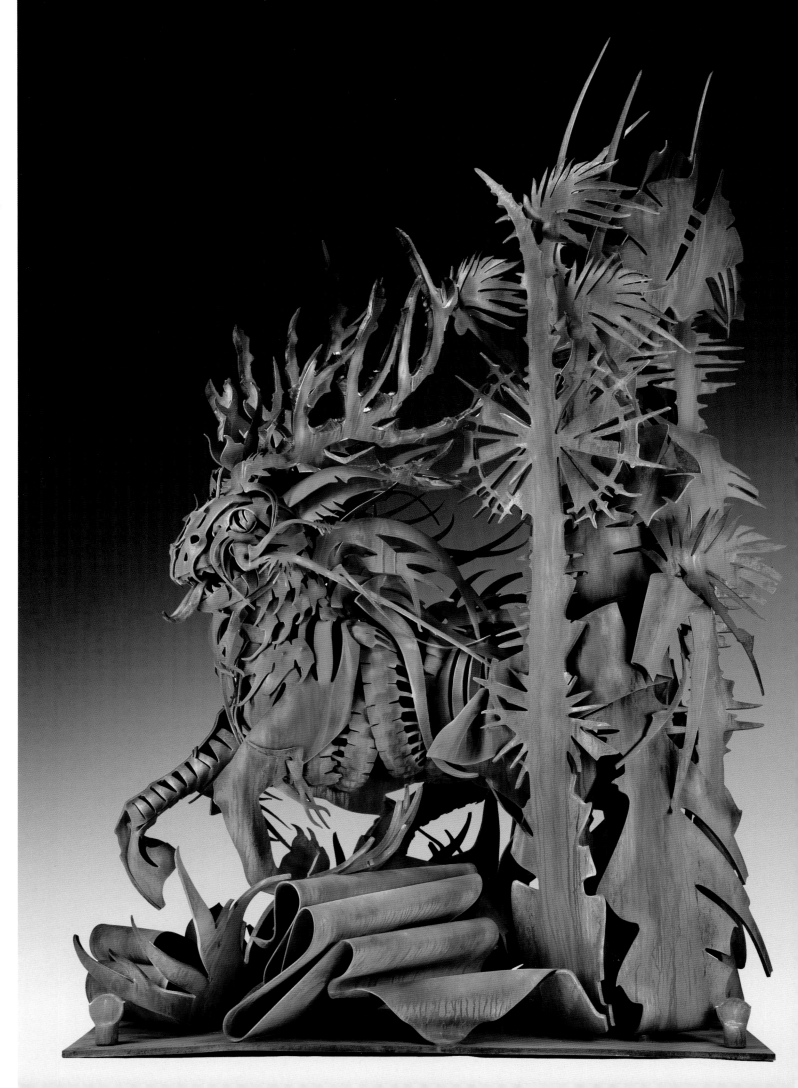

171. *Kirins*, 2009
Formed and Fabricated
Cor-ten Steel
11' x 7' x 4'6" Each
Studio Documentation

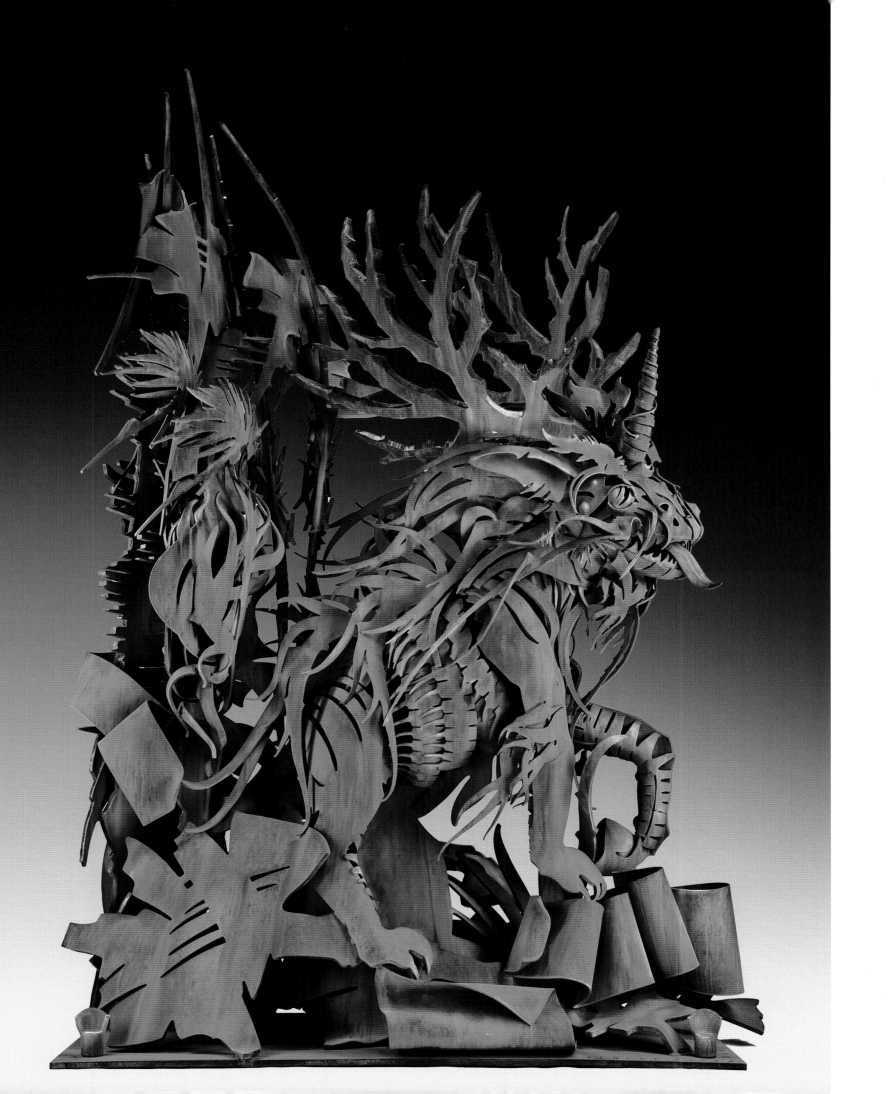

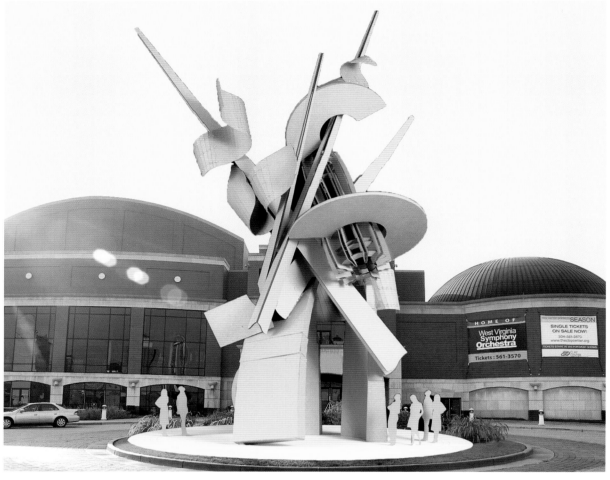

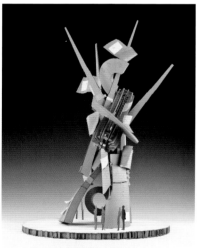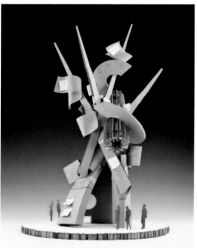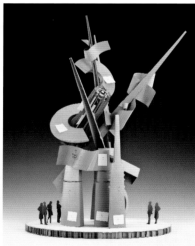

Commissioned by the Clay Center in Charleston, West Virginia, is a sculpture 70 feet tall placed at the main entrance of this cultural complex. The sculpture is positioned in the circular drive adjacent to the building and surrounded by a city park. The sculpture functions as a symbol and identity reflecting the diversity, vitality and dynamism of the arts and culture of the State.

172 - 175.
Clay Center for the Arts
2007
Presentation Models
Cardboard and Wood
24" x 12"
Studio Archive

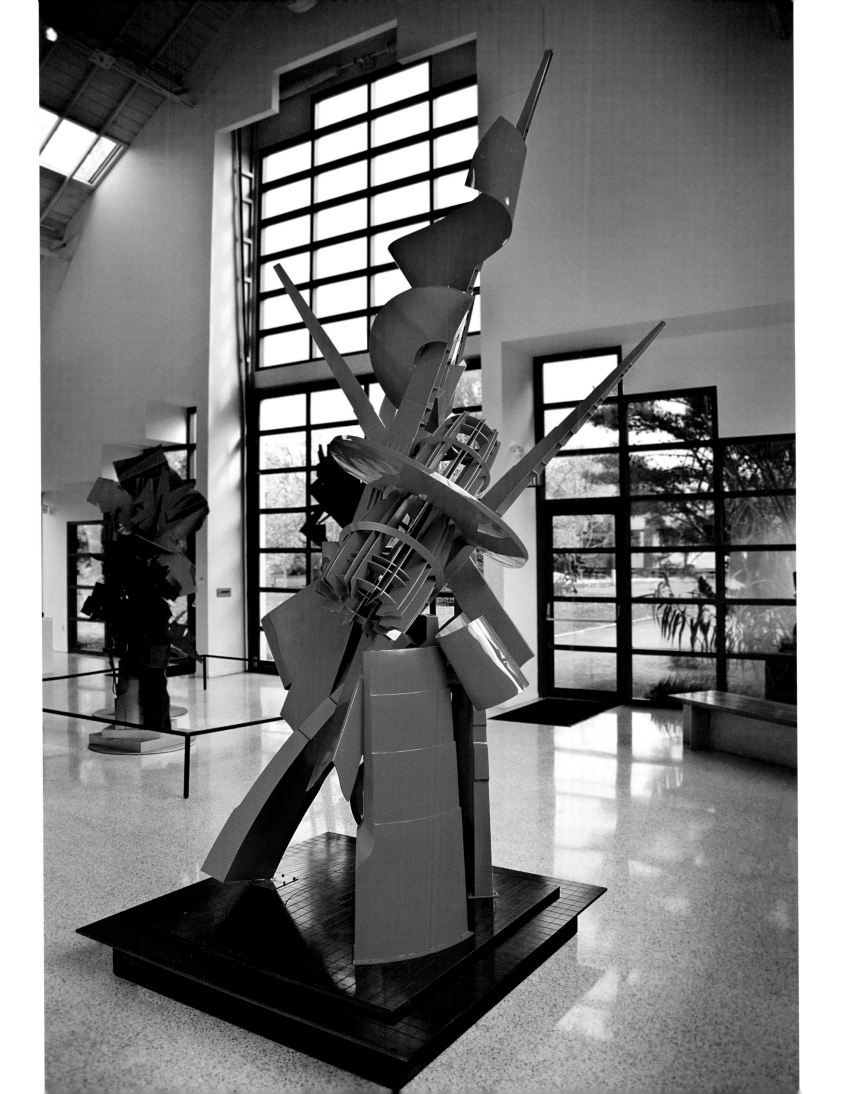

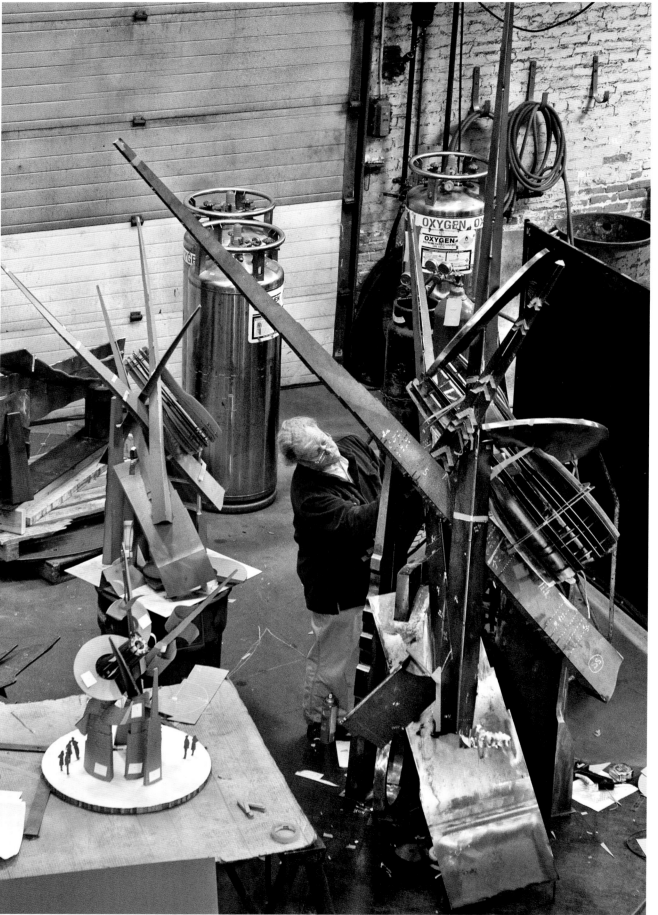

Image on page 151
176. *Clay Center for the Arts Maquette*, 2009
Formed, Fabricated and Polychromed
Mild Steel
12' x 6' x 7'3"

177. *Clay Center for the Arts*, 2009
Paley, Fabrication of Final Structurally
Engineered Metal Model
Mild Steel
12' x 8'
North Washington Street Studio
Rochester, New York

178. *Clay Center for the Arts*, 2007
Developmental Drawing
Studio Archive
11" x 8.5"

179. *Hallelujah*, 2009
Formed and Fabricated Cor-ten,
Stainless Steel and Bronze
68' x 39' x 33'6"
Clay Center for the Arts and Sciences,
Charleston, West Virginia

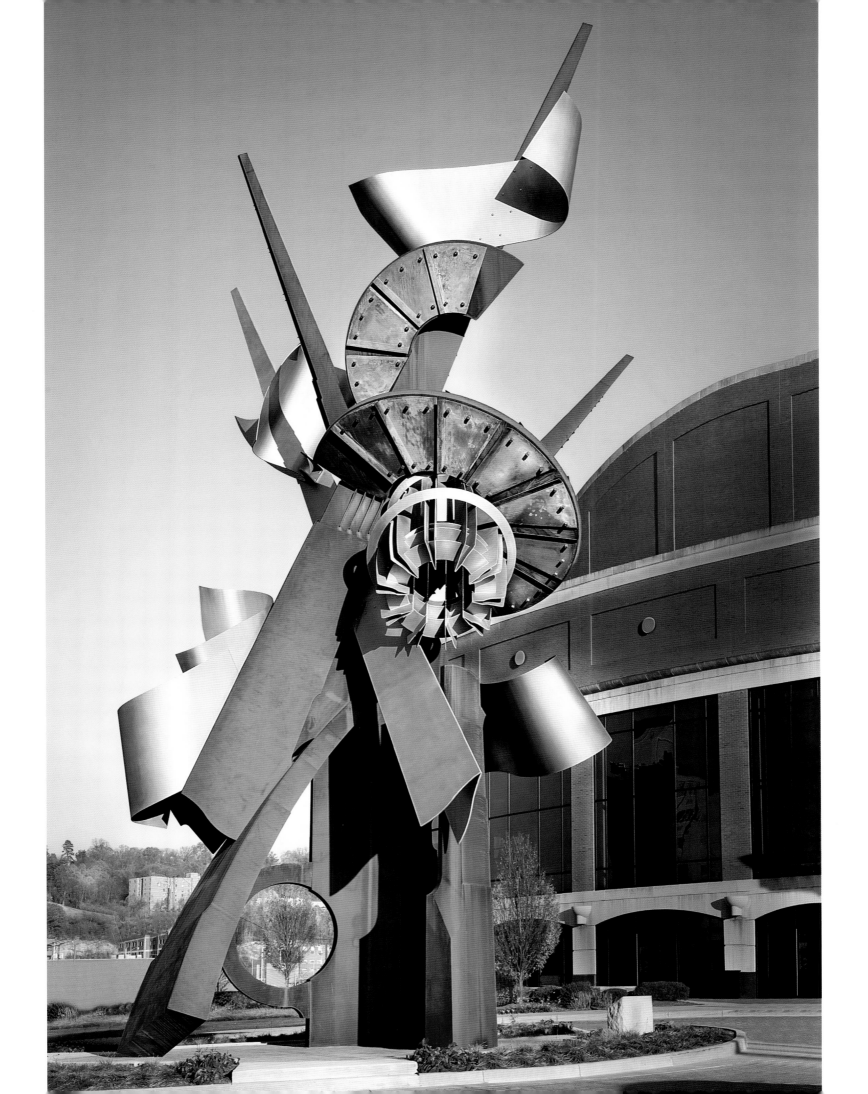

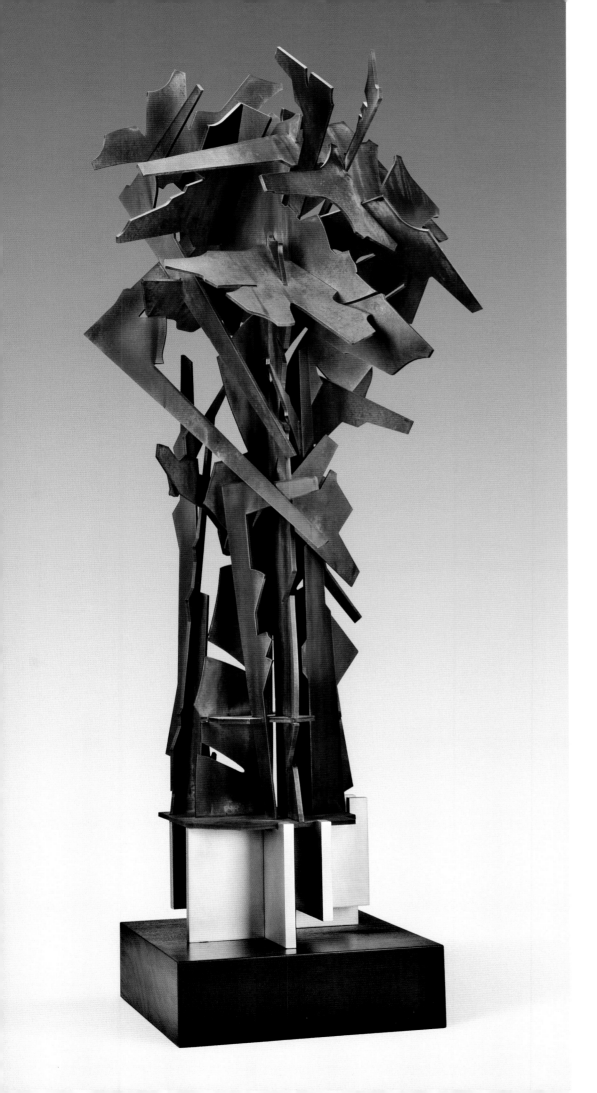

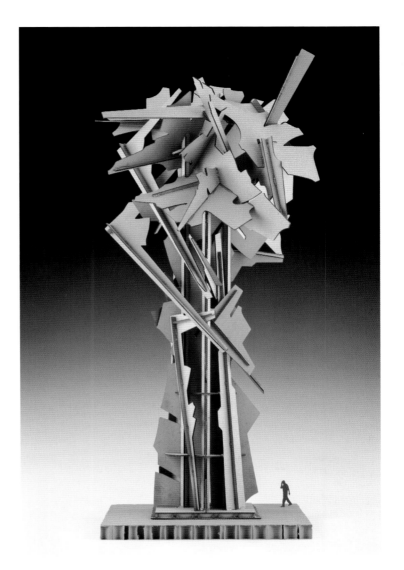

180. *Evanesce*, 2001
Proposal Drawing
Red Pencil on Paper
21" x 29"
Studio Archive

181. *Evanesce Maquette*, 2008
Presentation Model
Fabricated and Patinaed Mild and
Stainless Steels with Wood Base
52" x 18" x 16"

182. *Evanesce Model*, 2008
Cardboard
24" x 7" x 6"
Studio Archive